THE ADVERTISING WORLD OF
Norman Rockwell

Other Books by the Authors
Dr. Donald R. Stoltz, Marshall L. Stoltz

NORMAN ROCKWELL AND THE SATURDAY EVENING POST

Volume 1: The Early Years, 1916-1928

Volume 2: The Middle Years, 1928-1943

Volume 3: The Later Years, 1943-1971

THE ADVERTISING WORLD OF
Norman Rockwell

Dr. Donald Robert Stoltz

Marshall Louis Stoltz

William B. Earle

Madison Square Press

Robert Silver Associates

Copyright © 1985 The Norman Rockwell Museum

ISBN 0-942604-04-0
Library of Congress Catalog Card Number 84-61418
Library of Congress Cataloguing in Publication Data

Designed by Robert Anthony, Inc.
Edited by Arpi Ermoyan and Lester Kaplan
Layouts by Melcon Tashian
Production supervision by Arpi Ermoyan
Rights and Permissions by Katherine Brown
Mechanicals by Carnig Ermoyan, Tom Cushwa and Susan Roecker
Typesetting by True To Type
Printing direction by Yoh Jinno

Printed in Japan by Dai Nippon

23—Reprint courtesy of Nabisco Brands, Inc. 29,30,31—© 1984 Brown & Bigelow by permission of Brown and Bigelow and Boy Scouts of America. 39—Illustration courtesy of The Chase Manhattan Bank. 50,51—Orange CRUSH₀ is a trademark of Crush International, Inc. 62,63—Courtesy of Borden, Inc. 70,71—Courtesy of Uniroyal, Inc. 73—Reprint courtesy of Nabisco Brands, Inc. 86,87—Reproduced courtesy of General Foods, Corp., owner of the registered trademark Grape-Nuts. 106,107—Reproduced courtesy of General Foods Corp., owner of the registered trademark JELL-O. 111—By permission of Mr. and Mrs. Winston L. Shelton, owners of the original painting, and KFC Corporation. 123—Reproduced courtesy of General Foods Corp., owner of the registered trademark MAXWELL HOUSE. 128,129—Reproduced by permission of Merck Sharp & Dohme, Division of Merck & Co., Inc. 130,131—From the United Artists release "Along Came Jones" © 1945 Cinema Artists Corp. 140,141—Courtesy of Pan American World Airlines, Inc. 144,145—Reproduced courtesy of Kraft, Inc. 155 —Courtesy of Chrysler Corporation. 162,163—Courtesy of Raybestos—Manhattan. 170,171—Courtesy of Rock of Ages Corporation—A Nortek Company, Barre, Vermont. 182,183 —Reprint courtesy of Nabisco Brands, Inc. 191,192,193,194, 195—Copyright held by Top Value Enterprises, Inc.— Reproductions compliments of the Trading Stamp Systems Division. 202,203—Courtesy of The Upjohn Company.

To Our Children
Brad, Andrea, Shari, Robyn and Craig
We Dedicate This Treasury of
American Art, History and Industry

Table of Contents

Portrait of the American Artist, Norman Rockwell

Norman Rockwell was born on February 3, 1894, in a brownstone house on 103rd Street and Amsterdam Avenue in New York City. From the time he could hold a pencil he loved to sketch and everything he saw intrigued him: animals, automobiles, parades and all kinds of people. Never much of an athlete, he loved to watch kids play baseball and football and he drew them all.

He loved summer and hated the city and in 1903 he was delighted when the Rockwell family moved out of the city to suburban Mamaroneck. In 1908 he entered The Chase School of Fine and Applied Art and shortly thereafter left high school to become a full-time art student. In 1910 he enrolled in The Art Students League where many famous artists had studied. In his spare time he worked as a waiter, delivered mail, gave art lessons and was an extra at the Metropolitan Opera, where he met Enrico Caruso.

By 1912 he had his first studio and was doing advertising work for local merchants and book illustrations. By the time he was nineteen he was art editor for *Boys' Life Magazine* and doing illustrations for the *Boy Scout Hike Book.*

In 1915 he moved his studio to New Rochelle, New York, and on May 20, 1916, the single most important day thus far in his life, his first painting to appear on the cover of *The Saturday Evening Post* was published. His success following that was meteoric and soon he was painting covers for *Collier's, Life, Leslie's, Judge, Country Gentleman, Farm and Fireside, Literary Digest, Popular Science* and many others.

During the 1920s he became rich and famous. He played golf, sailed and traveled. He married and divorced his first wife, Irene, and became the top artist for the *Post.* Toward the end of the decade he began to experiment with new art styles and the quality of his work suffered. Bachelorhood did not agree with him and the depression years were unhappy times.

On April 17, 1930, Norman married Mary Barstow, a young school teacher from Alhambra, California, and within the next few years three sons, Jerry, Tom and Peter were born. During this period his lifestyle began to change and in 1935 his greatest work began to emerge. His book illustrations became classics and his *Post* covers were masterpieces.

Soon came the 40's and artist Norman Rockwell approached World War II with the vigor and intensity of a commanding general. His patriotism drove him to unprecedented heights. He painted soldiers and sailors and American flags on everything and his pictures were seen everywhere. In 1943 came his greatest achievement— "The Four Freedoms." These four paintings, inspired by a speech by President Franklin Roosevelt, represented the reason, in the minds of many people, for America being in the war, and the paintings were responsible for the sale of $132 million worth of U.S. War Bonds.

Following the war, Rockwell settled down to the task of painting everything he could. He painted magazine covers, advertisements, story illustrations, portraits of famous personalities and of course his favorite subjects—kids, cats, dogs, grandpops, swimmin' holes, schools and vacations.

In 1959, after moving the family to Stockbridge, Massachusetts, Mary died and Rockwell became depressed and disinterested. But soon, as usual, he pulled himself together and new and exciting paintings began to emerge.

In 1961 he met and shortly thereafter married Molly Punderson, a retired school teacher who had the personality, vitality and enthusiasm to encourage him to new horizons. They traveled, vacationed, rode bicycles and thoroughly enjoyed each other, and the Rockwell legend continued to grow.

The following years were happy ones. The Rockwells enjoyed their home in the cozy, happy town of Stockbridge and even when the town would buzz with visitors, celebrations or parades to honor him, he maintained his usual warm, humble, friendly image. Accolades came from everywhere, throughout America and from around the world, and one of the most sincere, was the creation of the museum bearing his name in the place which was so important, The Curtis Building in Philadelphia, where *The Saturday Evening Post* was published.

On November 9, 1978, Norman Rockwell passed away and on that day all America paused to reflect and thank the man who had given them so many precious moments and fond memories. And on that day the museum became a monument to the man and a living testimony to his work.

D.R.S.

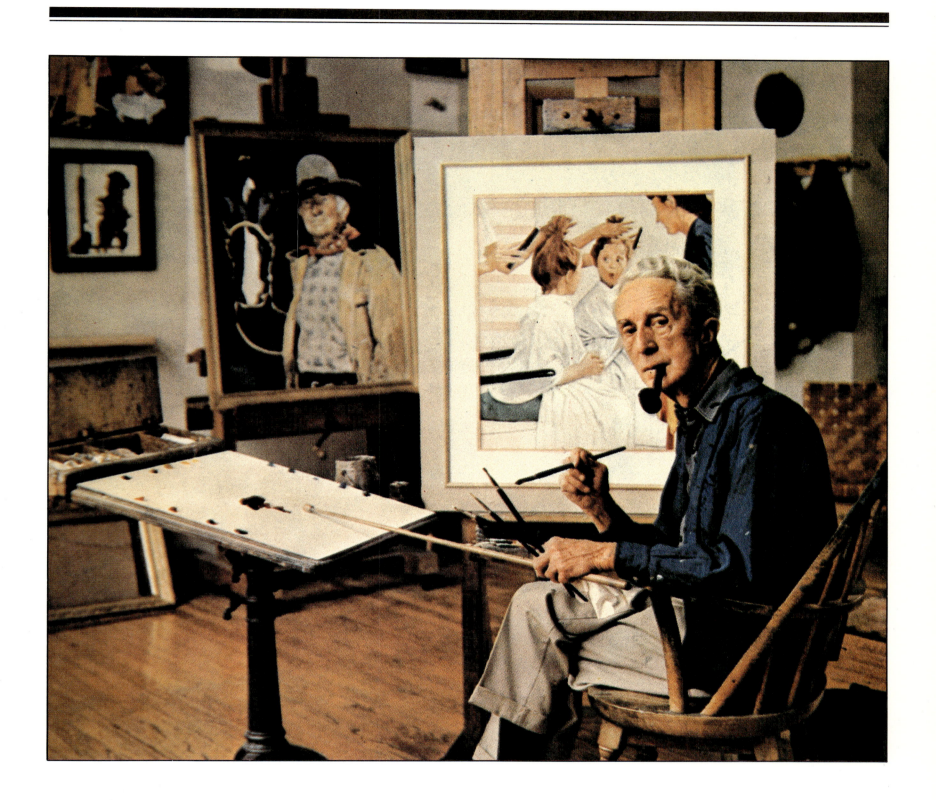

Foreword

"Advertising is to business what electricity is to the city—light and power." So stated George Horace Lorimer, the great editor of *The Saturday Evening Post* and probably the single most important man in the life of Norman Rockwell.

In 1916 it was Mr. Lorimer who hired Rockwell, then just twenty-two years old, and published his first picture on the cover of *The Saturday Evening Post* in May of that year. Over the years, as the Rockwell name gained importance and the demand for his work increased, it was Mr. Lorimer who was his steadfast guide and advisor. Lorimer knew that although the great authors and artists who worked for the *Post* were the driving force that ran the magazine, it was his advertisers who supplied the energy, the fuel that ran the motor. As the Rockwell covers gained popularity, so increased the desire of businesses great and small to have him illustrate their products.

When Cyrus H. K. Curtis bought the *Post* in 1897 for $1,000, its advertising revenue did not exceed $7,000 a year. By 1927, thirty years later, the *Post* was receiving advertising revenues in excess of $50 million. Since the beginning of the Curtis era, American businesses have spent more than $2 billion on advertisements in the *Post*.

In 1911, the year after Norman Rockwell dropped out of high school in the tenth grade and enrolled in the Art Students League, he and his friends vowed never to prostitute their art, and declared they would devote themselves exclusively to fine art and magazine illustration. But in 1914 the oath was broken when Rockwell's first advertisement, a pen-and-ink drawing for Heinz Baked Beans, appeared in the *Boy Scout Hike Book*.

By 1919, when he painted his first full-color ads for Piso's Cough Syrup, Fisk tires and the Overland automobile, the oath was long forgotten. In the years that followed, countless companies approached him to illustrate their products, and although the monetary compensation was usually very good and the exposure excellent, his first allegiance was to magazine cover illustration, so he became very selective in his advertising work.

In 1921 Norman signed a contract to do an advertisement each month for one year for the Orange Crush Company at $300 per ad, which was too much to resist. However, after the first few ads, the project became laborious and he found it difficult to come up with fresh ideas. Upon completion of the series, he resolved never to sign another advertising contract.

Two years later Lennen and Mitchell, a large advertising agency, offered him $25,000 a year to work exclusively for them. The offer was incredible, but past experience had taught him a lesson so he rejected the proposal.

Being independent enabled Rockwell to paint ads for companies he admired and products he liked. When he learned that an ad he was doing was for chewing tobacco, he refused to continue. The company took him to court, and after some trying moments, he was enjoined from doing any further ads for chewing tobacco.

Although his first allegiance was to the *Post*, Rockwell quickly realized that there was big money in advertising art, the recognition was tremendous and the subject matter usually not too difficult. So, in between cover paintings, there always seemed to be time for a few advertising illustrations.

As the Roaring Twenties brought exciting new trends in fashion, food and automobiles, Norman Rockwell's name became synonymous with new product advertisement. By 1920 he already had painted ads for Fisk Rubber Company, Goodrich Bicycle, Post Grape-Nuts & cereal, Borden's milk, Perfection Oil Heaters, Fleischmann's Yeast, Overland automobiles, Paramount Pictures, Jell-O, Edison-Mazda and several others. The list of companies that he painted ads for in the decades that followed is astounding. The early ads were either in sepia or black-and-white. Most of the later ads were beautiful, detailed oil paintings.

Although many of them have disappeared, several companies still have these treasured ads on display or in their archives. The largest collection belongs to the Massachusetts Mutual Life Insurance Company of Springfield, Massachusetts, which had the remarkable foresight to commission him to do 78 pen-and-ink sketches for their American Family Series.

During the writing of this book we contacted over 100 companies throughout the country. All were eager to cooperate and excited by the proposed book. The most fascinating, yet frustrating, part of this undertaking was the knowledge that still more ads exist for companies we never heard of, and that these ads will continue to turn up for years to come. This only adds to our admiration for the amazing and prolific talent of this true American genius, Norman Rockwell.

Research and correspondence with the many companies took hundreds of hours, reams of letterhead and countless phone calls. It proved to be a fabulous journey through Americana. Being in contact with the great businesses that supply our needs and that have become part of our everyday lives was an exciting adventure, not only in art, but also in history, economics, psychology, sociology and the American way of life.

I could not have done it alone. I wish to thank Mr. Ralph Gadiel, for his assistance and encouragement; Mr. Bill Earle, for his patience, knowledge and fabulous collections of Rockwell memorabilia; Mary Moline, for her expertise and

for her unbelievable *Rockwell Encyclopaedia*, which was invaluable to us; my brother Marshall, my partner in this project, for his photographic skills, research ability and all-around everyday assistance; and our wives, Phyllis and Eileen, along with our children, for their perseverance and understanding.

And finally, I want to thank a very important young lady named Mary. After four years of work, as this book was reaching its final pages, one company remained from which we were anxious to get permission. This was Acme Markets, in Philadelphia, for whom Norman Rockwell painted a picture of a little boy eating a big Thanksgiving turkey drumstick. After many letters and phone calls, I still did not have permission to use this wonderful ad. Just as I was about to send the manuscript to the publisher without the ad, young Mary appeared in my medical office with severe abdominal pain and very frantic parents. During the examination, Mary's dad mentioned that he worked for Acme Markets. As I explained Mary's problem to her parents, I casually mentioned my dilemma concerning the ad. Later that same day Mary's problem was solved when a very large and inflamed appendix was removed. On the following day my problem was solved, when our permission came from Acme Markets, and our book went off to the publisher.

D. R. S.

Preface

The year was 1948 and the war was over. Americans no longer had to stand in line to redeem their ration stamps for a pound of coffee or sugar. Nor would we have to open tin cans at both ends, flatten them with the full force of our body weight, and send them off to the war effort. And no longer would we have to pull blackout curtains tightly closed, holding our breath in hopes that a passing air raid warden would not spot a small sliver of light peeking through. And no longer would so many of our citizens live in dread of the Western Union messenger bringing a telegram of ill tidings from the War Department.

The patrician rule of F.D.R. had ended with his passing three years earlier and the White House had since been occupied by a salty Midwesterner named Harry Truman. Truman was that year preparing to do battle for the Presidency against a dapper New York Republican named Tom Dewey. Norman Rockwell, ever aware of current events, demonstrated his sense of history and humor by painting an election cover for *The Saturday Evening Post* showing a husband and wife sitting at the breakfast table, each holding a picture of their favorite candidate, having a family squabble as to who the ultimate winner might be. As Rockwell had done in similar works painted for previous Presidential elections, he had the wife holding Truman's picture, the gentleman who would be the eventual victor. Since Rockwell painted the picture a good four months before the election, his political perceptions were rather keen.

In that year of 1948 a Philadelphia insurance salesman, Samuel Stoltz, gave his two sons, Donald, 13, and Marshall, 11, a Boy Scout calendar from Brown and Bigelow, illustrated by Norman Rockwell. The picture depicted a troop of Boy Scouts hiking down a well-worn path with a canoe held high over their heads, while a young Cub Scout sat on a stump wistfully watching and waiting for the day when he would trade Cub blue for Scout green and join the boys on their adventures.

Don and I were so awed by the realistic nature of Rockwell's illustration that we decided to try to collect more of his works. This led to our own great adventure. We poured through magazines and newspapers, examined books and pamphlets. Before long, the search became a family project, with our mother Pauline and young sister Iris helping the cause. Weekends were spent at flea markets, auctions and antique shops as the quest continued. Rockwell covers from *The Saturday Evening Post, Country Gentleman, Liberty, Boys' Life, Collier's, Life, Literary Digest,* and many others soon found their way into our family basement, while we lovingly built our collection. Treasures were also discovered inside the magazines—story illustrations by Rockwell,

exciting articles about Rockwell, and a wealth of Rockwell advertisements for such diverse products as Orange Crush, Jell-O, Pratt and Lambert paints, Overland automobiles, Fisk bicycle tires and Ticonderoga pencils by Dixon.

Don and I studied about the life and times of Norman Rockwell, wanting to learn about every facet of this fascinating man. At the same time, we began to hear of other great artists and illustrators of the day, such as J. C. and F. X. Leyendecker, Charles Dana Gibson, John Falter and Stevan Dohanos.

As the years passed into the 50's and 60's, our collection and knowledge grew. We had by now collected almost all of Rockwell's *Saturday Evening Post* covers and many other illustrations. We both were becoming experts on the subject of Rockwell.

Don, having graduated Philadelphia's prestigious Central High School, went on to Temple University and then to medical school at Philadelphia College of Osteopathic Medicine, from which he graduated in 1961. He has practiced medicine ever since.

I attended the same high school and college and after getting an Associate's degree in Physical Therapy at the University of Pennsylvania, went on to teach science at Haddon Heights High School in New Jersey.

Throughout these years, the collection, like Topsy, "just growed." By the time we both were married in the mid-60's, our parents' house was bulging with Rockwells.

In 1970 I decided to give my brother Don an unusual birthday present, so I thought I would arrange a visit with Rockwell—a brilliant idea, since I planned to be there as well!

When I called Stockbridge information, I was rather shocked that Norman Rockwell's number was offered quite readily. He himself answered the phone. I was suddenly swept with a feeling of excitement and emotion. After all these years of collecting and studying Rockwell, I finally found myself talking to our hero. It was like talking to Babe Ruth, Roy Rogers and Johnny Weissmuller all at once. I probably stammered as I introduced myself and explained the purpose of my call. Although I considered this call a rather brazen thing to do, I was immediately struck by the apparent warmth and charm of the man.

Mr. Rockwell (we were later invited to call him Norman), upon hearing of Don's birthday and my desire to arrange a meeting, indicated that at that particular time he was very busy, but that he would be glad to send Don a birthday greeting and invited me to call him back in a few weeks. He had evidently heard something about our collection and was impressed enough to want to discuss it with us. I hung up with a feeling of euphoria, and although I had deter-

mined that the whole chain of events would be a top-level secret so that the element of surprise would not be ruined for Don, I could not contain myself. Immediately, I called Don at his medical office and blurted out, "Guess who I just spoke with!" Don, of course, reacted with skepticism, as one might expect. I finally convinced him that I was not kidding, and was vindicated when in the next day's mail there arrived a bookplate with a Norman Rockwell picture on it and a personal note and signature from The Man himself.

I called back a few weeks later at which time Rockwell invited us to meet with him in his studio. Our meeting was set for two o'clock on a summer afternoon. At the appointed hour Don, his wife Phyllis and I approached the studio of The Great Master. Trembling with anticipation, I rapped on the studio screen door. Within seconds, I heard the sound of shuffling feet and there in front of me, the two of us separated only by a thin screen, stood Norman Rockwell himself. How tall he looked! "Mr. Rockwell," I announced, "my name is Marshall Stoltz." He looked down those three short steps and answered, "So what!" Don turned to me and whispered "What have you done now?" After explaining to Mr. Rockwell that we had an appointment with him, he remembered and invited us in.

We fully expected to be there no more than five minutes or so, but Rockwell began telling some marvelous stories about many of his paintings, stories which both Don and I have retold to Rockwell audiences many times over.

That first meeting stretched out to almost an hour, and as we left the studio (with an invitation to return), we could not have been happier if we were wearing an Eagle Scout Badge or a World Series ring.

That first meeting led to a friendship which lasted until Norman's passing in November of 1978.

In 1975 Don and I decided that we would like to share our collection with the people of the world. We approached Norman Rockwell with the idea of opening a Norman Rockwell Museum. He was flattered, but concerned that I would be giving up the security of my teaching profession to be the curator of a museum that might not be successful. His exact words were, "Frankly, I don't think people are that much interested in my work." We assured him that we felt otherwise, and he gave us the go-ahead with his blessing.

We were most fortunate to have moral and financial support from a number of friends. One in particular who has been a good friend and a great inspiration to us has been Louis Cinquanto, a neighbor of Don's. His help in forming the museum has been invaluable. Louis also

lent a hand when Don and I were writing a three-volume set of books entitled, *Norman Rockwell and The Saturday Evening Post*. These books contain every *Saturday Evening Post* cover ever done by Norman Rockwell, 324 in all. The covers were reproduced in full size and full color, each with a descriptive text explaining details about the subject matter, models, why and when the picture was painted, and anecdotes relating to the subject.

On February 4, 1976, with great fanfare, the Norman Rockwell Museum opened its doors to the public for the first time. How fitting that the museum should be located in the Curtis Publishing building, where for almost sixty years *The Saturday Evening Post* was published. How fitting also that both the Curtis Publishing building and the Norman Rockwell Museum, a tribute to a great American, are directly across the street from the Cradle of Liberty, Independence Hall, at Sixth and Walnut Streets in downtown Philadelphia.

For those who enjoy the works of Norman Rockwell, the museum provides a rare and unforgettable opportunity. Within its walls is the world's largest collection of the artist's work. The museum's displays include all 324 of Norman Rockwell's *Saturday Evening Post* covers, American Family drawings, scores of advertisements, prints, collotypes, lithographs and sketches. Highlight of a tour of the museum is the opportunity to see a life-size replica of Norman Rockwell's Stockbridge, Massachusetts, studio, complete with easel, canvas, brushes and props. The studio gives a personal glimpse of the setting in which Norman Rockwell actually worked during the last twenty years of his life. In the Four Freedoms Theater, one may see a unique slide presentation combining the talents of Norman Rockwell and Frank Sinatra. Don and I spent many hours and had great fun coordinating the words to Sinatra's rendition of "The House I Live In" to Rockwell's pictures.

In 1977 Norman Rockwell collectibles were greatly desired by the general public. Those major manufacturers who had been dealing in these products since the early and mid-70's were producing the collectibles at a record rate. The Norman Rockwell Museum Gift Shop was well supplied with Rockwell collectibles of all kinds, and we ran into a bit of a problem when we found that our suppliers could not keep up with the demand. We determined that with the artwork available to us, perhaps we could produce a product as good as and even better than was already being done. Don and I were introduced to a gentleman from Chicago by the name of Ralph Gadiel, who not only had expertise in the creation and manufacture of collectibles, but was also very skilled in marketing. He realized the virtue of our idea, and it wasn't

too long after that that the Norman Rockwell Museum, Inc. was born. Ralph started the collectibles company in 1978 as a mail order sideline after many years in the advertising business and marketing collectibles for other companies. The following year, Mike Cooper joined the growing firm as Vice President in charge of marketing and sales continued to soar. During that year the line was distributed to about 100 stores. The line has continued to grow and this marriage of minds and personalities has produced perhaps the fastest-growing manufacturer of Rockwell collectibles in the history of this great field. Today the Norman Rockwell Museum, Inc. is the largest manufacturer of Norman Rockwell collectibles in the world. The recognition and acceptance of our products by the general public has been overwhelming.

I have had the good fortune in my position as Curator to be able to travel throughout the country and abroad to meet Rockwell collectors and discuss with them the life and times of Norman Rockwell. Additionally, as a member of the National Speaker's Bureau of Chicago, Illinois, I travel extensively, lecturing to many well-known and varied groups upon the subject which is so near and dear to my heart. It is so inspiring to me to see the love that so many people have for the work of this great artist. In my travels, I have met the old and the young, the rich and the poor, and I have found that appreciation for Rockwell's works transcends all age and socioeconomic groups.

On November 8, 1978, Don and I were shocked and saddened to learn of the passing of Norman Rockwell. Following the announcement of his death we spent a very hectic few days dealing with newspaper, radio and television reporters as they clambered through the museum seeking additional information on the life of the great American. Don and I were extremely honored to be invited to Norman Rockwell's funeral service. Perhaps honored may seem a strange word to associate with a funeral, but faced with the realization that Norman knew kings and queens, presidents and politicians, sports heroes and movie stars, to be included among only fifty outside guests certainly was an honor indeed.

November 11, 1973, dawned beautifully clear and warm. Don and I and the other mourners walked up the curved path to St. Paul's Church through an honor guard of Cub Scouts and Boy Scouts, moved by the solemnity of the occasion. As we sat in the church pew, the organist began to play "America the Beautiful." We glanced around while waiting for the service to begin, and noticed that sitting all around us were many of the people who had appeared in Rockwell's paintings. Somehow, Don and I had the feeling that we knew many of the folks sur-

rounding us. We listened as Reverend Theodore H. Evans, Jr., declared, "This is not a time of mourning, but rather a service of thanksgiving for the life of Norman Rockwell." At the end of the service we all filed out of the church, into that brilliant sunlit day, and were taken aback when, from out of the side door of the church, there ran a small brown and white dog. That surely was a scene worthy of a Rockwell painting, and I was quite certain that somewhere up there Norman was busily sketching, hoping to beat the deadline on eternity.

M.L.S.

Acknowledgements

We express our sincere appreciation to the following people for their assistance and encouragement.

Ralph Gadiel: *For his energy and enthusiasm*

C. Richard Spiegel: *For the spark that lit the fire*

Les Kaplan: *For being the catalyst that brought it all together*

Mary Moline: *For her invaluable assistance and her incredible* Rockwell Encyclopedia

Mike Collins: *For being a good friend and President of The Norman Rockwell Society of America*

Bob Rapp: *For his knowledge, enthusiasm and humor*

Louis Lamone: *Norman Rockwell's close friend and photographer, for his interest and encouragement*

Donald Artzt, Esq.: *For his friendship and legal assistance*

Donald Walton: *For his great book* A Rockwell Portrait

Terry Kinney: *For hours of typing letters and manuscript in between her radiologic duties*

Sally Martin: *For her secretarial skills*

Iris Wallach: *Our sister, for her untiring help and support as Assistant Curator of The Rockwell Museum*

David Wood and the staff of The Norman Rockwell Museum at The Old Corner House, Stockbridge, Massachusetts: *For their knowledge, dedication and understanding*

The great corporations of America: *For their foresight in choosing Norman Rockwell to create incredible advertising art and for allowing us to re-create it*

Louis Cinquanto: *For always being there when we needed him*

And finally, but certainly not the least—Norman Rockwell, who gave the world his art and us his friendship.

Dr. Donald Stoltz
Marshall Stoltz

For their gracious cooperation during the creation of this book the publisher would like to thank the following:

Acme Markets, Inc.
American Motors Corporation
American Petroleum Institute
American Red Cross
American Telephone and Telegraph Company
Amoco Oil Company
Amway Corporation
Anheuser Busch
Beecham Products
The Arrow Company
Best Foods
Big Brothers/Big Sisters of America
Bissell
Borden Inc.
Boy Scouts of America
Budwine
Bristol Myers Company
Brunswick Corp.
Campbell Soup Company
Central Maine Power Company
The Chase Manhattan Bank
Chrysler Corporation
Cleveland Metal Products Company
The Coca-Cola Company
The Colonial Williamsburg Foundation
Crush International Inc.
Del Monte Corporation
Elgin & Waltham Watch Companies
Encyclopaedia Britannica
Ford Motor Company
General Electric
General Foods Corporation
General Motors Acceptance Corporation
The BF Goodrich Company
Goodwill Industries
Goodyear Tire & Rubber Company
Goulds Pumps, Inc.
Green Giant Company
Hallmark Cards Incorporated
G. Heileman Brewing Company, Inc.
H.J. Heinz Company
Hercules Incorporated
Hills Bros. Coffee, Inc.
Kayser-Roth Hosiery, Inc.
Kellogg Company
Kendall
Kentucky Fried Chicken Corporation
Keystone Automobile Club
Kraft Inc.
Thomas J. Lipton, Inc.
Lincoln Mutual Savings Bank
Massachusetts Mutual Life Insurance Company
McDonald Corporation
Melnor Industries
Merck Sharp & Dohme, Division of Merck & Co., Inc.
MGM/UA Entertainment Co.

Mobil Oil Corporation
Montgomery Ward & Co.
Narrangansett Brewing Company
Nabisco Brands, Inc.
Olivetti Corporation
Ortho Diagnostics
Pan-American World Airways, Inc.
Paramount Pictures Corporation—A Gulf & Western Company
The Parker Pen Company
Pepsi-Cola Company
Pratt & Lambert
Procter & Gamble Company
The Quaker Oats Company
Ralston Purina Company
RCA Records
Raybestos Manhattan
RKO General Pictures
Rock of Ages Corporation—A Nortek Company
Brooke Bond Foods Limited
Sanford Corporation
Schenley Affiliated Brands Corp.
Scott
Sears, Roebuck and Co.
Sharon Steel Corporation
Sheaffer Eaton Division of Textron Inc.
Sun·Maid Growers
Swift & Co.
Top Value Enterprises, Inc.
Twentieth Century-Fox
Uniroyal, Inc.
The Upjohn Company
Warner-Lambert
The Watchmakers of Switzerland Information Center, Inc.
Western Union Corporation

Throughout his illustrious career Norman Rockwell worked for many companies which are either no longer in business, have been absorbed by or merged with other companies or have moved to new quarters. Despite an exhaustive search and many letters, we have been unable to locate these companies and rather than delete these wonderful pictures from our book, we are printing them with sincere appreciation to the companies mentioned. If indeed any of these corporations are still in existence and we are informed, a credit will be printed in future editions.

Allen A. Hosiery
Bauman Clothing
Best-Ever Suits
Black Cat Hosiery
Black Jack Gum
Capitol Boilers
Dumont Labs
Dutchess Trousers
Guild Artists
Lowe Brothers Paints
Piso's Cough Syrup
Red Wing Shoes
Roebling Steel
Romance Chocolates
Tillyer Lenses
Valspar Varnish

ACME MARKETS

Acme was founded in 1891, when partners Samuel Robinson and Robert Crawford opened a small neighborhood grocery store in South Philadelphia, with a business philosophy that emphasized quality products, low prices and friendly service. Their business grew, and they opened more stores.

In 1917 the partners merged with four other grocery chains in the Philadelphia area to form the American Stores Company. The new company had 1,223 stores with bakeries and warehouses to support them.

During the twenties and thirties, the company continued to expand in size by opening stores in new communities and through acquisition.

The year 1937 brought about the opening of two supermarkets in Paterson, New Jersey, under the Acme name. These supermarkets were small by today's standards, and yet they changed the concept of food shopping from full service, in which clerks selected customers' orders, to self service, in which shoppers selected their own orders and paid for purchases at a checkout counter.

The company changed its name to Acme Markets, Inc., in 1962. In 1973 it was reorganized. A parent company was established, and it revived the American Stores Company name, establishing its offices in Wilmington, Delaware. Acme Markets, Inc. became a wholly-owned subsidiary of American Stores Company.

In 1979 the American Stores Company was merged with Skaggs Companies, Inc. of Salt Lake City, Utah, an operator of drug stores and combination food and drug stores. The new parent company retained the American Stores Company name, and later moved its offices to Salt Lake City.

The Norman Rockwell advertisement for Acme's own brand of turkeys, Lancaster Brand, was conceived by the Gray and Rogers advertising agency, which commissioned the art. The ad first appeared in the December 12, 1963, *Philadelphia Bulletin*, and has been used several times since then. The ad received the 1963 *Editor and Publisher* Run-of-the-Press Color Award for retail advertising. The original art was returned to Norman Rockwell.

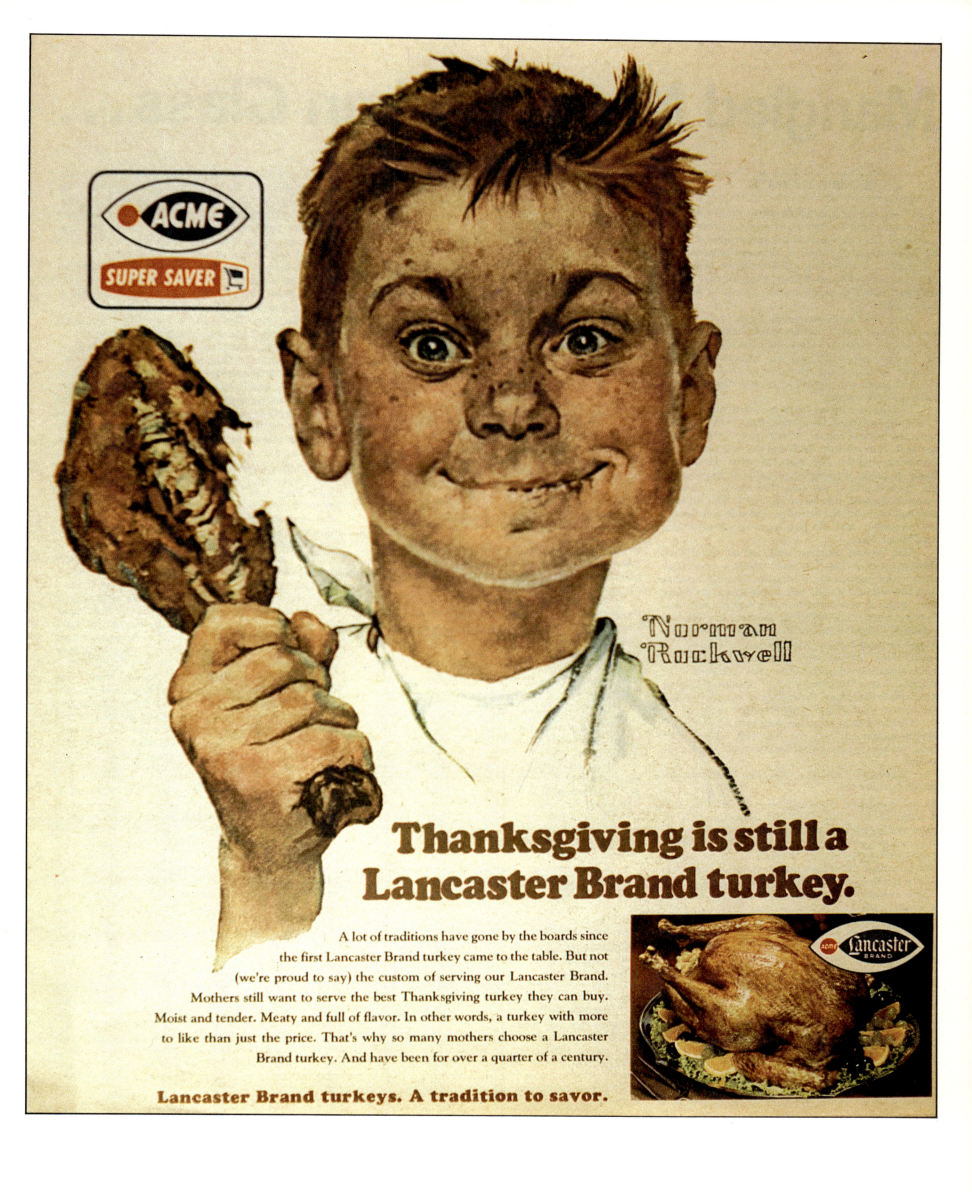

Thanksgiving is still a Lancaster Brand turkey.

A lot of traditions have gone by the boards since the first Lancaster Brand turkey came to the table. But not (we're proud to say) the custom of serving our Lancaster Brand. Mothers still want to serve the best Thanksgiving turkey they can buy. Moist and tender. Meaty and full of flavor. In other words, a turkey with more to like than just the price. That's why so many mothers choose a Lancaster Brand turkey. And have been for over a quarter of a century.

Lancaster Brand turkeys. A tradition to savor.

AMERICAN PETROLEUM INSTITUTE

In 1858 a group of businessmen formed The Seneca Oil Company and hired Edwin L. Drake, a retired railroad conductor, to drill a well near Titusville, Pennsylvania. Drake used a wooden rig and a steam-operated drill and with the assistance of a blacksmith named William A. (Uncle Billy) Smith and Smith's two sons began to drill in June of 1859. The group fought water, rock and cave-ins, but finally on August 27, 1859, at the depth of 69½ feet, oil bubbled from the ground and the American oil industry had its birth.

Initially oil was used mostly for kerosene lamps, but around 1900 a strange-looking, gasoline-powered, horseless carriage appeared and by 1910, 450,000 automobiles were traveling roads throughout the country. The demand for oil greatly increased; new wells were drilled in several states and large-scale oil production was begun.

On May 20, 1919, the American Petroleum Institute was founded. This nonprofit corporation, funded by 277 domestic corporate and 7,300 individual members, was open to any company engaged in the petroleum or allied industry with its principal office in the United States, Canada or Mexico.

In 1959 the American Petroleum Institute commissioned Norman Rockwell to paint a picture to commemorate the centennial celebration of the petroleum industry and on August 27, 1959, exactly 100 years after Mr. Drake struck oil in Titusville, this picture appeared on billboards across the country.

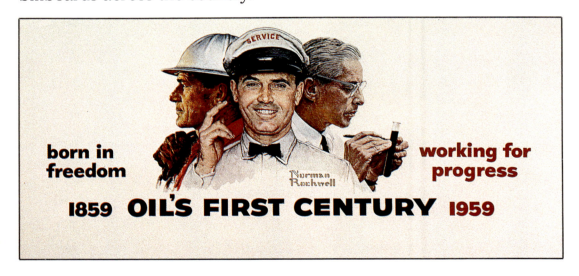

born in freedom

working for progress

Norman Rockwell

1859 **OIL'S FIRST CENTURY** 1959

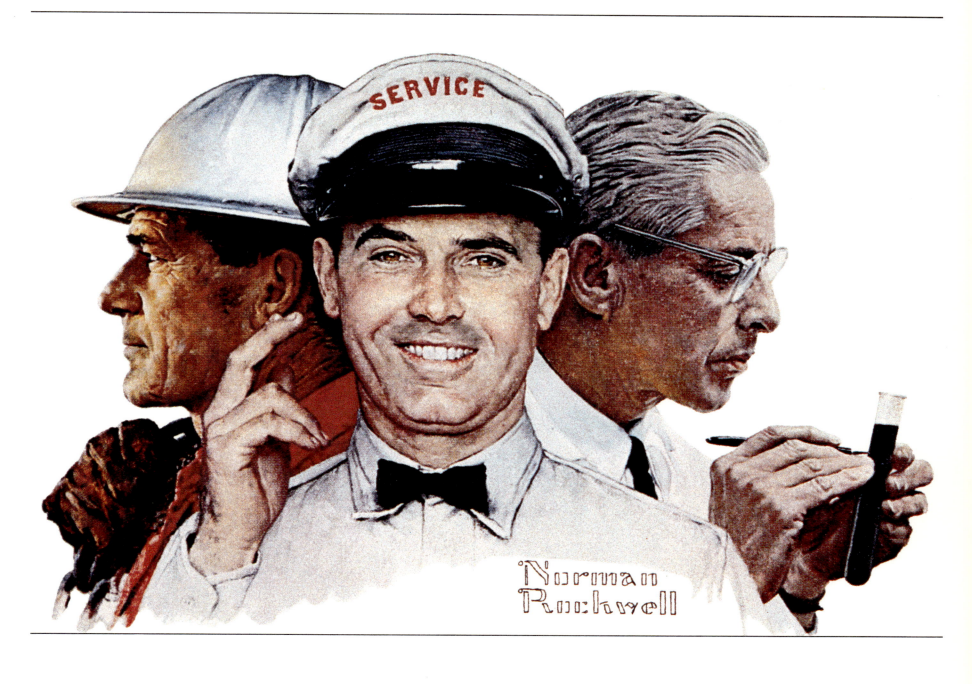

AMERICAN RED CROSS

In 1859 a Swiss philanthropist, Jean Henri Dunant, was touring a battlefield in Italy during the Austro-Sardinian War. That day he saw 40,000 men who had been killed or wounded on the field at Solferino. Horrified at the suffering of the wounded, he formed a group of volunteers to help them.

In 1862 Dunant made a worldwide plea for an international organization to help the sick or injured without regard to nationality and on October 26, 1863, sixteen nations met in Geneva to set the groundwork for what was to become the International Red Cross. The name and the emblem for the organization was the reverse of the Swiss flag—a white cross on a red background—to honor the country of its origin.

In 1871 Clara Barton helped establish the American Red Cross, which grew steadily and was instrumental in helping millions of servicemen and their families through the suffering of wars and an equal number of people around the world through many manmade and natural disasters.

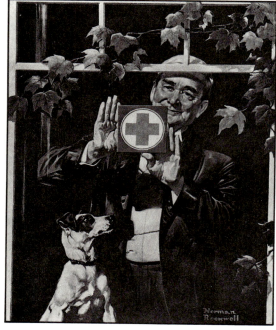

In 1918 the Red Cross commissioned Norman Rockwell to illustrate the cover of *The Red Cross Magazine* and four covers were painted through 1920. In 1932 he was approached again and a wonderful painting emerged entitled "The Window Card," which showed an older gentleman affixing a Red Cross sticker to his window, while his pet dog observed. At the bottom was the reason for the picture, asking people to "Join The Red Cross".

In 1951, at the suggestion of General George C. Marshall, Mr. Rockwell was again asked to paint a fund campaign poster. The picture depicted the theme "Mobilize for Defense" and showed three people in the process of responding to a disaster. The models were all neighbors of Rockwell's from Bennington, Vermont. Coe Norton was the first aid worker, Mrs. Harold Kaplan was the volunteer, and Dr. James P. Hammond was the doctor. The picture was a huge success and is exhibited at the national headquarters of the American Red Cross in Washington, D.C.

"…an opportunity, and an obligation"

This year, 1963, the Red Cross movement celebrates its one hundredth anniversary— a full century of service to peoples of the world. Throughout its history, the Red Cross has been an important symbol of hope and help to those in need. Wherever war, disease and disaster have struck, the Red Cross has been on hand to ease the burden of human suffering. Its staff and volunteers have built a tradition of mercy, of comfort and of kindness.

Today, as the Red Cross embarks upon its second century of service, each of us has an opportunity and an obligation, to become a part of this humanitarian tradition. For only through our help is this important work made possible.

The Red Cross needs the support of every American to continue its mission of mercy.

Let us all give that support.

ALWAYS THERE... WITH YOUR HELP

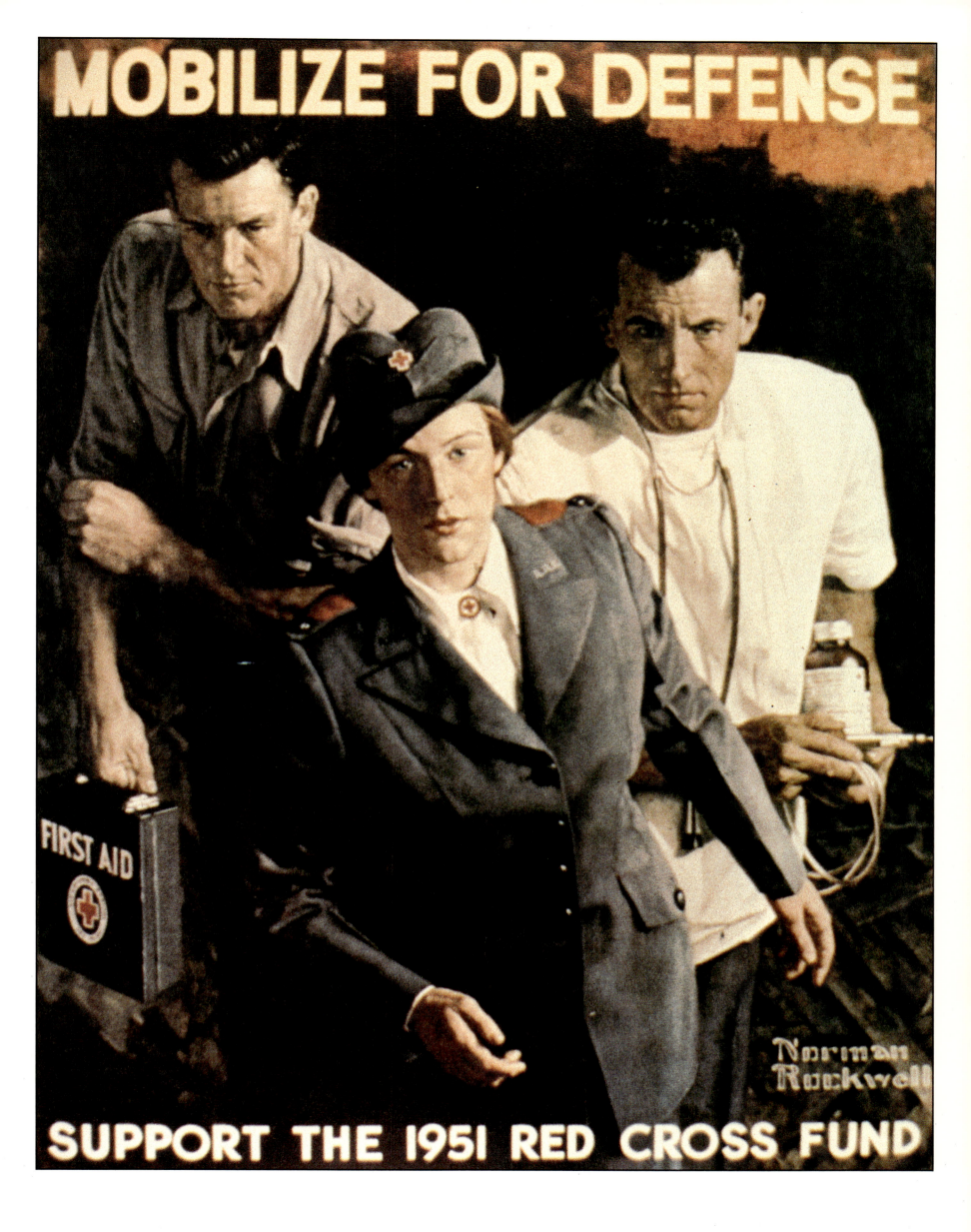

MOBILIZE FOR DEFENSE

FIRST AID

Norman Rockwell

SUPPORT THE 1951 RED CROSS FUND

7

ALLEN A. HOSIERY

The Allen A. Hosiery Company of Kenosha, Wisconsin, manufactured hosiery for men, women and children, and underwear for men and boys. The advertisements painted by Mr. Rockwell for the company appeared in *Ladies' Home Journal* in September 1926 (two boys singing) and *The Saturday Evening Post*, February 9, 1924, and September 4, 1926 (six school boys singing). The ad shown (The Pirates) appeared in *The Saturday Evening Post* on August 23, 1924.

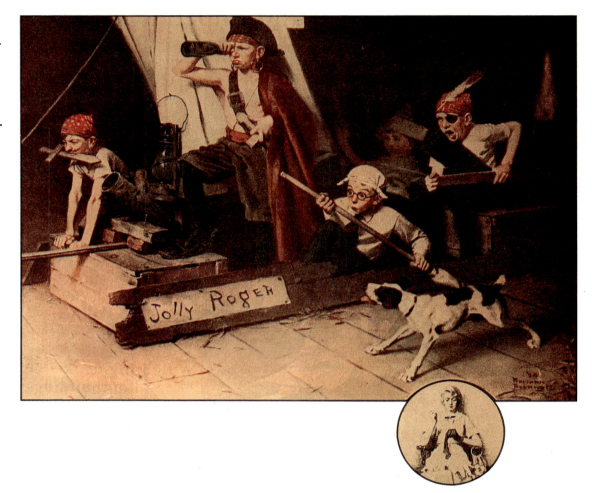

AQUA VELVA

In 1840 America was getting ready for a Presidential election. The entire country was echoing the slogan "Tippecanoe and Tyler too" and was getting ready to choose between John Tyler and William Henry Harrison for President.

Two young brothers in Manchester Green, Connecticut, formed a partnership to capitalize on the national mood. Pioneers were moving westward, new cities were forming, and Americans wanted to get their chores done in much less time. The brothers, James Baker Williams and George W. Williams invented something that would help at least the male segment by speeding up the time they spent shaving.

Their product was America's first shaving soap, which was called, Williams's "genuine Yankee soap," and with it began a long line of proprietary products. One of these was Aqua Velva After Shave Lotion.

In 1948, the J. B. Williams Company commissioned Norman Rockwell to draw a sketch to advertise Aqua Velva. The ad, which showed a young man holding a bottle of Aqua Velva and stating "a luxury that actually does you good," appeared in *Life* magazine on January 19, 1948, and May 25, 1953, and in *The Saturday Evening Post* on January 31, 1953, and June 26, 1953.

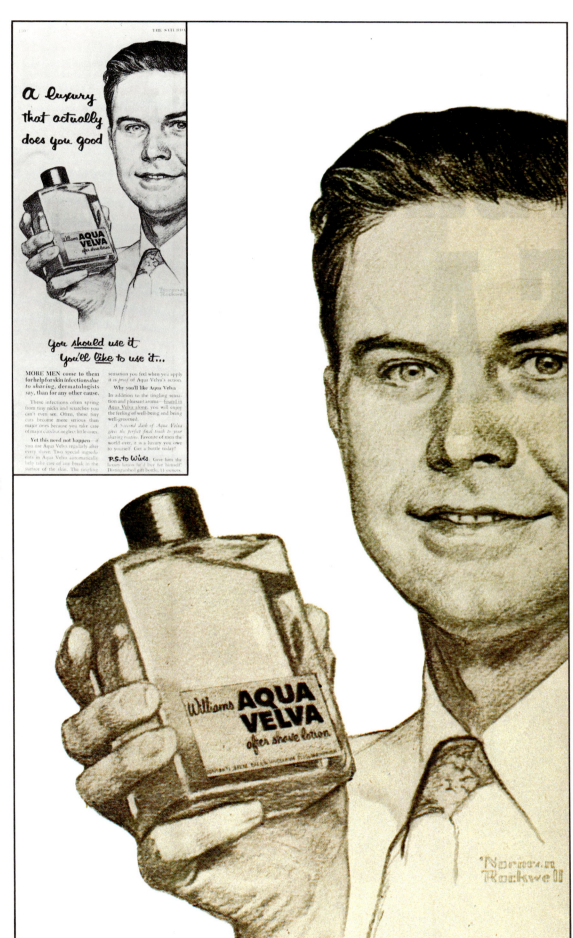

AMERICAN TELEPHONE AND TELEGRAPH COMPANY

Virtually from the first days he began working on the telephone, Alexander Graham Bell conceived of it as an instrument that would provide great service to the country's homes and businesses. From its earliest days, the Bell System placed service as its highest priority. And the annals of the business are filled with stories of telephone people performing near-heroic feats to keep telephones working well. One of those legendary feats came about in the famous blizzard of '88, when a lineman named Angus MacDonald donned his snowshoes and trod some 20 miles in the height of the blizzard checking on critical long-distance telephone lines. The event was later portrayed in an oil painting known simply as "Spirit of Service." The painting shows a shadowy figure trudging through great swirls of snow, his head lifted up into the searing cold wind as he looks at the wind-blasted telephone lines.

It seemed only natural when, in later years, the Bell System decided to do an advertisement that spoke of its continuing dedication to service that Norman Rockwell be asked to portray "the immortal lineman." Rockwell, in capturing the essence of the lineman—the hearty, selfless, dedicated individual—succeeded as only his simple, subtle style could in re-creating the spirit of service for a new generation of telephone employees and customers.

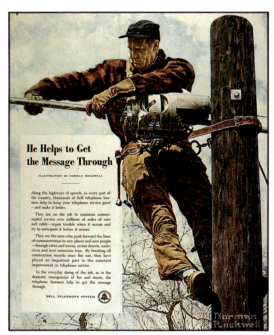

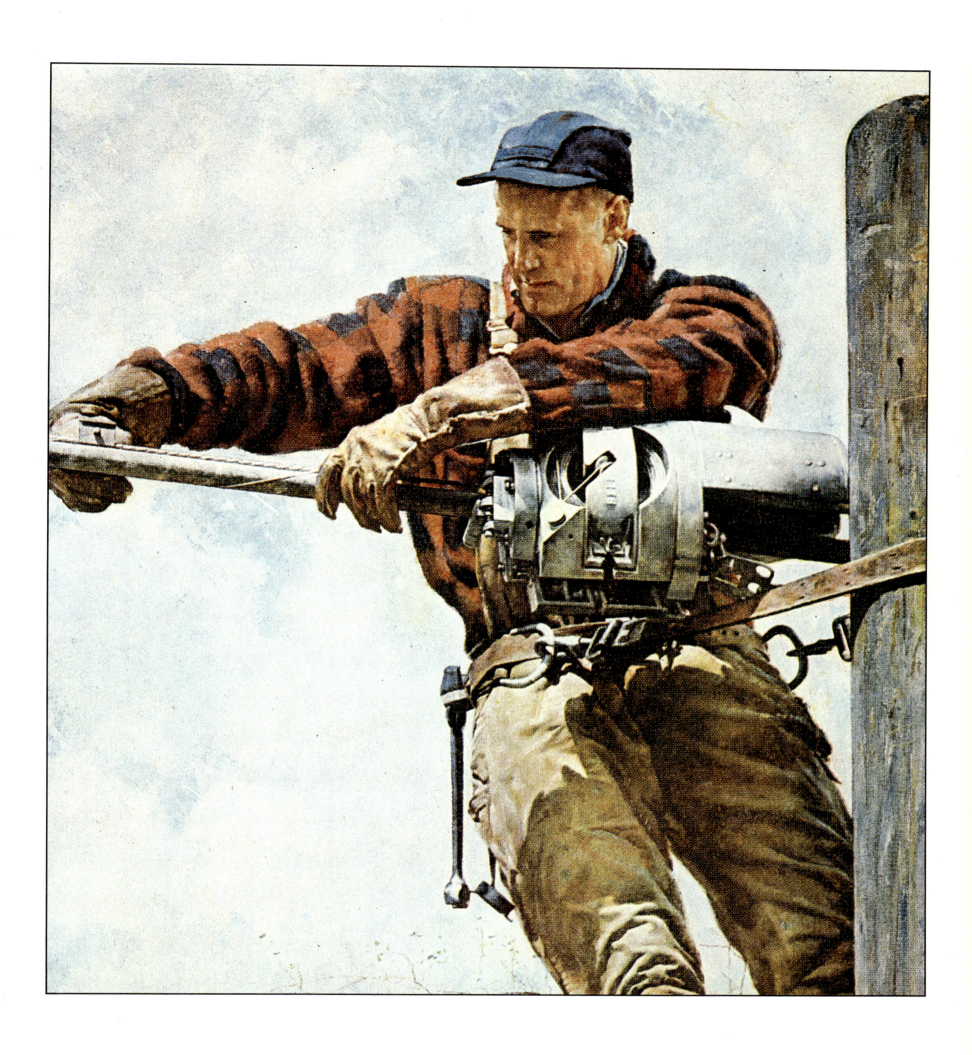

AMOCO OIL COMPANY

Louis Blaustein, a European immigrant, picked Baltimore to launch his small American Oil Company in 1910. With his son, Jacob, he began by selling kerosene with the help of three employees, a horse named "Prince," and a 270-gallon tank wagon. Competition was tough, but the Blausteins met it by being up at 4:00 a.m., following the delivery routes and making certain customers were pleased.

The Blausteins decided early that to succeed, their American Oil Company needed a unique motor fuel, heavily advertised and promoted by brand name and backed by an aggressive sales force. They believed that a knowledgeable public would pay a few pennies more for outstanding quality and service. As a result, within five years, the company began marketing Amoco-Gas, "The world's first original special anti-knock fuel." Amoco-Gas was a mixture of 65% gasoline and 35% benzol and was higher in octane than competitive fuel.

When Amoco-Gas appeared, automobile engines were improving and low-octane gasolines resulted in engine knock. By 1923, most marketers were clamoring to avoid the knocks that Amoco-Gas eliminated.

By 1925 Mr. Blaustein's small American Oil Company had grown to one of the largest oil-supplying companies in the world and following a sale of 50% ownership in the company to Pan American Petroleum, the combination of companies had the second largest tanker fleet in the country, and ranked second in crude oil production.

The American Oil Company and Pan American expanded in the 30's and 40's, adding refineries, customers and outlets. Marketing was supported by aggressive sales and advertising programs. One of the most popular advertising campaigns was two paintings drawn by Norman Rockwell, one of which was a gentleman driving a car, who stated "Tried 'em All, Amoco for Me," and the other, a young man beating a bass drum in a parade, banging out the message, "America marches ahead."

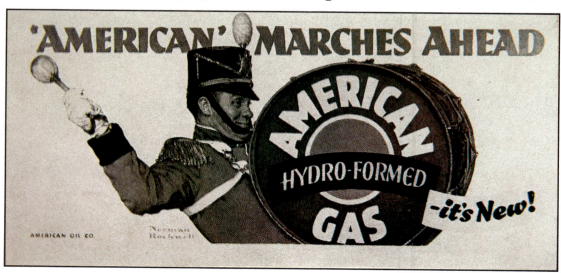

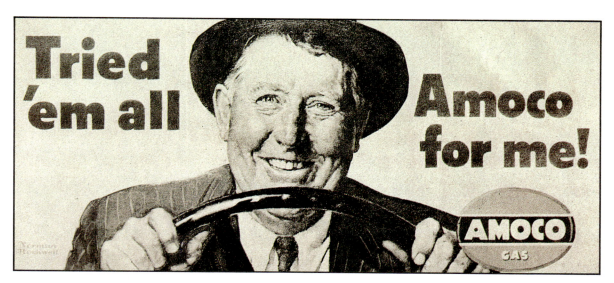

Tried 'em all Amoco for me!

AMOCO GAS

Wishing you a "smooth running" 1939

American Oil Company

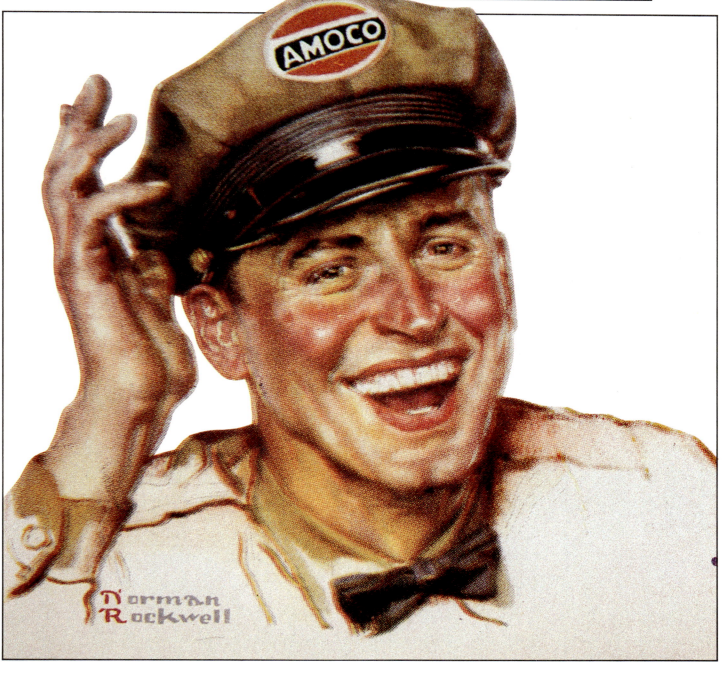

AMWAY

In 1940 Richard DeVos, a fourteen-year-old high-school student in Grand Rapids, Michigan, made a business deal with his sixteen-year-old friend Jay Van Andel. Since Jay was old enough to drive and motored his Model-A Ford to school every day, Rich would pay him 25 cents a week for gas if he could ride along. The pair struck an agreement and began a life-long friendship.

Following this association Richard and Jay had several small business ventures and in 1959 organized a corporation that in the next 20 years would reach $1 billion in sales, with over 300,000 distributors, who considered themselves partners in the company, selling a myriad of household items.

Richard DeVos and Jay Van Andel always maintained that hard work and free enterprise were the American way of life and thus they called their company Amway.

Since the company specialized in family-type products, who could better illustrate Amway ads for products or dealerships than Norman Rockwell. In the late 1960s Mr. Rockwell did a series of pen-and-ink drawings depicting Amway-type people and at the same time did a fine drawing of the co-founders which appeared in the December, 1969, issue of *Reader's Digest*.

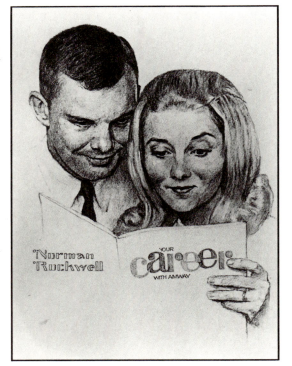

Norman Rockwell

ANHEUSER-BUSCH

Many historians consider beer to be the oldest alcoholic beverage, with its origin before recorded history. Several ancient civilizations have recorded detailed recipes for beer brewing, although industrial brewing did not begin until the twelfth century in Germany.

The first commercial brewery in America was founded in New Amsterdam in 1623 and many famous Americans owned their own breweries or beer houses, among them Samuel Adams, William Penn and George Washington.

In 1857 Mr. Eberhard Anheuser, a wealthy soap manufacturer, loaned some money to help finance a failing brewery in St. Louis. Despite his help the business failed and Mr. Anheuser took control and reluctantly ran the brewery for a few years. In 1866 he gave the reins to his son-in-law Adolphus Busch, a young St. Louis brewery supply salesman, who took the floundering company and turned it into a huge corporation which became Anheuser-Busch in 1879.

In 1876 a new beer was marketed called Budweiser "The King of Beers". This was followed by Michelob in 1896 and many others in the years that followed.

In 1934 "The King of Breweries" commissioned "The King of Illustrators" Norman Rockwell to paint an advertisement. The beautiful painting "When Gentlemen Agree" emerged and appeared in many national and local publications. The original painting now hangs at the Missouri Historical Society in St. Louis.

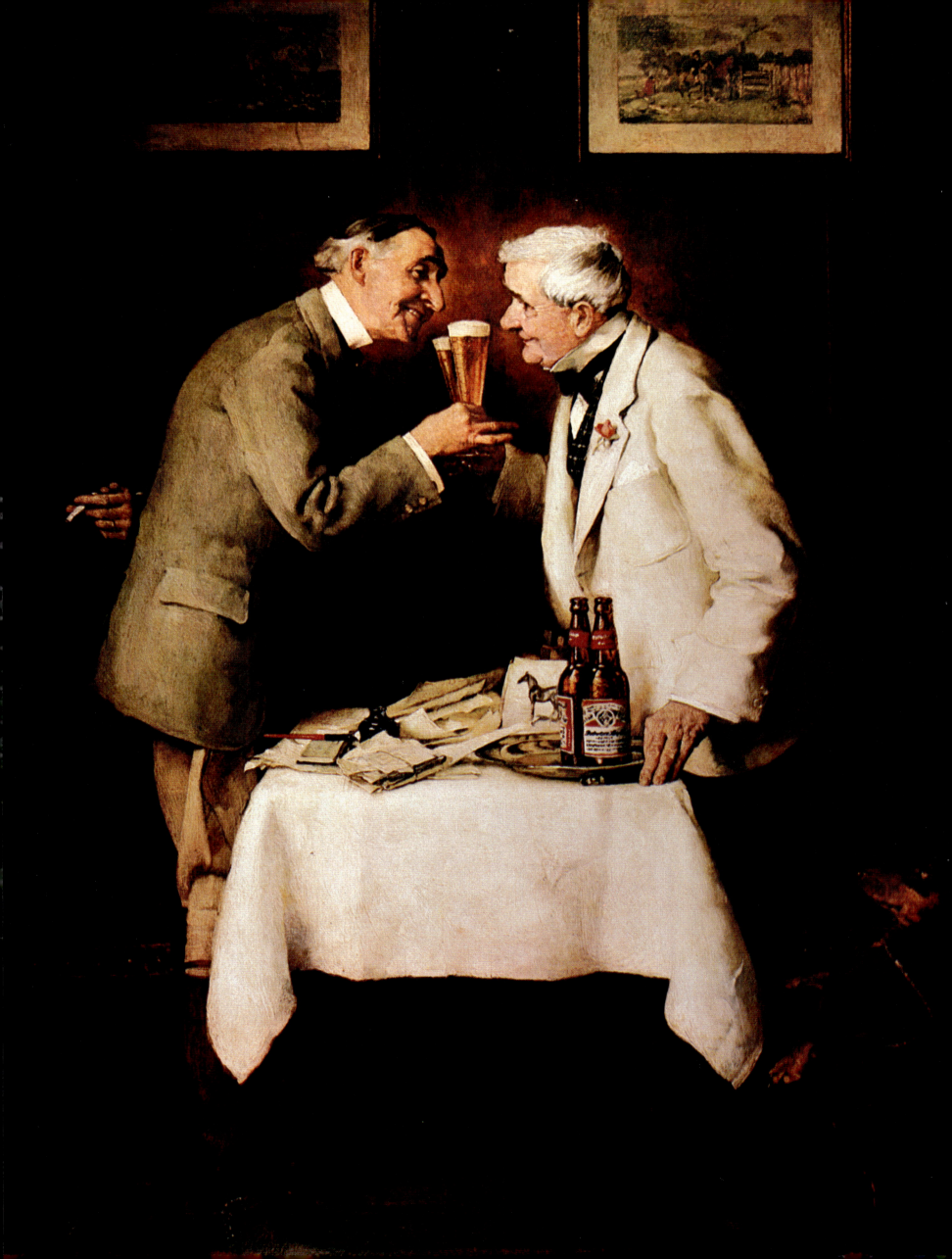

ARROW SHIRTS

The year was 1820. The place Troy, New York. Orlando Montague was a prosperous blacksmith and his greatest enjoyment was attending civic and choral engagements. However, being a very fastidious gentleman, he insisted on a clean shirt every evening. Mrs. Montague, after quite some time, got tired of laundering her husband's shirts, and decided to ease her chores. She proceeded to cut off the collars of several shirts, bound the edges and neckbands and attached strings to hold them in place. Although the idea was disturbing at first to Mr. Montague, he decided to make the best of it and showed off his new-found detachable collar to his friends. The idea soon caught on and other Troy housewives began snipping the collars from their husbands' shirts. Shortly thereafter Ebenezer Brown, who ran the general store in Troy, seized upon the idea and began to manufacture collars in the back room of his store. Before long, small shops and sewing rooms popped up everywhere around town for the manufacture of separate collars.

Shortly thereafter, a small plant originated by a Mr. Maullin and Mr. Blanchard began manufacturing men's collars and soon a new fashion was sweeping the country. Over the next several decades the company grew rapidly and in 1889, following several mergers, the trade name "Arrow" was brought to the company by a Mr. Cluett. In 1898 a Mr. Peabody bought out the interest in the company and the name was changed again to Cluett, Peabody and Company. It was incorporated in 1913. Mr. Frederick F. Peabody made the trademark Arrow a national household name. Under his guidance, the familiar Arrow logo was seen everywhere and soon the company was manufacturing 400 different models.

About that time, the Arrow Company engaged the services of the famous *Saturday Evening Post* artist, J. C. Leyendecker, who created the famous Arrow collar man. This ad became one of the most popular promotional devices in the history of advertising, and the Arrow man became the most popular man in the country. His glamour was praised in songs and poetry and he was even the inspiration for a Broadway play, "Helen of Troy, New York."

By the end of World War I, the Arrow Company employed 6,000 people and their sales were over $32 million. Arrow collar advertisements appeared in magazines, newspapers, and billboards and lines of men formed outside stores all across the country when a new Arrow collar was advertised. Following the line of using great American illustrators for advertisements, Mr. Norman Rockwell was contracted to do some advertising work and in March of 1921, "His First Dress Shirt" appeared in *Vanity Fair* and on April 6, 1929, the popular advertisement "Airtone" appeared in *The Saturday Evening Post*.

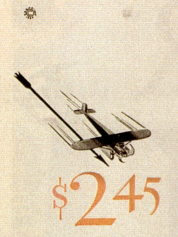

$2⁴⁵

"AIRTONE" is *"air-minded"*!

ARROW'S newest, most surprising, and most exciting shirt (called Airtone) is designed strictly "from the air." Its basic colors are the tones of sky and clouds, from the tint of desert dawn as the mail-pilot sees it, to the cool blue-green of mountain twilight. On these pastel tones are traced tiny "air-lanes" of rich contrasting colors.

And on every* model (among some twenty beautiful patterns) is tailored an Arrow Collar of the same material …starched, or soft…with all the skill that makes Arrow's name the foremost in men's linen. The price is one which only unmatched skill and efficiency could approach—exactly $2.45. Every good men's-outfitter has your size.

**Every model but one: the exception is the neckband-type, with a starched Arrow Collar to match, tailored of the same fine fabric as the shirt.*

CLUETT, PEABODY & CO., INC., TROY, NEW YORK
Arrow Collars . Handkerchiefs . Shirts . Underwear

ARROW
Airtone
SHIRTS

BALLANTINE BEER

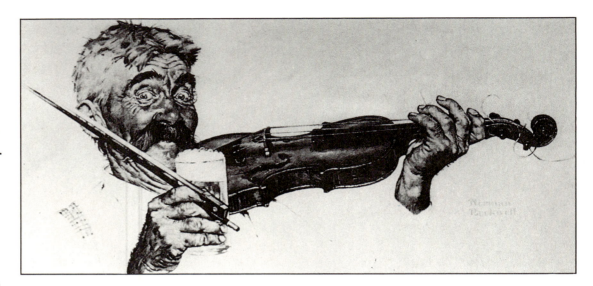

Ballantine had its real beginning in 1830 when Peter Ballantine emigrated from his native Ayr, Scotland, to Troy, New York, and shortly thereafter became identified with the brewing industry in nearby Albany. Here he mastered the technicalities of ale and porter brewing, and by his native Scotch ability and unbounded industry, he soon prospered.

Seeking a suitable location to establish a business of his own, he decided on the city of Newark, New Jersey, where he started operating a brewery in 1840. The business grew and expanded until the era of Prohibition.

When Congress again legalized malt beverages in 1933, it took some time to refit and equip for brewing, and the first beer and ale shipments rolled out of the brewery in 1934. Now, 150 years later, Ballantine is still distributed by hundreds of wholesalers, and Ballantine is still America's oldest and largest-selling ale.

In 1940 the brewery chose Norman Rockwell to paint an illustration for their annual report. Mr. Rockwell asked his neighbor, Harvey McKee, to pose as the fiddler and another classic in American commercial art was created.

BAUER AND BLACK

For many years, Bauer and Black has been one of the leading producers of bandages, gauze pads, cotton products and other medical supplies. In 1926 Mr. Rockwell illustrated an ad for the Bauer and Black Company in commemoration of First Aid Week, which occurred between May 1 and May 8. The ad, which showed a Boy Scout giving first aid to a little girl, was used to promote Bauer and Black products and to announce awards that were to be given to girls and boys who rendered the best first aid. The advertisement appeared in *The Saturday Evening Post* on May 1, 1926, and in *Youth's Companion* on April 29, 1926.

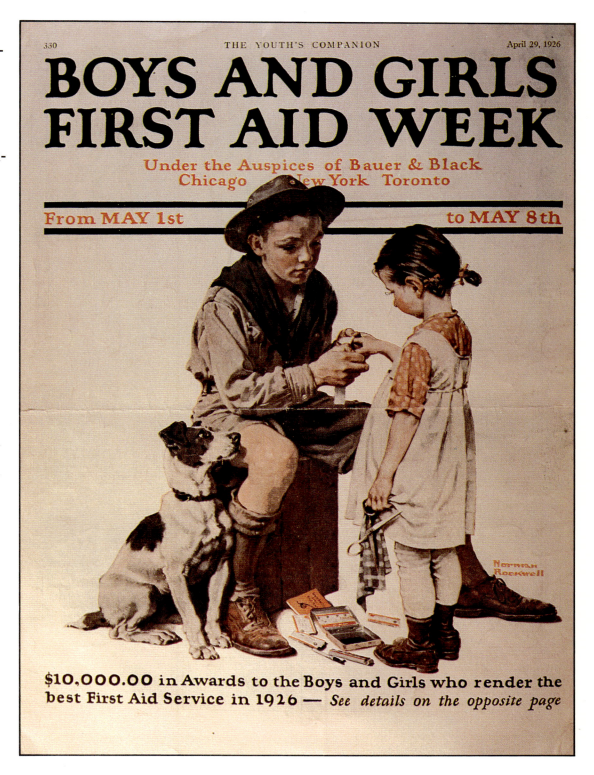

BAUMAN CLOTHING

The Bauman Clothing Corporation was located on Fifth Avenue in New York City in 1919 when it commissioned a new young artist to sketch an advertisement. The ad, which showed a young boy fascinated by a new book entitled *Tudor Jones*, stated that anyone who bought Wear-Pledge Clothes for Boys, produced by the Bauman Company, would get a copy of the new novel with their purchase.

The advertisement appeared in *Ladies' Home Journal* in September 1920, and followed a previous ad drawn by Norman Rockwell for Bauman Clothes, which appeared in *The Saturday Evening Post* on August 30, 1919.

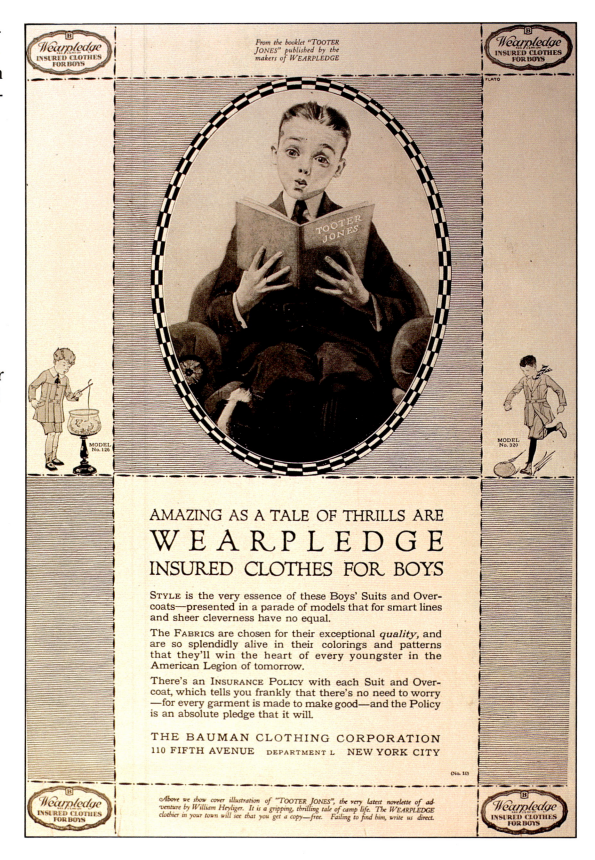

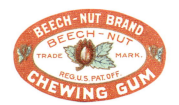

BEECH-NUT

One of the most well-known names in the food industry is that of the Beech-Nut Company. For almost every American mother, the name Beech-Nut is a household word, and millions of American babies were raised on Beech-Nut baby foods. But the name is also quite familiar to children and adults alike as the manufacturer of famous candies and chewing gum.

In 1937 the Beech-Nut Company contracted Norman Rockwell to do an advertisement for Beech-Nut gum and candy. This catchy and humorous ad, which shows a jolly policeman stopping a Beech-Nut salesgirl and asking for a piece of gum, was used to advertise chewing gum and candy that were found in every grocery store and market across the country. The ad appeared in *American* in June of 1937, *Cosmopolitan* in May of 1937, *Ladies' Home Journal* in June of 1937, *Liberty* on April 10, 1937, *True Detective* in June of 1937 and *The Saturday Evening Post* on April 24, 1937.

BEST-EVER SUITS

Between 1917 and 1920, some of the most popular of Norman Rockwell's earlier pictures included boys at play. One of his favorite characters was Cousin Reginald, who always was prim and proper in contrast to the usual kids in the neighborhood. Mr. Rockwell used this popular theme to illustrate one of the neighborhood kids wearing a new Best-Ever Suit and showing off the product to the other kids in the neighborhood.

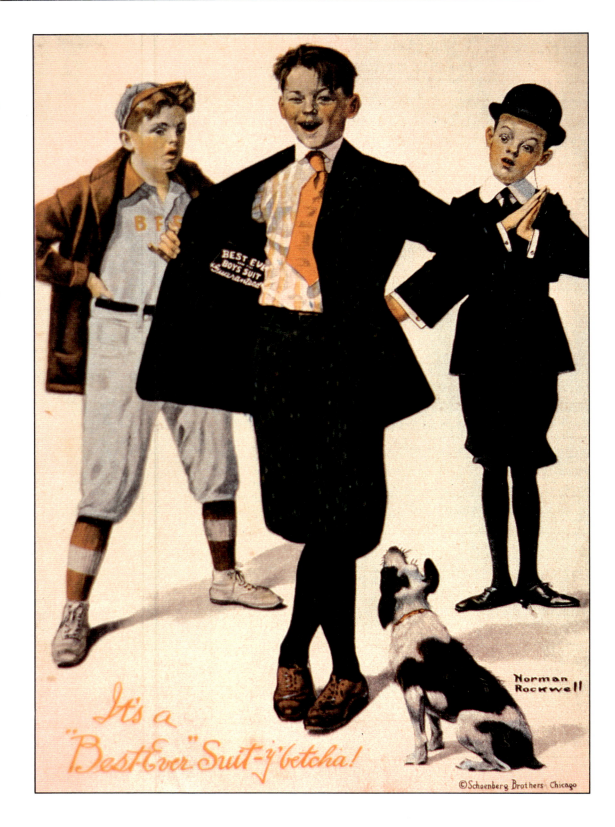

It's a "Best Ever" Suit - y'betcha!

©Schoenberg Brothers Chicago

Norman Rockwell

BISSELL

In 1876 Mr. and Mrs. Melville Bissell owned and operated a small crockery and glassware shop in Grand Rapids, Michigan. In those days crockery was shipped in a bed of sawdust to prevent breakage and the shop was always covered with the packing material. Anna Bissell urged her husband to find a way to keep the store clean. Inventive Melville created a device that not only solved a family problem but started a business that has grown and prospered for over 100 years.

His invention was the Bissell Sweeper, which has swept rugs around the world from the homes of American housewives to the Oriental carpets in the palaces of Turkish sultans.

In 1929 the Bissell Company commissioned Norman Rockwell to create an ad for the already famous sweeper and a wonderful oil painting emerged which has been used for promotional purposes over the years and now hangs in the executive offices of the company under the watchful eye of the president, Mr. John M. Bissell, Melville's grandson.

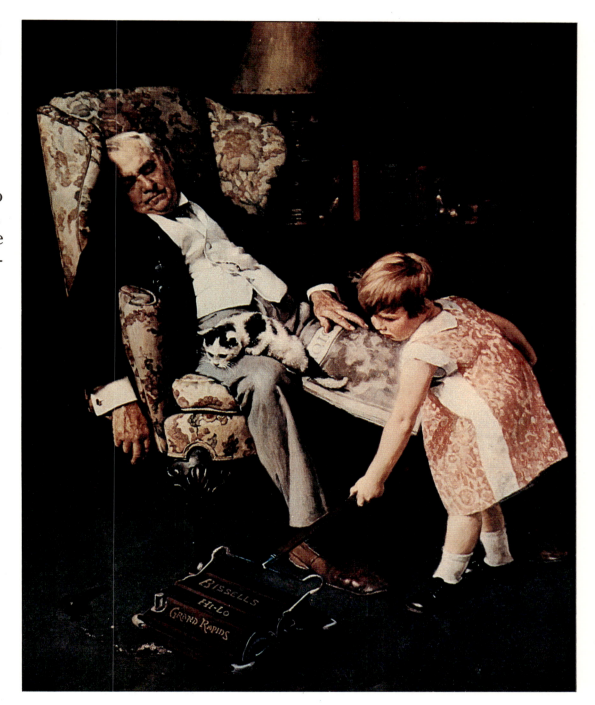

BIG BROTHERS

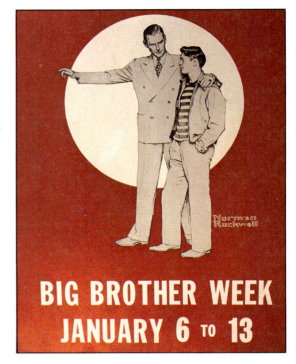

BIG BROTHER WEEK
JANUARY 6 TO 13

The Big Brothers/Big Sisters Movement began shortly after the turn of the century. A national social climate characterized by massive immigration, abuses of the industrial revolution, and the resultant abject poverty—especially in the cities—spawned a serious juvenile crime wave. To worsen matters, little attention was given to correcting the causes, to rehabilitation, to preventative measures. Rather, children who committed even minor offenses were often tried and, if convicted, incarcerated with hardened adult criminals.

Very early in the new century, an aroused social consciousness, sparked by the many injustices, and fueled by the Progressive movement, resulted in many reforms in the juvenile justice system. Significant actions also occurred in the private sector. During the first two decades such organizations as the Boy Scouts, the YMCA and YWCA and the Boys Club Federation came into being. The Big Brother and Big Sister movement also took root. The movement grew out of work by individuals who befriended children who had come before juvenile courts. Prior to World War I, organized Big Brothers and Big Sisters groups could be found in New York, Cincinnati, Milwaukee, St. Louis and in scores of other cities. By the 1920s there were several hundred groups and even a national federation.

The first national federation was a victim of the Great Depression, although individual agencies continued to function. The movement probably reached its lowest ebb just prior to and during World War II. In 1946 a new national organization was created for big brothers—Big Brothers of America. Its primary organizer and first president, Charles G. Berwind, of Philadelphia, wanted to obtain a national symbol for the new organization, one that would immediately identify its purpose.

He called on Norman Rockwell to create this symbol. The result was in line with Rockwell's many other warm and very human portrayals of American family life. The drawing was used for many years on Big Brothers of America stationery, in institutional advertising and in many other applications. It usually appeared with the slogan, "No Man Ever Stands So Straight As When He Stoops To Help A Boy." It became well-known very quickly and instantly identified the organization.

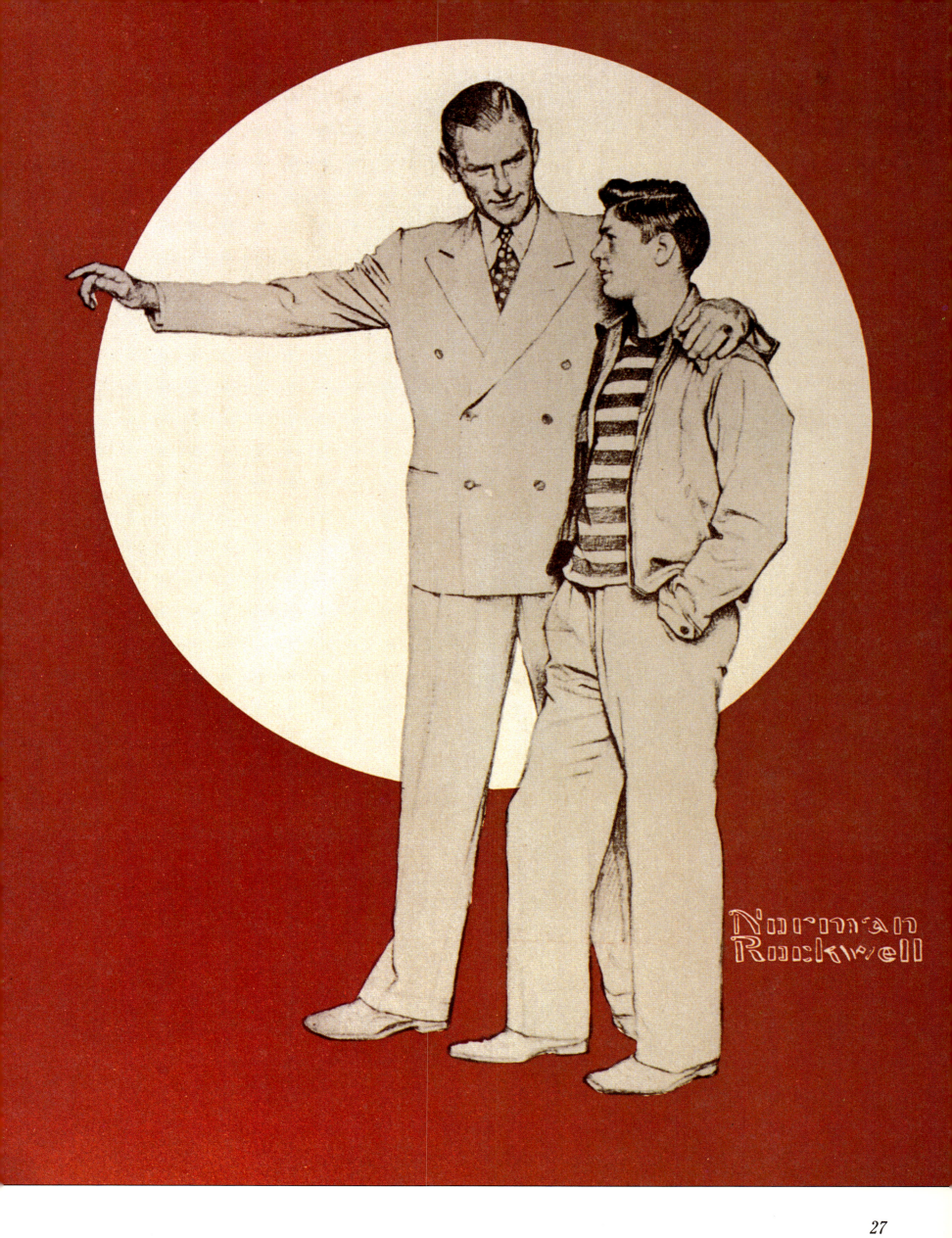

BLACK CAT HOSIERY

The Black Cat Textiles Company of Kenosha, Wisconsin, was a prominent producer of hosiery for adults and children. Black Cat Reinforced Hosiery was the choice of many parents because of its durability. The company had offices throughout the eastern part of the country and was associated with Cooper's Underwear of Bennington, Vermont. In 1917 Norman Rockwell was commissioned to do an advertisement for the company and a very typical Rockwell picture, entitled "Real Boys", which had the same humor as many of his early magazine covers, appeared in *The Saturday Evening Post* on August 25, 1917. The ad was quite successful and he was asked to do more advertising work. "For Children's Play" appeared in the *Post* on August 17, 1918, and "Flying the Kite" appeared on April 26, 1919.

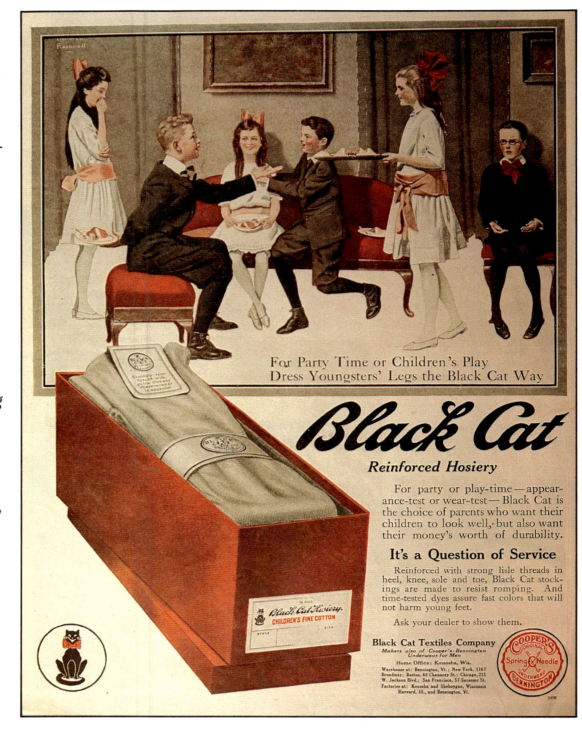

For Party Time or Children's Play
Dress Youngsters' Legs the Black Cat Way

Black Cat
Reinforced Hosiery

For party or play-time — appearance-test or wear-test — Black Cat is the choice of parents who want their children to look well, but also want their money's worth of durability.

It's a Question of Service

Reinforced with strong lisle threads in heel, knee, sole and toe, Black Cat stockings are made to resist romping. And time-tested dyes assure fast colors that will not harm young feet.

Ask your dealer to show them.

Black Cat Textiles Company
Makers also of Cooper's-Bennington Underwear for Men
Home Office: Kenosha, Wis.
Warehouse at: Bennington, Vt.; New York, 1107
Broadway; Boston, 68 Chauncey St.; Chicago, 231
W. Jackson Blvd.; San Francisco, 57 Sansome St.
Factories at: Kenosha and Sheboygan, Wisconsin
Harvard, Ill., and Bennington, Vt.

BLACK JACK GUM

The Adams Chewing Gum Company, a division of the American Chicle Company, was a famous producer of chewing gum for over 60 years. In 1920 the company commissioned Norman Rockwell to create an advertisement for them, and his picture of a young baseball player chewing Black Jack gum to quench his thirst appeared in *The Saturday Evening Post* on March 20, 1920.

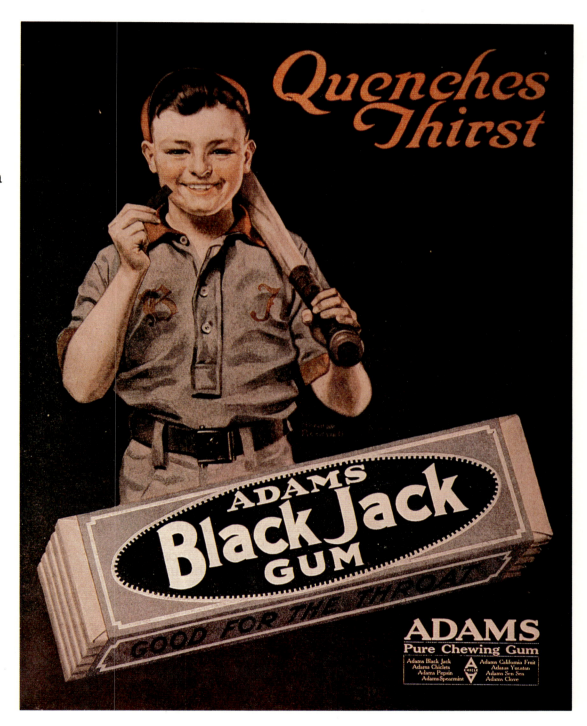

BOY SCOUTS OF AMERICA

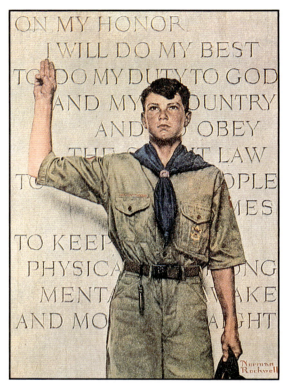

In 1910 the Boy Scouts of America was incorporated and launched its program to educate young men in body and mind. The organization was designed to help boys build character, to train in the responsibilities of participating in citizenship and to develop personal fitness. In 1913, when the Boy Scouts movement was only three years old, Norman Rockwell became an integral part of scouting.

His relationship with the Scouts began when, at the age of nineteen, he brought some of his work into the office of *Boys' Life* magazine, one of the Boy Scout publications. Edward Cove, the editor of *Boys' Life*, first asked the young Mr. Rockwell to illustrate a Scout hiking manual. In 1915 Cave offered Rockwell a steady job as art director for the magazine. He was required to paint the cover for the magazine every month and to illustrate at least one of the stories in every issue. Rockwell's affection for boys, his interest in capturing vignettes of life and his admiration for the Scouts led him to paint storytelling pictures of the principles and practices of Boy Scouts. His work with the Boy Scouts ranged from story and cover illustrations in books and periodicals to calendar art. Between 1923 and 1976 he painted every Boy Scout Calendar illustration except two.

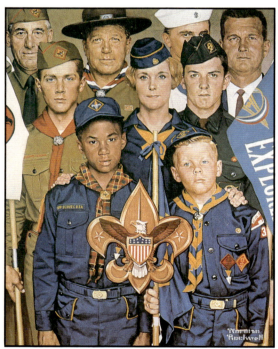

One cannot think of Norman Rockwell without envisioning his knack for capturing Americana and such everyday scenes as the experiences of curious, eager young boys. Rockwell's association with the Boy Scouts went beyond that of artist and subject. He merged characters and stories to create a meaningful, true-to-life picture of the Boy Scouts of America. The Scouts have bestowed numerous honors upon Rockwell including the Golden Eagle award for outstanding service to the organization.

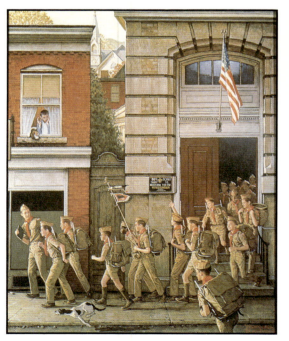

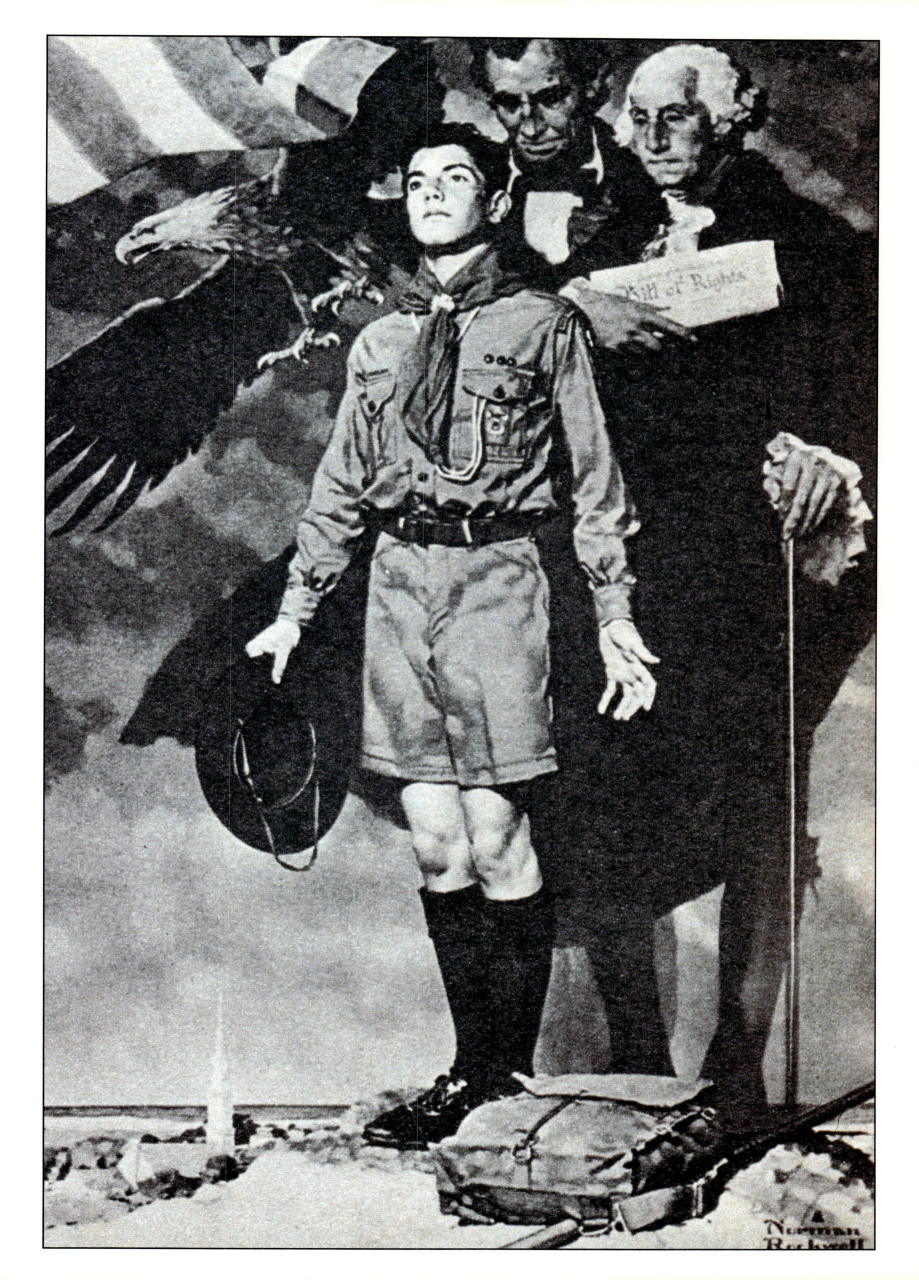

Norman Rockwell

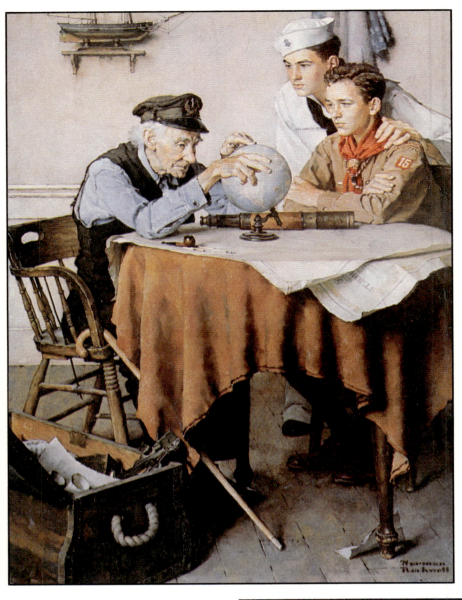

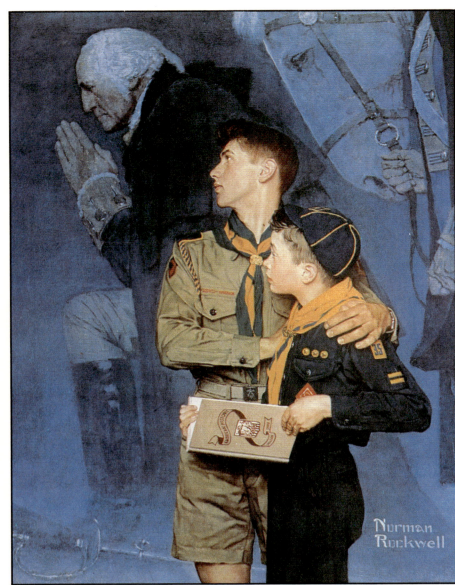

BRUNSWICK

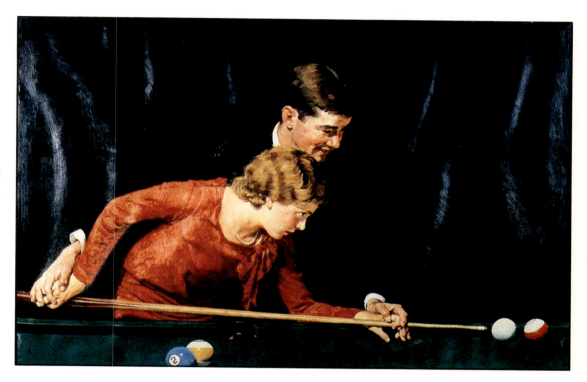

The history of the Brunswick billiard table is a long and colorful one. John M. Brunswick began manufacturing billiard tables in 1845. In 1859 the Cincinnati, Ohio, directory carried a picture of Mr. Brunswick's factory. It was accompanied by the caption, "The largest steam power billiard table manufactory in the United States."

Also manufacturing billiard tables at that time was Julius Balke, proprietor of the Great Western Billiard Table Manufactory. Brunswick and Balke joined forces with yet another partner, H.W. Collender. Mr. Collender improved a billiard cushion which had been invented by Michael Phelan, a senior member of the old firm of Phelan & Collender. This billiard cushion became the standard of the industry after Mr. Collender's improvements, and can claim some measure of credit for the Brunswick table's early and enduring popularity.

Soon the Brunswick-Balke-Collender Company was the nation's leader in billiard tables, and their dedication to quality and playability became hallmarks of the company now known as Brunswick.

By 1912 the Brunswick-Balke-Collender Company had main offices in Chicago, New York, Cincinnati and San Francisco, and factories in the United States, Canada, and Paris, France.

BUDWINE

In 1894 Henry C. Anderson began working on a cherry concoction at the family estate in Watkinsville, Georgia. Henry was a strict teetotaler and wanted to create a drink that would lure people away from alcohol. He teamed up with a German chemist from Elberton, Georgia, and formulated a blend of several fruit and grain extracts that got its public debut at his sister's high school graduation party in 1905. Originally, Henry wanted to call his drink "G.D." for "Good Digestion." Cooler heads prevailed, and by the fall of 1906, Mr. Anderson's cherry soda had entered the market under the name of "Bludwine."

Bludwine found immediate favor with health-conscious turn-of-the-century Americans and within a few years was distributed within twenty-eight states and was selling a million bottles a day. It continued to grow through the first two decades of the century, but in 1918 the new Federal Drug Administration assaulted their slogan "for your health's sake" and made them drop it. Shortly after, it was decided to remove the 'L' from the name and the company became the Budwine Company. Later that year, the company had another major problem when a defective batch of soda water was distributed and its reputation suffered irreparable damage. Following that, the original owners lost interest, and in 1929 the Budwine Company was sold to Joseph Costa, Jr. of Athens, Georgia.

When Mr. Costa purchased the company, most of the original records had been destroyed. One day while looking through some material ready to be discarded as trash, he noticed a large painting of a boy and his dog. The picture was done for an advertisement several years prior, and the name, Norman Rockwell, caught is eye. He enthusiastically took that painting with him and had it restored. Today the "Budwine Boy and His Dog" hangs in the main office of the company and is used for public relations purposes.

Since 1929 the Budwine Company has been sold a few more times, and its distribution gradually decreased. In September of 1979 the Pepsi-Cola Bottling Company of Hickory, North Carolina, began producing Budwine in a step to secure more Budwine bottlers. At the present time, it is produced and distributed by ten bottlers in four states, and it appears that its popularity and geographical distribution will continue to grow.

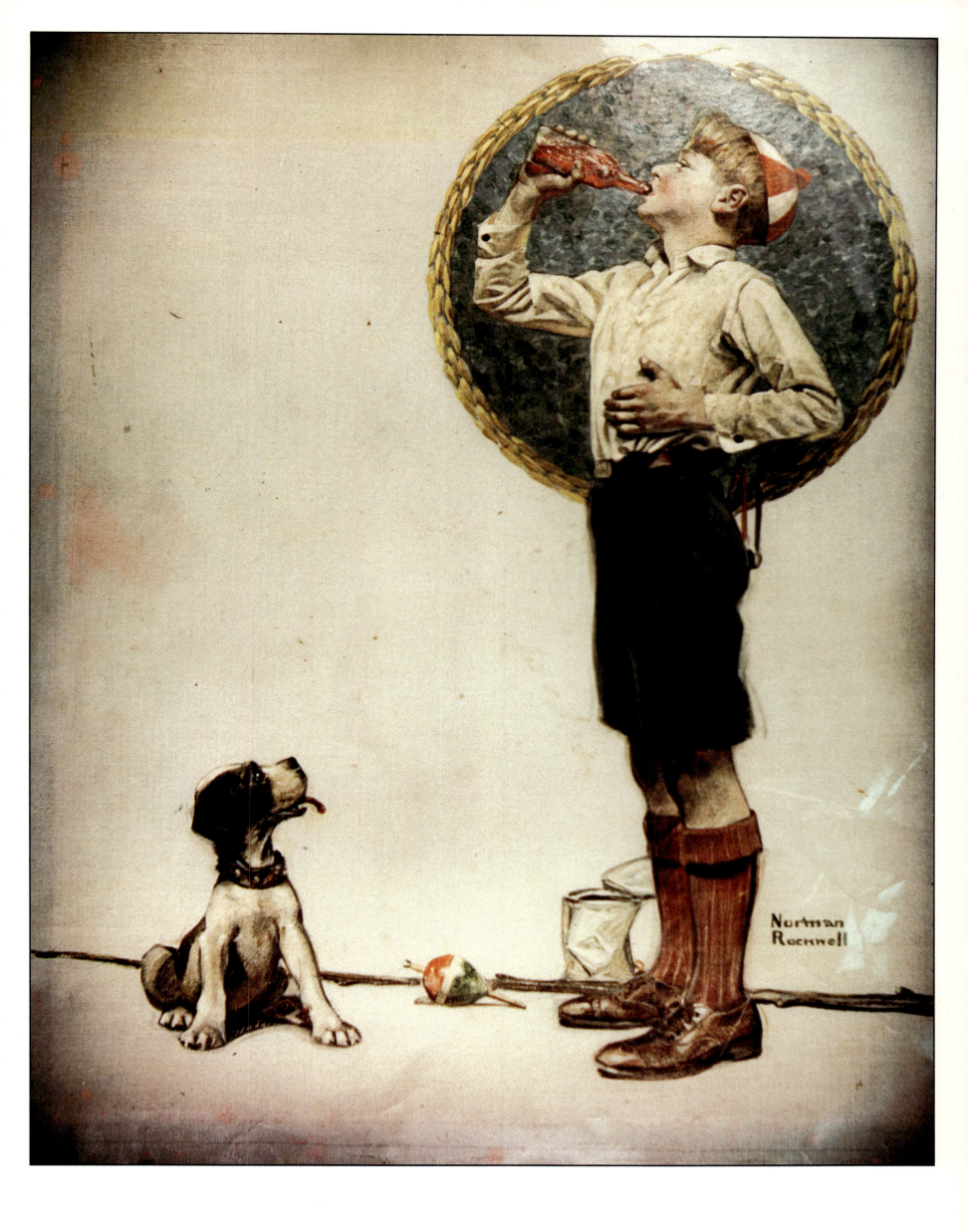

CAMPBELL'S TOMATO JUICE

In 1869 a New Jersey fruit merchant by the name of Joseph Campbell met Abram Anderson, an ice box manufacturer, and they formed a partnership to can tomatoes, vegetables, jellies, condiments and mincemeat. Together the two men established a canning and preserving business which achieved a reputation for quality food products. In 1876 Anderson left the partnership and shortly after, the name of the company was changed to the Joseph Campbell Preserve Company. In the first 30 years of its existence the company grew from a small canning business to a large well-known corporation whose familiar red and white labels were recognized everywhere. The colors on the labels were suggested by Cornell College football uniforms.

In 1900 Campbell Soups won a Gold Medallion for excellence at the Paris Exposition. The Gold Medallion has been featured on labels of Campbell products ever since. In 1904 the company hired Grace Gebbie Drayton, a Philadelphia artist, to do some advertising work. She created the famous Campbell kid characters who were identified with Campbell products for years to come. From 1905 the Joseph Campbell Company received its new corporate name and its first magazine advertisement, which told of 21 kinds of Campbell Soup, appeared in *Good Housekeeping*.

In 1934 the Campbell Soup Company hired Norman Rockwell to paint some advertisements for Campbell Tomato Juice. The popular picture of a rosy-cheeked gentleman drinking a glass of thick red tomato juice and stating, "That's the real tomato flavor" appeared in *Fortune* and *The Saturday Evening Post*.

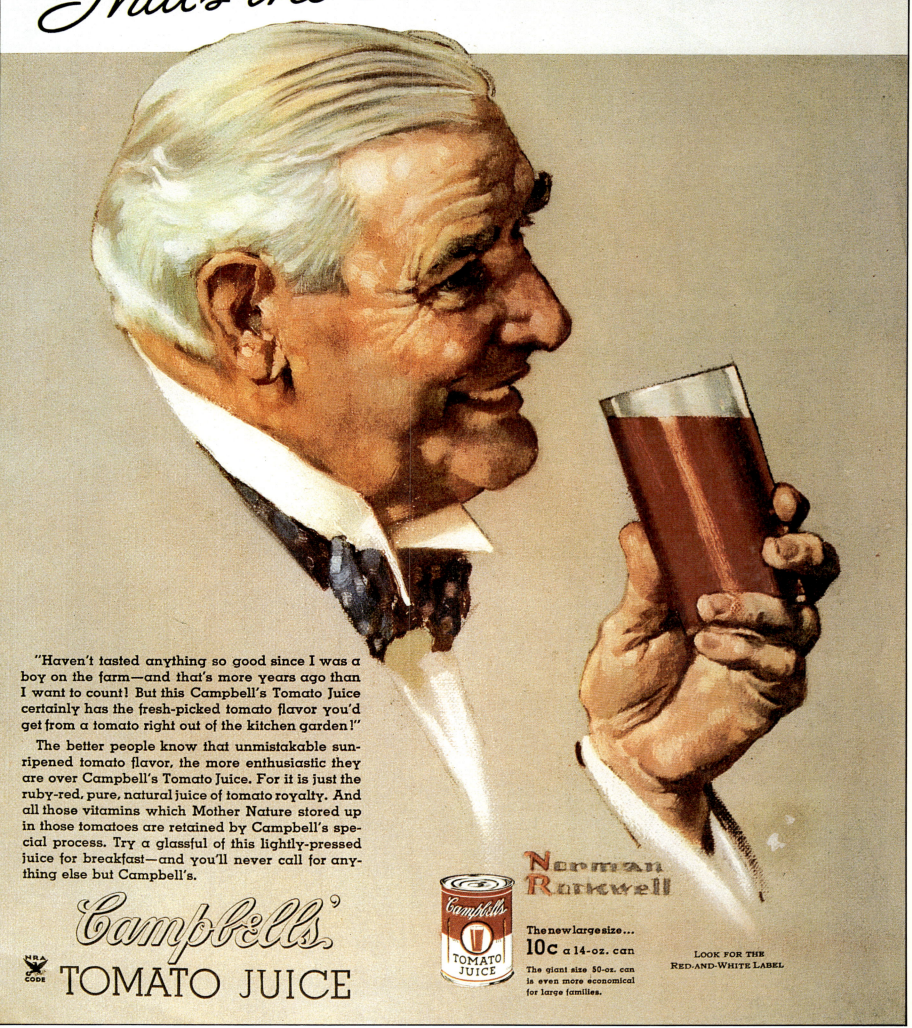

"*That's the real* tomato flavor!"

"Haven't tasted anything so good since I was a boy on the farm—and that's more years ago than I want to count! But this Campbell's Tomato Juice certainly has the fresh-picked tomato flavor you'd get from a tomato right out of the kitchen garden!"

The better people know that unmistakable sun-ripened tomato flavor, the more enthusiastic they are over Campbell's Tomato Juice. For it is just the ruby-red, pure, natural juice of tomato royalty. And all those vitamins which Mother Nature stored up in those tomatoes are retained by Campbell's special process. Try a glassful of this lightly-pressed juice for breakfast—and you'll never call for anything else but Campbell's.

Campbells'

NRA CODE

TOMATO JUICE

Norman Rockwell

The new large size...
10c a 14-oz. can
The giant size 50-oz. can is even more economical for large families.

LOOK FOR THE RED-AND-WHITE LABEL

CAPITOL BOILERS

Capitol Boilers and Radiators were produced by United States Radiator Corporation in Detroit, Michigan, for many years. In 1929 the company commissioned Norman Rockwell to create an advertisement for them and his picture "The Melody Stilled by Cold," which showed a young violinist warming his hands by a stove, appeared in *Better Homes and Gardens* in April, 1929, and *The Saturday Evening Post*, March 2, 1929.

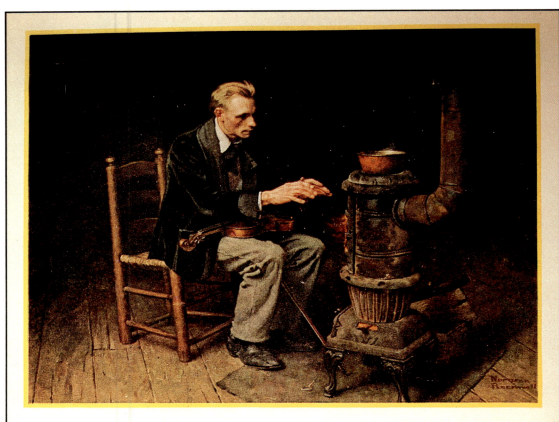

The melody stilled by cold

BY the fire he sits, symbol of the sentimental tradition that genius thrives in a garret. Yet the melody he has written, his cold-stiffened fingers can not translate into the singing beauty which he intended.

Elsewhere in the world, wherever comfort is not starved by cold, any trained musician could reproduce his haunting melody. For the ribbon of written notes speaks a universal language. Everywhere the simple staff notation indicates the same length and pitch of all the tones.

Unfortunately the same certainty of meaning is not represented in the ratings that are placed on all boilers. Competitive conditions in the heating industry have brought such inflation of ratings that it is not unusual for a heating engineer to divide by two or more the rated capacity of a boiler, to be on

the safe side of comfort and fuel economy. No wonder that heating results have not always been happy.

For such uncertain choice, *Capitol Guaranteed Heating* substitutes boilers with their ratings guaranteed in writing. Definitely this bond of protection assures you that the boiler you buy will do all that you pay for, that even on coldest winter days it will deliver ample heat, economically.

With equal impressiveness, it evidences the excellence of every Capitol Boiler — round; square; smokeless; and the Capitol Red Cap, the masterpiece of residence boilers with a round insulated jacket of glistening cobalt blue and cardinal red.

All are sold and installed *only* by responsible heating contractors. All are described in our new illustrated booklet, "A Modern House Warming." Write for a free copy.

★ GUARANTEED HEATING

Your contractor receives a written guarantee on the heating capacity of every Capitol Boiler. No other heating equipment assures you satisfaction so definitely.

UNITED STATES RADIATOR CORPORATION

8 Factories and 34 Assembling Plants Serve the Country GENERAL OFFICES DETROIT, MICH. *For 39 years, builders of dependable heating equipment*

© 1929, United States Radiator Corp.

Guaranteed Heating WITH

Capitol Boilers

AND RADIATORS

THE PACIFIC STEEL BOILER CORPORATION

Division of the United States Radiator Corporation, builds welded steel heating boilers for large installations.

CHASE MANHATTAN BANK

Although Norman Rockwell only completed the tenth grade in school, something he always regretted, he admired well-educated people and during his lifetime strove to learn as much as he could about everything. Although his formal education was minimal, a study of his paintings reveals that his self-education was more than adequate.

In 1955, when the Chase Manhattan Bank of New York City, the second largest commercial bank in the United States, engaged Mr. Rockwell to paint an advertisement, he accepted the challenge eagerly. The topic was "a bright future for banking" and in the remarkable painting Mr. Rockwell depicted the 1955 graduating class whose bright, handsome young women and men were looking out to the challenge of the outside world for their careers and professions.

The ad appeared in *The Saturday Evening Post* on June 18, 1955, and was a moment of pride for the entire banking industry.

Bright future for banking

This June thousands of graduates look forward to a career. Here's the story of bankers—what they work for, what they are like.

You can't always recognize a budding banker by an expression. You've got to dig a little into character.

As bankers, we naturally know some of the character essentials that make for success in our business. These we're passing along on the chance that they might help inspire the right youngster toward a bright future in banking.

Profile of a Banker

Bankers take a healthy pride in their jobs. They like people. They like to help people, and they believe that banking offers a good way to do just that.

Bankers are also strong individualists. But they're completely in agreement on certain basic things like private enterprise, individual rights, self-reliance, and our country's future.

Judgment comes into the picture, too. The banker must be a realist. It's mostly your money he's dealing with, and it's his responsibility to lend it wisely.

Bankers in Action

The successful banker gets where he is because he's resourceful enough to match every ounce of essential caution with a full pound of imagination and concern for the community interest. He knows his neighbors well. Like the lawyer, the doctor and the churchman, he keeps their confidences and helps them when he can.

Such is the profile of a banker . . . of the banking profession itself. For the young men and women who can match it there's a bright future in a growing industry. There's also a world of opportunity in a rewarding career that provides interesting jobs and makes useful citizens.

The Chase Manhattan Bank of New York presents this message in the interest of a wider understanding of the banker's place in our national life.

THE
**CHASE
MANHATTAN
BANK**

(MEMBER FEDERAL DEPOSIT INSURANCE CORPORATION)

CENTRAL MAINE POWER COMPANY

Central Maine Power Company is an investor-owned electric utility which provides electric service to more than 800,000 people in over 300 communities throughout central and southern Maine. Since being founded in 1899 by Walter S. Wyman and Harvey D. Eaton in West Waterville (now Oakland), CMP has merged with more than 130 utilities to develop a strong, interconnected electric system powered today by a balanced mix of hydroelectric, oil-fueled and nuclear-fueled generating stations. CMP's membership in the New England Power Pool and a tie-line to Canada provide for added reliability and economy in meeting customers' needs through regional planning, power exchanges and the maintaining of reserve capacity with other pools in the Northeast and Canada.

In 1914 Maine citizens voted in public referendum to make CMP a regulated monopoly serving an exclusive service territory.

As the state's largest electric utility, the company must meet the responsibility of providing vital electric service to two-thirds of the state's population by maintaining a strong electric system: strong in generation, in fuel supply, in transmission and distribution and strong in the support of industry research and development.

In the early 1960s Central Maine Power Company commissioned Norman Rockwell to create four advertisements to enlighten the public about the corporation. Although the four ads which depicted company activities during the four seasons were completed, only one was used and that appeared in *The Saturday Evening Post*.

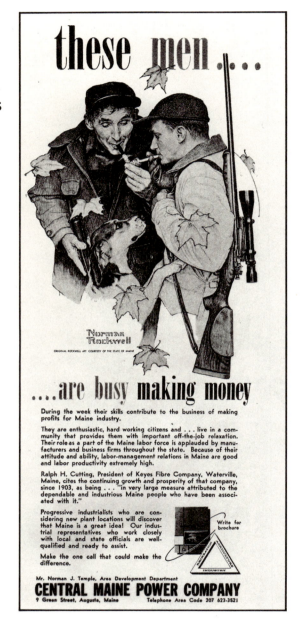

COCA-COLA

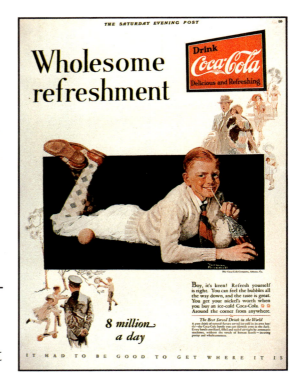

The year was 1886, the place was Atlanta, Georgia. A pharmacist named Dr. John S. Pemberton, working on a new cough medicine, produced a syrup in a three-legged pot in his back yard and soon after it became a popular soda fountain drink in Atlanta. Dr. Pemberton's partner, Frank M. Robinson, suggested a name for the drink and in his own handwriting scrawled out "Coca-Cola" in a script that has become recognized around the world. In that year of 1886 sales averaged about 13 drinks a day.

In 1888 Dr. Pemberton died and the rights were sold to three parties. Mr. Asa G. Candler purchased one third for $500 and later acquired complete control for $2300. Mr. Candler, with great advertising ability, increased sales tenfold and together with his brother John Candler, Frank M. Robinson and a few other friends formed The Coca-Cola Company in 1892.

In 1919 the Candlers sold the company to an Atlanta banker, Ernest Woodruff, for $25 million, but they must be credited with the spark that ignited the flame and the fame of "Coca-Cola."

Under the control of Mr. Woodruff a massive advertising campaign was started and "Coke" ads painted by famous artists were seen everywhere. In 1928 the company commissioned Norman Rockwell to do several pictures and these immensely popular paintings appeared on calendars, serving trays, billboards and on the pages of popular magazines such as *American, Boys' Life, Cosmopolitan, Liberty, Literary Digest* and *The Saturday Evening Post*. Today the five Rockwell Coca-Cola ads are much-sought-after collectors' items.

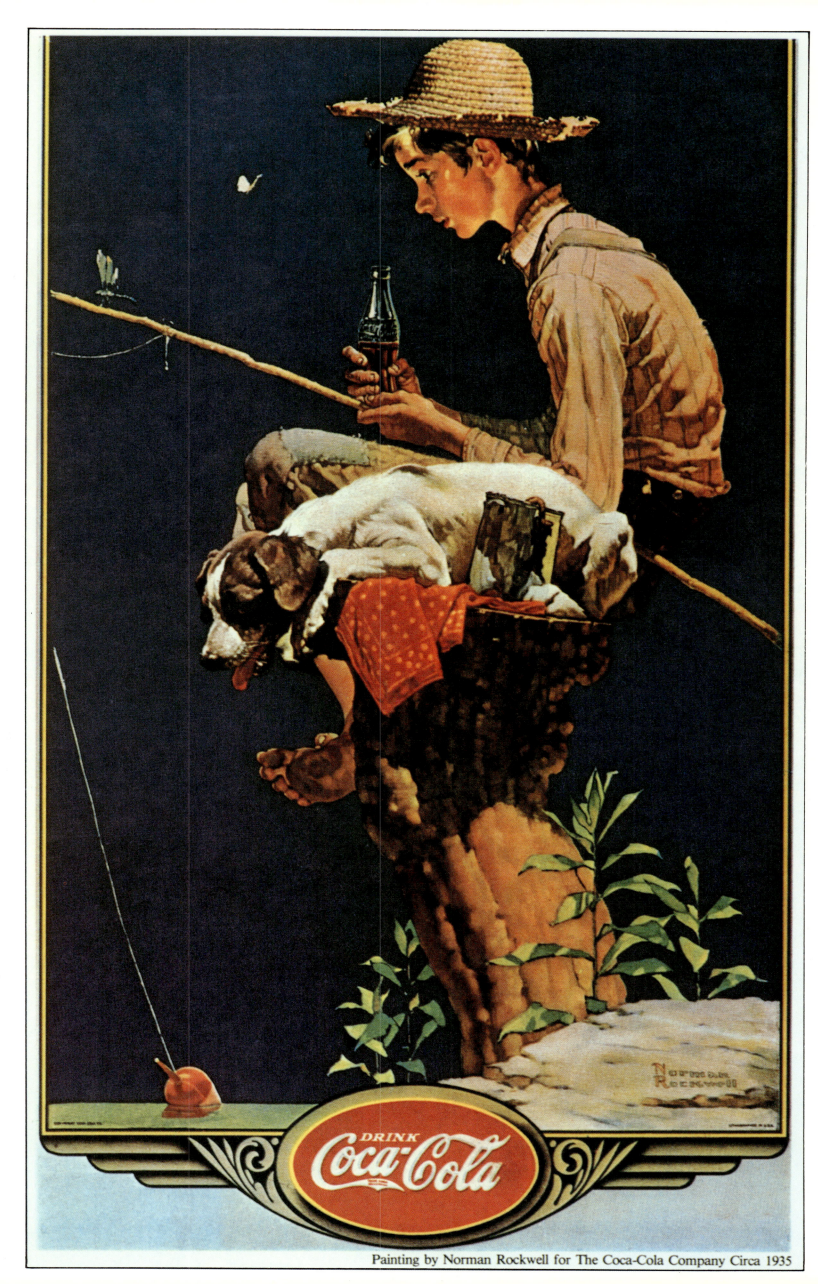

43

Painting by Norman Rockwell for The Coca-Cola Company Circa 1935

COLGATE TOOTHPASTE

The American Revolution was but a generation old—Thomas Jefferson was beginning his second term as President—and New York City boasted a population of 78,000, when young William Colgate opened a tiny shop in the thriving port city in 1806. Selling "Soap, Mould and Dipt Candles of first quality," the 23-year-old Colgate hardly dreamed that his modest establishment at 6 Dutch Street was the foundation of a corporate giant that would sell its wares all over the world.

Industrious, dedicated to producing fine products, and unusually courteous to his customers (he may have founded the city's first home delivery service), Colgate prospered and expanded.

Although the need for additional space forced him to move his plant to New Jersey, he continued to maintain the Dutch Street offices. When the company finally relocated, it had set a record for commercial tenancy in New York—104 years at the same address.

When William Colgate died in 1857, Colgate & Company continued under the management of his two sons, Samuel and Joseph, and his nephew, Charles. Inheritors of William's drive and innovativeness, they and their descendants maintained the company as a "family business" for 102 years, when, in 1908, they became publicly owned. In 1928 the company merged with Palmolive-Peet and changed its name to Colgate-Palmolive-Peet Company (The Peet was dropped in 1953).

In 1924 Colgate and Company commissioned Norman Rockwell to paint an advertisement for Colgate's Ribbon Dental Cream. At that time Mr. Rockwell was the art director for the Boy Scouts of America and art director of *Boys' Life*. He painted a picture of a Scout getting wise dental advice from an old gentleman. The ad appeared in several magazines in 1924, including *American*, *Ladies' Home Journal*, *Literary Digest*, *National Geographic* and *Woman's Home Companion*.

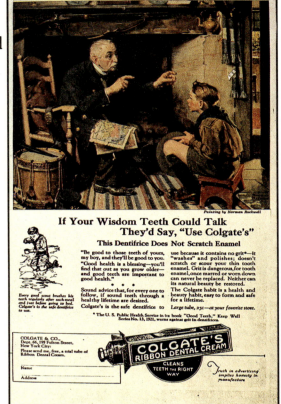

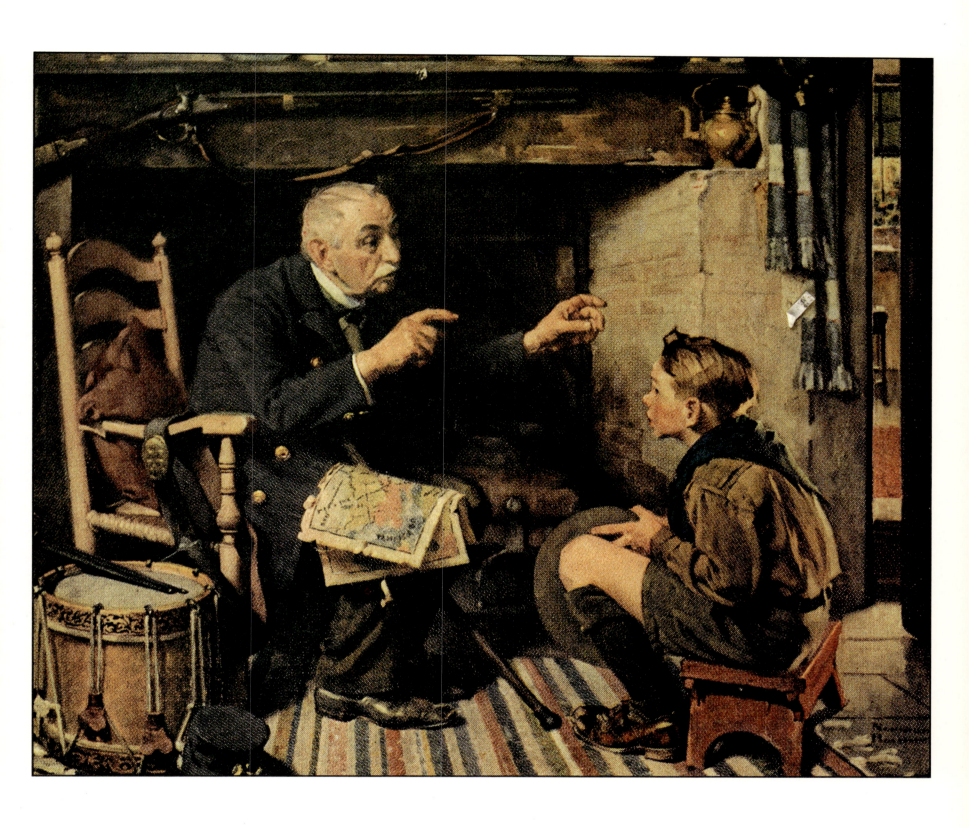

CREAM OF KENTUCKY

The state of Kentucky has long been known as the birthplace of bourbon whiskey. It appears that during the American Revolution Louis the XVI of the Bourbon dynasty in France came to the aid of the American Colonies in their struggle against Great Britain. In his honor, a portion of northeastern Kentucky and part of Virginia was named Bourbon County. In 1789 the Reverend Elijah Craig, a Baptist minister, distilled the first whiskey having all the characteristics that now distinguish bourbon, and this took place in Bourbon County.

There are three important criteria that determine true bourbon: one, the water must be entirely free of any impurities; two, the principal grain is corn; and three, after it is distilled it is aged in charred kegs made of white oak. To meet all these criteria, the state of Kentucky was the perfect home of bourbon whiskey because its water was pure, corn was plentiful and white oak covered the mountainsides.

Over the years, as the demand for bourbon grew, many distilleries began production, using the original Kentucky formula. One of the most famous was the Schenley Company and in honor of the state where bourbon whiskey began, their product was called "Cream of Kentucky."

In 1936, the Schenley Corporation commissioned Norman Rockwell to do a series of pen-and-ink drawings advertising Cream of Kentucky bourbon. Mr. Rockwell did a series of over a dozen drawings, showing Americans in all walks of life, both the average man and the famous man at work or at play enjoying "Cream of Kentucky" bourbon. The ad campaign was so successful that the Rockwell pictures continued to appear in major American magazines such as *Collier's*, *Liberty*, *Life*, *Look*, *The New Yorker*, and *Time* for over thirteen years.

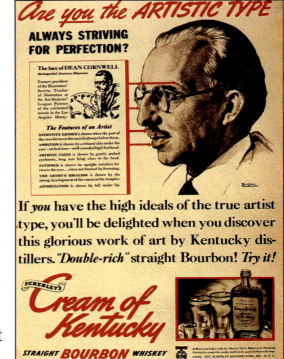

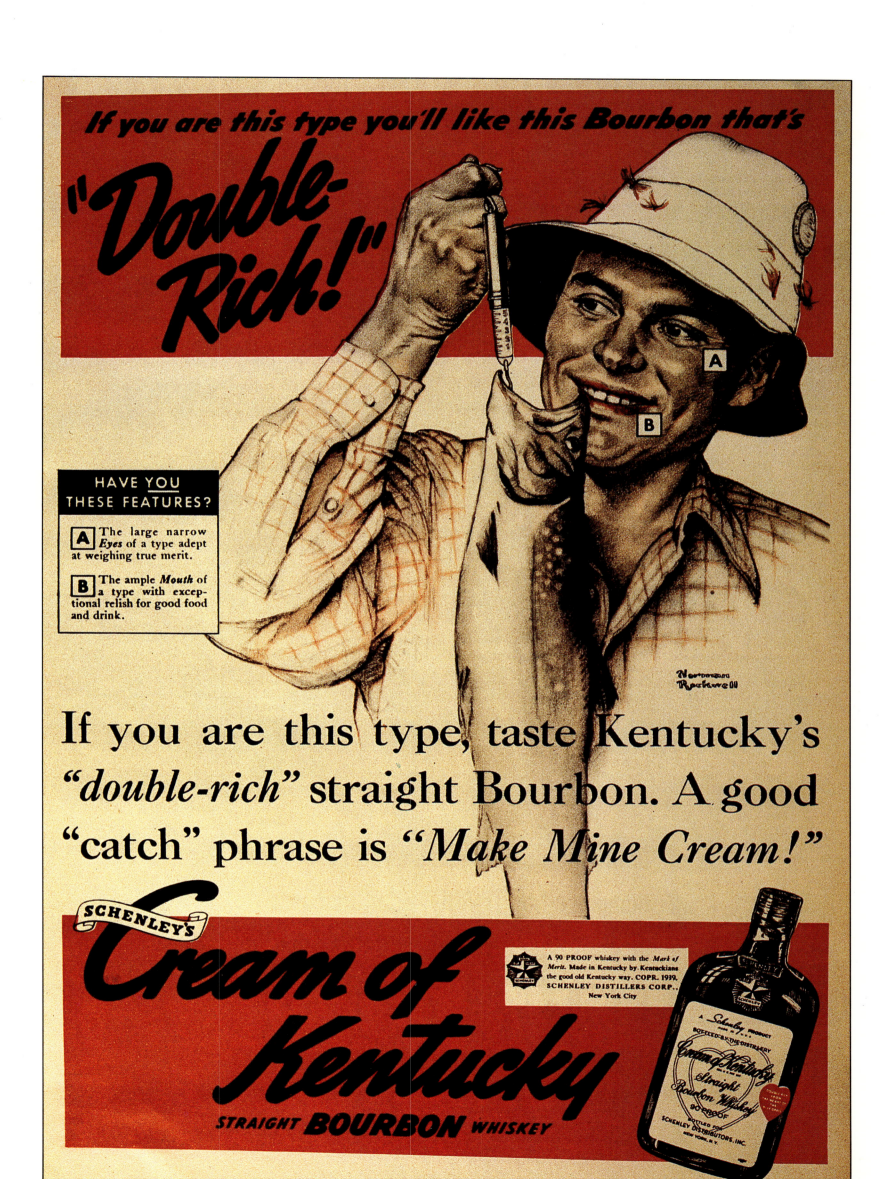

CREST TOOTHPASTE

In 1833 a young soap and candle maker from Ireland married the daughter of Alexander Norris in Cincinnati, Ohio. Later that same year Mr. Norris's other daughter also married a candle maker and merchant who had recently arrived from England. After a few years Mr. Norris urged his sons-in-law to form a partnership for mutual benefit, and in 1837 William Procter and James Gamble heeded their father-in-law's advice and started the firm of Procter and Gamble. From this perfect union emerged one of the great soap and detergent companies.

As the company grew, Procter and Gamble began to search for artistic talent to advertise their products and in 1900 commissioned the famous *Saturday Evening Post* artist J. C. Leyendecker to illustrate an ad for Ivory Soap. This ad was followed by many other successful ads through the years by many fine artists.

In 1957 Procter and Gamble hired Norman Rockwell to paint a series of ads for Crest Toothpaste. From 1957 to 1959 the faces of Bobby Banks, Danny Fay, Janie Carrol, Patricia Patterson, Douglas Morgan and many others became famous on the pages of well-known magazines like *Good Housekeeping, McCall's, Better Homes and Gardens, Reader's Digest* and *Ladies' Home Journal.* And the Crest slogan "Look Mom, No Cavities" became a household password. Other Procter and Gamble Crest ads stated that "Since 1955 Crest has helped over 40 million kids prevent cavities" and Norman Rockwell was certainly an important part of that campaign.

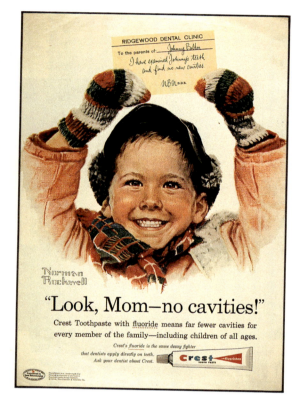

"Look, Mom—no cavities!"

Crest Toothpaste with fluoride means far fewer cavities for every member of the family—including children of all ages.

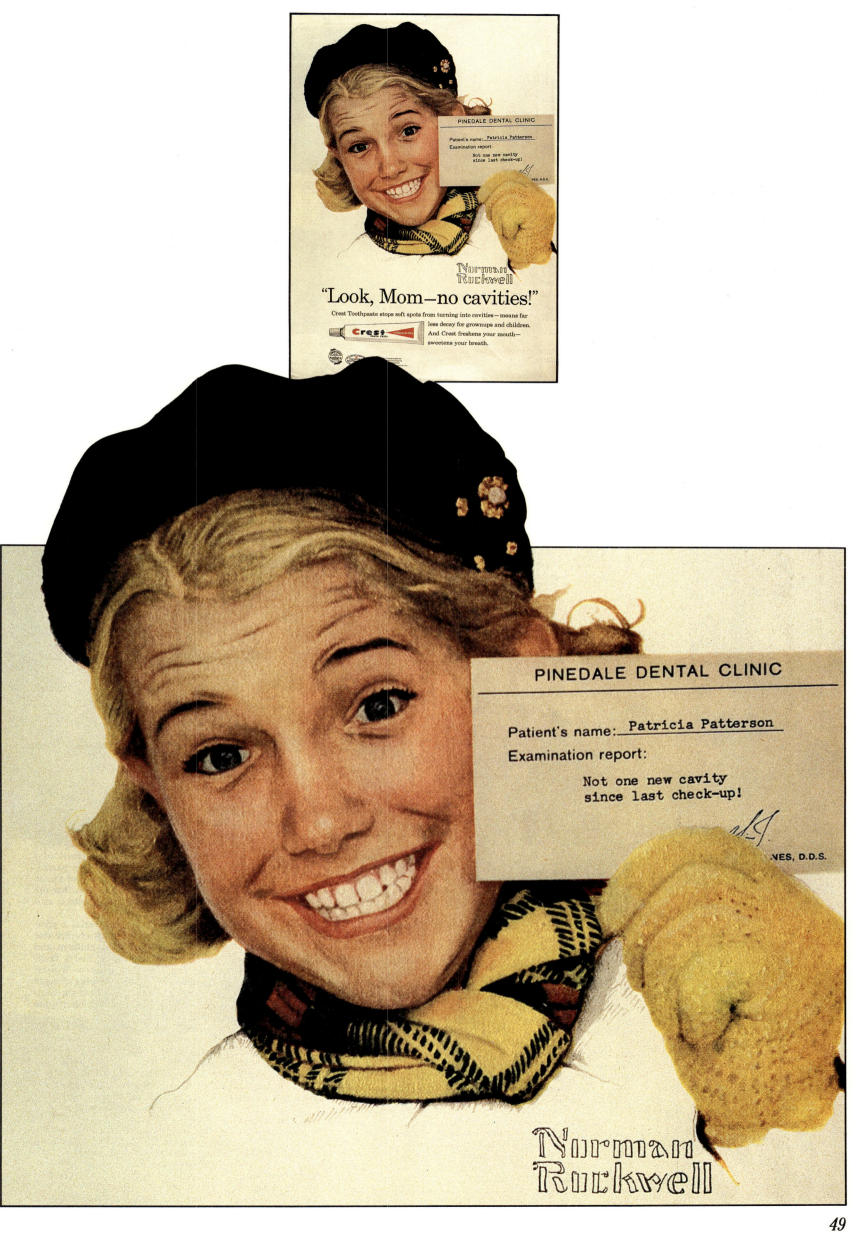

CRUSH

The very first bottle of Orange Crush was sold in Chicago in 1916. While the 63-year lifespan of Crush International has a history of tremendous growth, several changes have taken place along the way. Today, when discussing Crush, we are actually talking about a company producing an array of popular soft drinks of which Orange Crush, Hires Root Beer and Sun Drop are the principal products. Years ago, the company, known then as The Orange Crush Company, also produced Lemon Crush and Lime Crush, which it no longer does.

In 1921, just five years after its inception, an enterprising advertising man for The Orange Crush Company signed Norman Rockwell to a long-term contract to do twelve Orange Crush ads at $300 per ad. At the time it seemed like a lot of money to Rockwell and although the agreement was wonderful for the soda company, he regretted it and vowed never to sign another contract. After the first two or three ads, ideas became difficult and getting a bottle of Orange Crush prominently into the picture became exasperating. He tried repeating the slogan "The Delectable Refreshment" over and over again to try to get new ideas and by the fifth and sixth painting he was totally frustrated.

Mr. Rockwell wrote in his autobiography, "By the time I got to the eleventh and twelfth picture I was dreaming about bottles of Orange Crush Soda Pop—long lines of them—quart size, regular size, marching down on me with all the labels distinctly readable. A stampede of bottles. I'd wake up in the middle of the night screaming, ORANGE CRUSH, ORANGE CRUSH!"

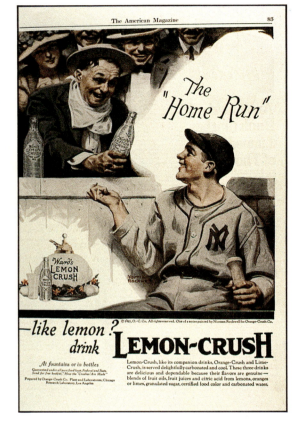

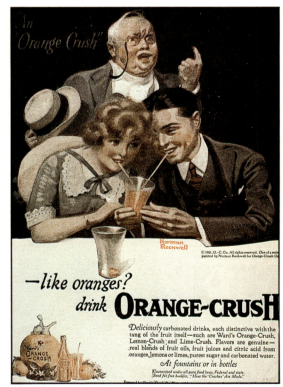

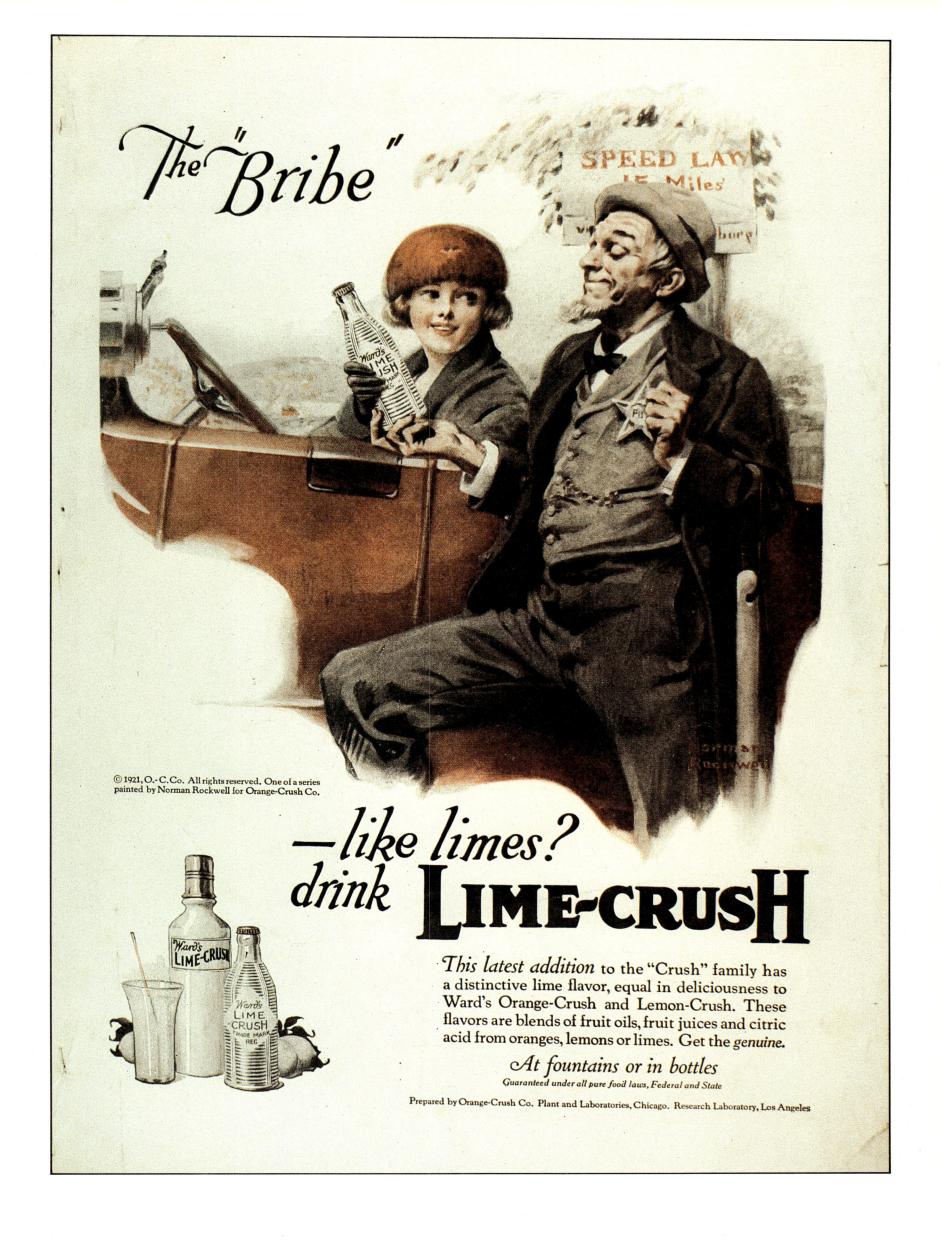

The "Bribe"

—like limes? drink LIME-CRUSH

This latest addition to the "Crush" family has a distinctive lime flavor, equal in deliciousness to Ward's Orange-Crush and Lemon-Crush. These flavors are blends of fruit oils, fruit juices and citric acid from oranges, lemons or limes. Get the *genuine*.

At fountains or in bottles
Guaranteed under all pure food laws, Federal and State

Prepared by Orange-Crush Co. Plant and Laboratories, Chicago. Research Laboratory, Los Angeles

51

DEL MONTE

The history of Del Monte Corporation embraces the development of the canning industry in California following the Gold Rush boom of the 1850s. Through predecessor companies, Del Monte traces back to the earliest beginnings of food production and processing on the West Coast.

Founded in 1916 as the result of the merging of four pioneer California canning companies, Del Monte (called California Packing Corporation until the name was changed in 1967) set out to build a national reputation for its food products. The company's first advertisement, carried in the April 21, 1917, issue of the *Post*, had a disarmingly simple message: "California's finest fruits and vegetables are packed under the Del Monte brand." That single-minded attention to quality and brand has persisted at Del Monte with the distinctive red shield now familiar to consumers the world over.

During the 1920s, Del Monte and its advertising agency, McCann-Erickson, commissioned Norman Rockwell to illustrate two advertisements for the *Post*. The dress and the moment have changed, but the values remain the same.

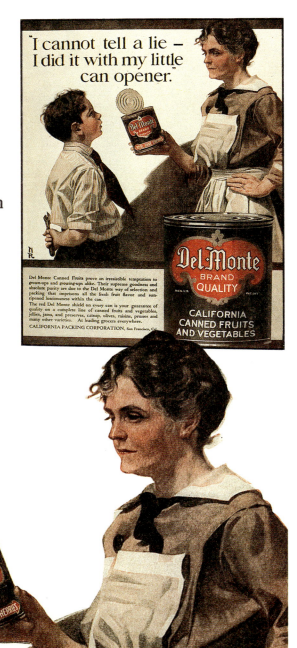

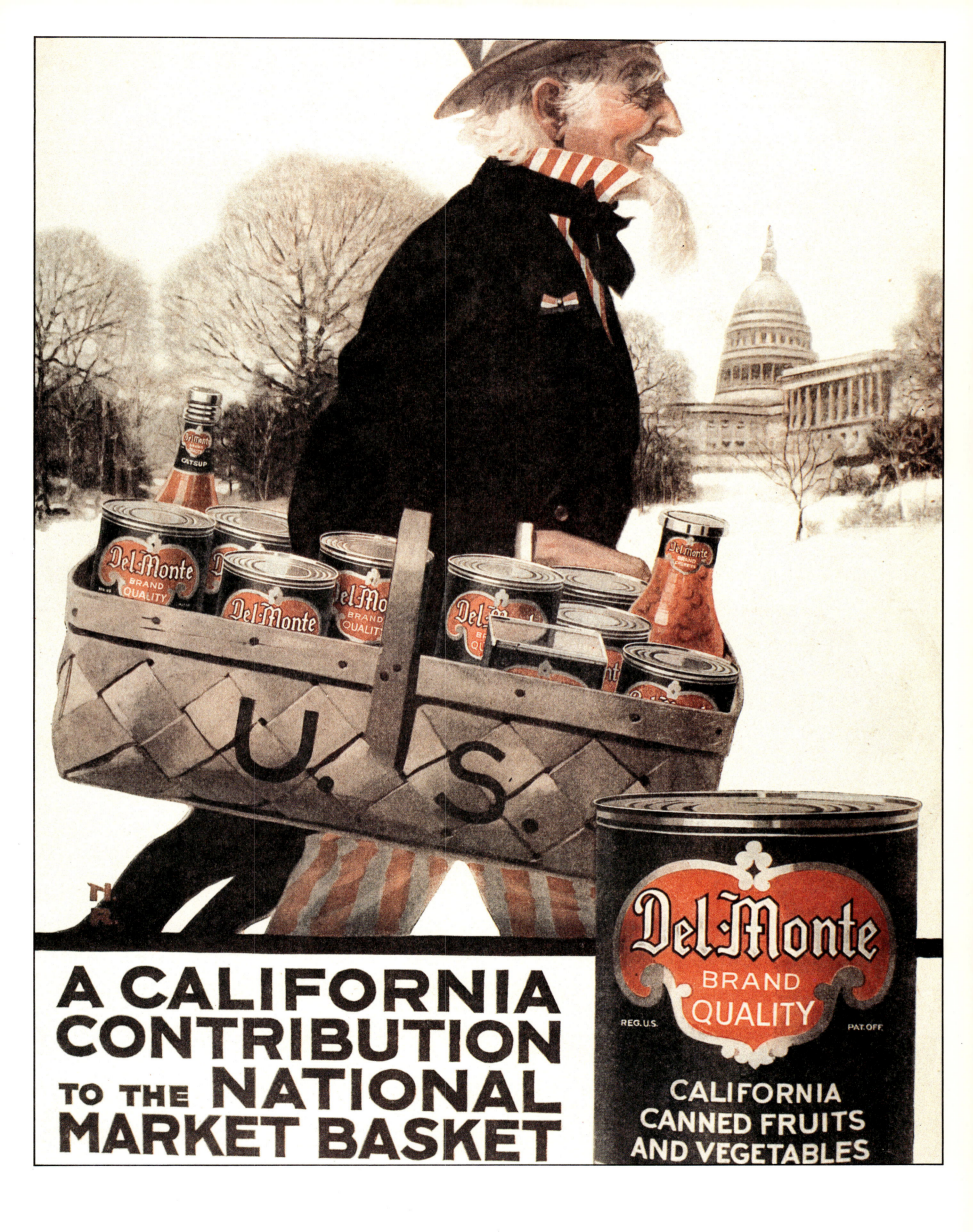

A CALIFORNIA
CONTRIBUTION
TO THE NATIONAL
MARKET BASKET

Del Monte
BRAND
QUALITY
REG. U.S. PAT. OFF.
CALIFORNIA
CANNED FRUITS
AND VEGETABLES

DEPARTMENT OF THE ARMY

The United States Army boasts of a longer history than that of the nation which created it. On June 14, 1775, the Continental Congress, reflecting the mood of an aroused populace, established The American Continental Army for defense purposes.

Two hundred years later the U.S. Army also services our country in the areas of agriculture, education, geographical expansion, leadership and management, medicine, space exploration and transportation.

Similar to that of the Army, Norman Rockwell's career has been diverse. He worked on a series of patriotic calendars and posters during World War II. His precise and yet humanistic style reflects the Army's code of duty and honor for one's nation. In "The American Way" he depicts a touching scene of a soldier feeding a war orphan.

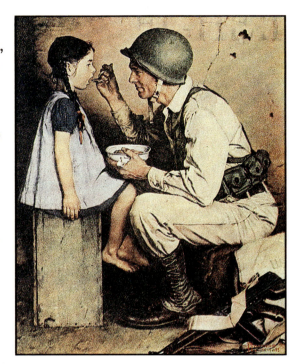

The oil painting "Let's Give Him Enough and On Time" was executed in 1943 for a war poster. Rockwell's neighbor at the time, retired Colonel Fairfax Ayers, arranged to have a machine gun and crew sent to the illustrator's studio. They arrived by jeep, and the gunner insisted that his weapon be pictured as spotlessly clean. He did allow Rockwell to tear his shirt, and the final poster represents one of our grand soldiers in a tough spot on the firing line.

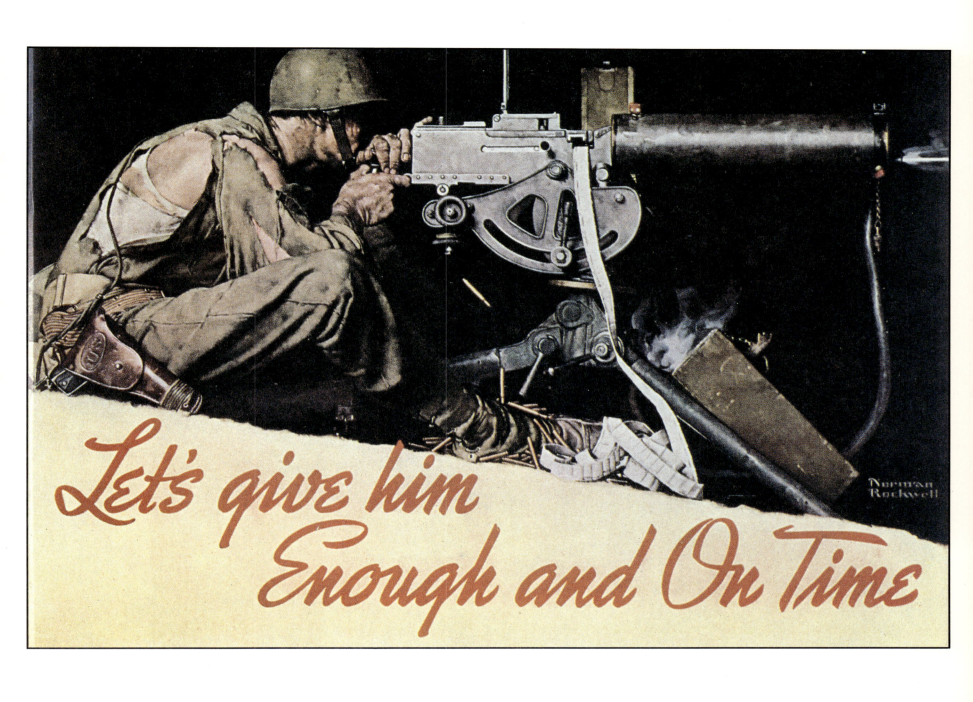

Let's give him
Enough and On Time

Norman Rockwell

DEPARTMENT OF THE NAVY

The United States Naval Academy is located in Annapolis, Maryland. It is a government-operated military college that educates and trains young men to become officers in the United States Navy and Marine Corps. The Academy occupies about 1,100 acres on the Severn River in Annapolis. It was founded in 1845 by George Bancroft, Secretary of the Navy under President James K. Polk. Students at the Naval Academy are called midshipmen. They attend the school for four years and are awarded a Bachelor of Science degree and commissioned as Ensigns in the Navy or Second Lieutenants in the Marine Corps.

As with every other school, the graduating class from the Naval Academy has a yearbook. In 1921 the Academy commissioned Norman Rockwell to paint a picture in honor of the Navy crew at the 1920 Olympic games to appear in their yearbook. This picture, "The Lucky Bag," appears on pages 320 and 321 of the yearbook.

Mr. Rockwell painted one other promotional picture for the Navy. It was entitled "Home from a Cruise." It was transferred to the Naval Academy Museum in 1924 from the Bureau of Navigation. The painting today hangs in the Museum Directors' Office.

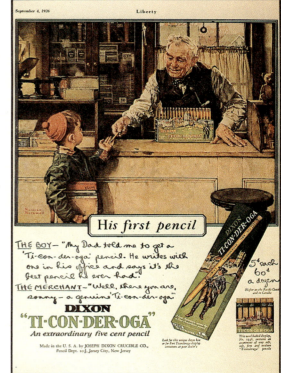

ort Ticonderoga on Lake Champlain in New York State was an important stronghold during the Revolutionary War. It commanded the invasion route by water from Canada.

When the fighting began, the Province of Connecticut ordered Ethan Allen to seize the fort from the British. On May 10, 1775, Allen led the Green Mountain Boys in a surprise attack in one of the most famous victories of the Revolutionary War. Fort Ticonderoga fell without any loss of life.

Twenty-four years later, Joseph Dixon was born in Marblehead, Massachusetts. He was an American inventor and manufacturer. He founded a factory to make lead pencils and stove polish from graphite in Salem, Massachusetts, in 1827. In 1832 he patented a process of using colored inks to prevent counterfeiting. After moving his factory to Jersey City, New Jersey, Mr. Dixon patented and introduced graphite crucibles for making pottery and steel in 1850.

Between 1926 and 1930, Norman Rockwell painted three pictures for the Dixon Company. These three oil paintings were used for advertisements and appeared in *Liberty* and *Collier's*. They were entitled, "You Are a Lucky Lad," "His First Pencil" and "Ticonderoga." In the "Ticonderoga" painting, Mr. Rockwell depicted two boys discussing the value of the Dixon Pencil with a picture of Ethan Allen in the background. One boy is explaining "Ethan Allen and his Green Mountain Boys took old Fort Ticonderoga without a fight, Jack, and this good old Ticonderoga Pencil licks all other pencils just as easy."

DUMONT

DUMONT LABORATORIES

Dumont Laboratories was one of the pioneers in television and in the early days of TV, Dumont television sets were seen in households throughout America. In 1950 Dumont contracted Norman Rockwell to create some advertisements, and these pictures appeared in *Better Homes and Gardens* and *Good Housekeeping* in December 1950, *Harpers Monthly* in August 1950 and *Life*, August 7, 1950, *National Geographic*, August 1950, and *The Saturday Evening Post*, August 19, 1950, and December 9, 1950. Although the name Dumont may not be familiar to today's generation of television viewers, Mr. Rockwell's advertisements will give the company a place in history.

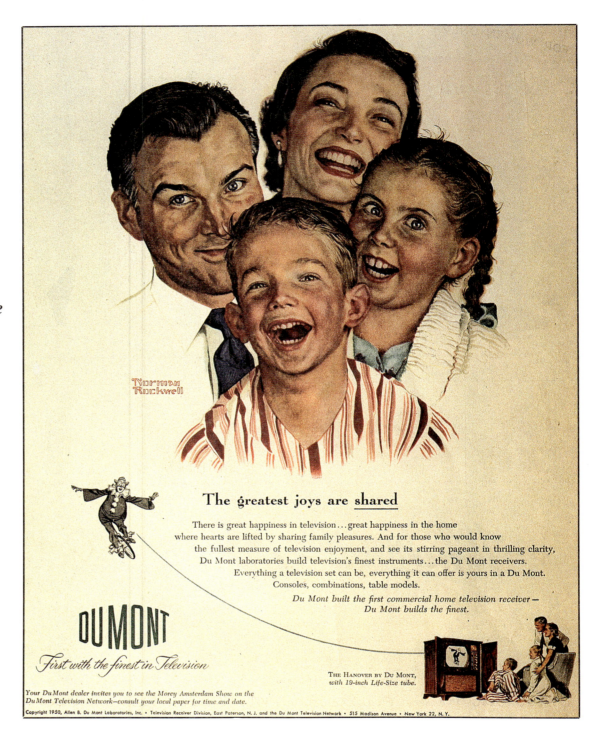

The greatest joys are shared

There is great happiness in television...great happiness in the home where hearts are lifted by sharing family pleasures. And for those who would know the fullest measure of television enjoyment, and see its stirring pageant in thrilling clarity, Du Mont laboratories build television's finest instruments...the Du Mont receivers. Everything a television set can be, everything it can offer is yours in a Du Mont. Consoles, combinations, table models.

Du Mont built the first commercial home television receiver — Du Mont builds the finest.

DU MONT

First with the finest in Television

THE HANOVER BY DU MONT, with 19-inch Life-Size tube.

Your DuMont dealer invites you to see the Morey Amsterdam Show on the DuMont Television Network—consult your local paper for time and date.

Copyright 1950, Allen B. Du Mont Laboratories, Inc. • Television Receiver Division, East Paterson, N. J. and the Du Mont Television Network • 515 Madison Avenue • New York 22, N. Y.

DUTCHESS TROUSERS

Old man Tracy, of Tracy and Tracy, was an aristocrat among gentlemen and Norman Rockwell's painting of Mr. Tracy wearing his new Dutchess Trousers while he plays a game of golf was a classic in Rockwell advertising art. The picture appeared in *American* in July 1926, in *Inland Printer* in February of 1928 and in *The Saturday Evening Post* on June 5, 1926. Mr. Rockwell did other advertisements for the Dutchess Trouser Company which appeared in *The Saturday Evening Post* on July 3, 1926, and in *Vanity Fair* in November of 1926.

OLD MAN TRACY, OF TRACY AND TRACY

EAGLE BRAND

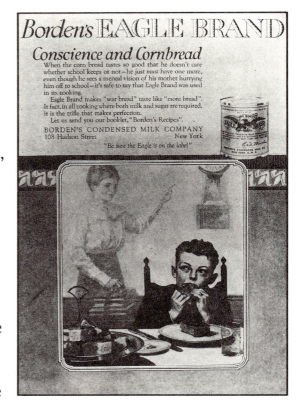

Although Borden is today a diversified company with four major divisions, its origin, like most great undertakings, was the idea of one man.

Gail Borden, Jr., the founder, was a rugged individualist and a great humanitarian. Prior to founding what was to become Borden, Inc., he already had enough careers to satisfy the most restless of men. He was at times a riverman, a school teacher, a surveyor, a government official, a newspaper publisher and an inventor. As surveyor he helped lay out the city of Covington, Kentucky. He published the first permanent newspaper in Texas and is credited with having coined the phrase "Remember the Alamo!" as a headline. He invented something called a "prairie schooner" which was a wagon with sails, a "lazy susan" table, and a product he called a meat biscuit that went to California with the miners in the Gold Rush of 1849.

His biscuit won him a gold medal, presented by Queen Victoria, at the Great Council Exposition in London in 1851. On the long sea voyage back home Borden was deeply affected by the sight of babies deprived of fresh milk because the cows kept aboard ship were too seasick to be milked. He set out to discover a method of preserving milk—a technique that had escaped the best minds since the discovery of cheese thousands of years before.

Two years later, in 1853, he had a satisfactory product: pure fresh milk with most of the water removed under vacuum at low temperature, and sugar added as a preservative. He called it condensed milk and later gave it the name "Eagle Brand." His original vacuum pan is now part of the permanent collection of the Smithsonian Institution in Washington, D.C.

In 1856 Gail Borden received his patent on condensed milk and that same year set up a factory in an abandoned carriage shop in Wolcottville, Connecticut. He opened a sales office in New York City, designed most of the machinery, ran the factory, and sold the milk products from a pushcart on the New York streets.

In 1918 the Borden company, in an attempt to promote condensed milk, commissioned Norman Rockwell to do some advertisements. Two paintings were done, one "Conscience and Cornbread" and the other "Head of the Class" appeared in 1918 in *Delineator*, *Ladies' Home Journal*, *St. Nicholas* and *Youth's Companion*.

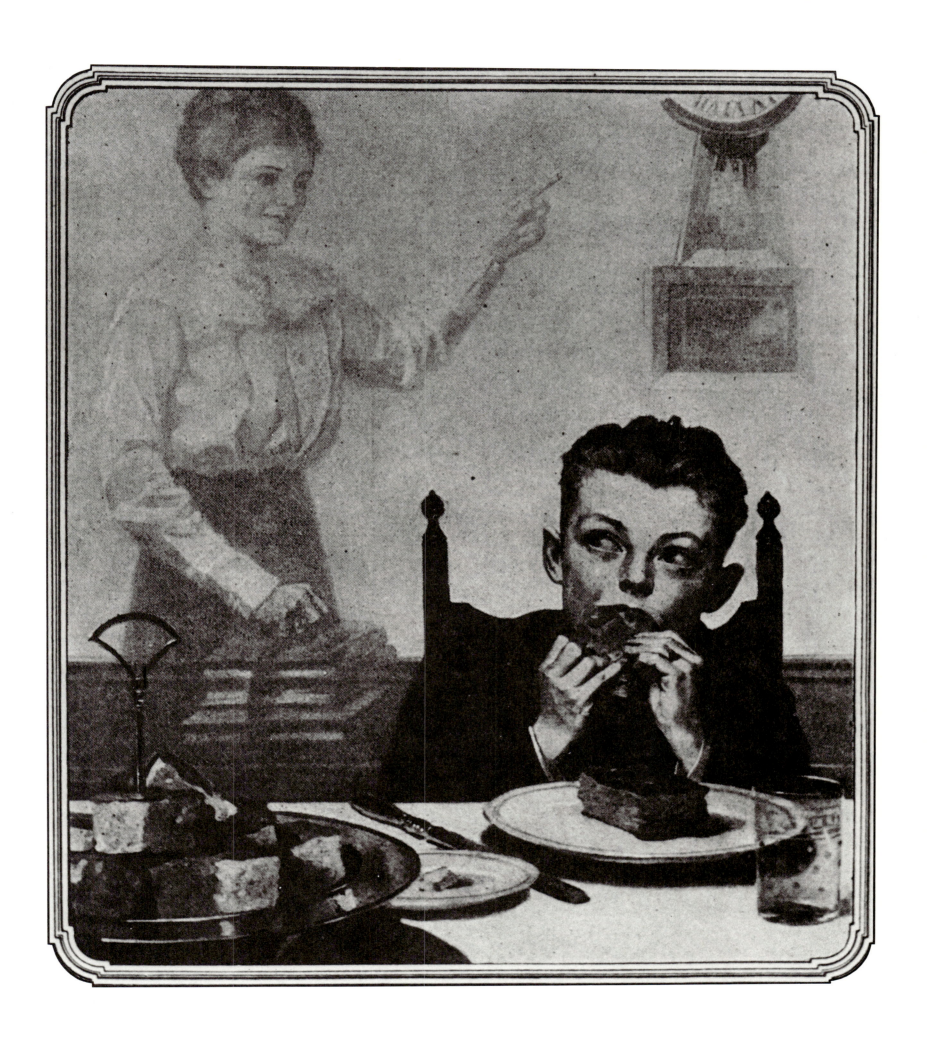

EDISON MAZDA

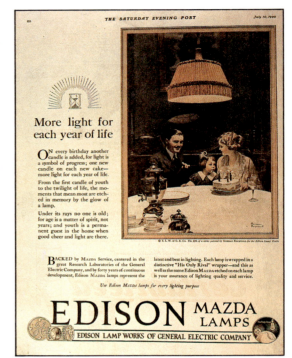

Thomas Alva Edison was born in Milan, Ohio, on February 11, 1847. He was the youngest of seven children of Samuel and Nancy Edison. His father was a shingle manufacturer with a prosperous business in Canada, but was forced to leave during the rebellion of 1837 when Thomas was seven years old. The family moved to Port Huron, Michigan, where young Tom was enrolled in school. After three months he was taken out of school because he disrupted the classroom with so many questions. That was the end of his formal education, with the rest of his learning coming from his parents. At the age of twelve he got a job on the Grand Trunk Railway selling newspapers, sandwiches and peanuts. One day at the Mount Clemens, Michigan, station, young Edison noticed a freight car rolling towards the station agent's son. Young Tom jumped in front of the train and rescued the boy just in time, and the grateful station agent taught him how to use the telegraph key and gave him his first job as a telegrapher.

It wasn't long before Tom was looking for ways to improve the telegraph machine, and as soon as this was done, many new ideas poured forth from his very inventive mind. In 1876 Edison started what he called his "Invention Factory" in Menlo Park, New Jersey. From this laboratory a flood of inventions and improvements flowed and he became known as "the Wizard of Menlo Park." It was in this laboratory that he created the phonograph and improved the incandescent lamp. In the years that followed he worked on motion picture devices and contributed to the development of sound movies. He also worked on a telephone transmitter and a mimeograph machine and in 1849 he sold his patents for a new stock ticker for $40,000. In his lifetime he is credited with more than 1,300 inventions.

In 1887 Edison moved his laboratory to a larger, more modern facility in West Orange, New Jersey. His earlier company was known as The Edison Electric Light Company, which grew into the Edison General Electric Company. In 1892 the company merged with the Thomas-Huston Electric Company to form General Electric.

Some of his later inventions included the dictaphone, a duplicating machine, the storage battery, a cement mixer and a method of making synthetic rubber from goldenrod plants. Thomas Edison continued working in his laboratory and contributing to society until his death on October 18, 1931, in West Orange, New Jersey.

In 1920 Edison-Mazda, the Lamp Division of General Electric, commissioned Norman Rockwell to do a series of advertisements for their product. These beautiful paintings, which have become classics in Rockwell art, appeared in *Good Housekeeping* in March, May, October and December of 1925 and in *Ladies' Home Journal* in June, August and October of 1922 and April, September, October, November of 1925. Between 1920 and 1925, these advertisements brightened the pages of *The Saturday Evening Post* on fifteen occasions.

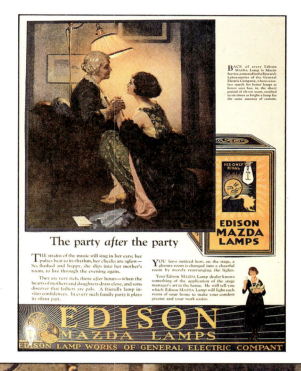

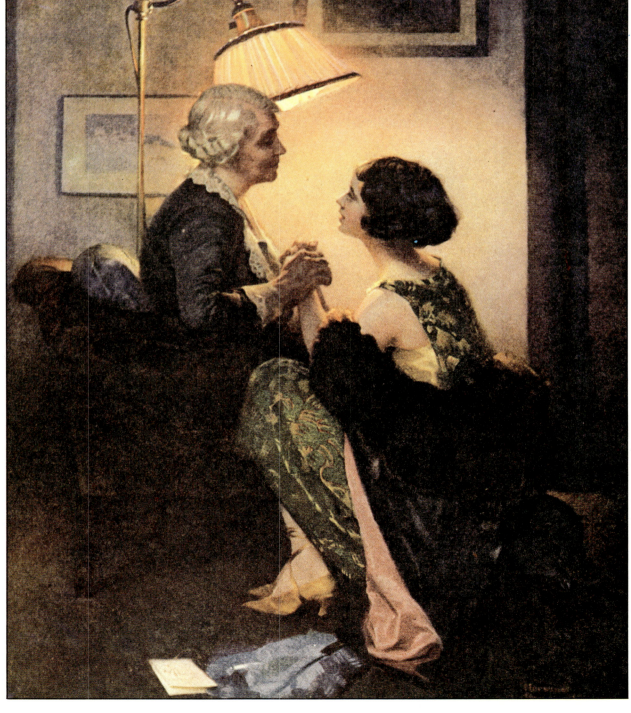

ELGIN WATCHES

On August 18, 1864, Benjamin W. Raymond, then mayor of Chicago, and a board of six directors, founded the National Watch Company, later to be known as the Elgin National Watch Company. The site chosen for the factory was a small town, 40 miles from Chicago, called Elgin.

The National Watch Company opened for business in a crude frame building so rickety it had to be supported by heavy timber. Despite the condition of the factory, Mr. Raymond demanded from the very first hour that his watches be high-quality timepieces. Thus, it was not surprising that it took three years to produce the first watch movement. On April 1, 1867, the first watch was completed and named for B.W. Raymond. Two years later the first Lady Elgin was produced. This was an engineering breakthrough because of the size reduction, although it was the size of one of today's men's pocket watches. The next step in engineering progress was the elimination of the key to wind the watch. In 1873 the company produced its first stem-wound watch, which was enthusiastically accepted by the watchmaking trade and consumers.

In 1874 the board of directors changed the company name to the Elgin National Watch Company. This was partially based upon the wide popular usage of the name Elgin when referring to the watches produced in this city. The demand was great for the reliable watches, which enjoyed widespread popularity, especially among railroad workers, because of the renowned accuracy.

By the 1870s Elgin Watches had become fashionable. Sophisticated advertising was running in *The Saturday Evening Post* and other national publications. Among the ads produced was the Norman Rockwell illustration. Correspondence with descendants of early Elgin purchasers has proven that not only did "she say it for a lifetime," but for several generations.

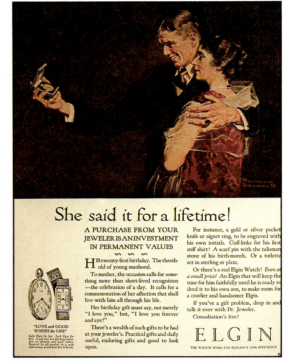

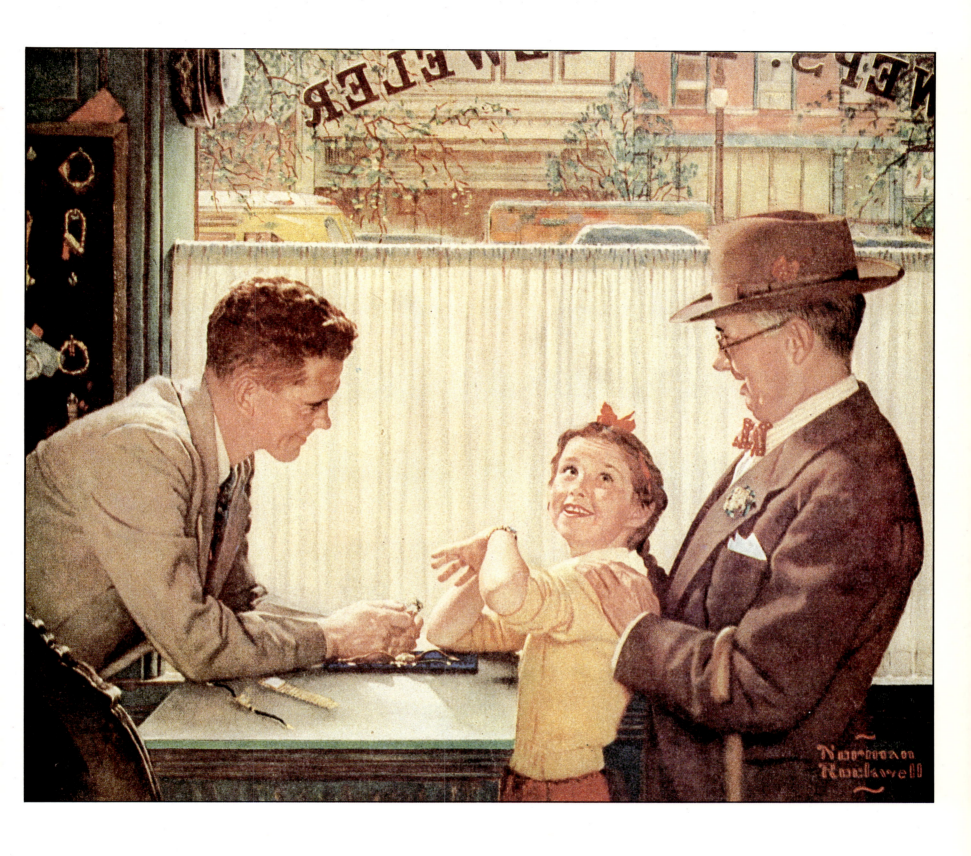

ENCYCLOPAEDIA BRITANNICA

In 1925 readers of the *Literary Digest* were fascinated by a Norman Rockwell painting depicting two elderly gentlemen arguing over a disputed fact. As one man, portrayed by James K. VanBrunt, a friend of Norman Rockwell's who was used as a model on several *Saturday Evening Post* covers, violently expresses his opinion, the other gentleman calmly proceeds to settle the argument by looking in the *Encyclopaedia Britannica*.

The word "encyclopaedia" did not come into common use until the 1700s. It came from a Greek word which means "teaching in the circle of arts and sciences." As man learned more about himself and the world in which he lives, he began to write about what he learned. This information on many subjects was scattered in thousands of books and manuscripts in various parts of the world. As a result, it was difficult for people to find easily what they wanted to know and learn. The encyclopaedia was the answer, because it brought such information together in one place where it could be found readily. The *Encyclopaedia Britannica* was first published in Great Britain between 1768 and 1771. It was published in 100 installments by a society of gentlemen in Scotland.

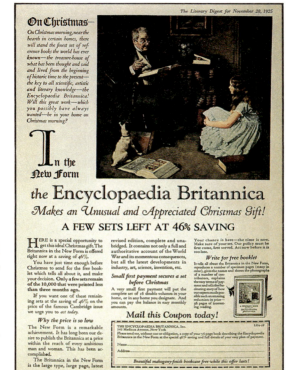

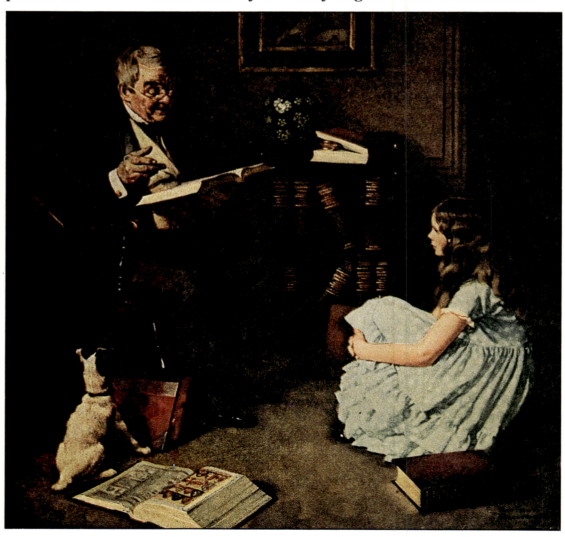

KNOW

A Magazine For Britannica People Everywhere

I QUARTER 1980

FISK TIRES

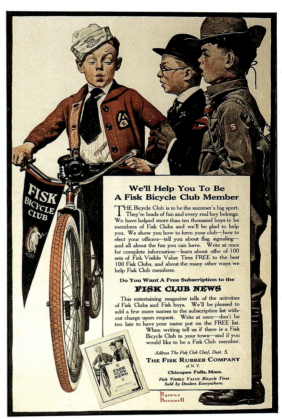

In 1917 the Fisk Tire Company of Chicopee Falls, Massachusetts, challenged Norman Rockwell to do a series of advertising paintings for Fisk Tires. The company was producing rubber tires for automobiles and bicycles and did extensive advertising in several magazines. The slogan "Time to Re-Tire" was very popular and caught the fancy of Mr. Rockwell's sense of humor. The series that he did for the Fisk Company was among his most popular. The Fisk Bicycle Tire advertisements appeared in *American Boy* from 1917 to 1919. The company started a bicycle club which was extremely popular among young boys, and Mr. Rockwell's ad of kids on bikes increased its popularity. The advertisement also appeared in the *Christian Herald* in 1917, the *Literary Digest* in 1917, *St. Nicholas* magazine in 1918, and in *Youth's Companion*. Mr. Rockwell was called upon again for another series of advertisements which ran in 1924 and appeared in *Country Life*, *Liberty*, *Theatre* and *The Saturday Evening Post*.

Later, Fisk Tire Company became part of Uniroyal, Inc., formerly the United States Rubber Company. Today many of Mr. Rockwell's famed Fisk Tire ads still hang in the Uniroyal plant in Chicopee, Massachusetts, which was formerly the Fisk Tire plant.

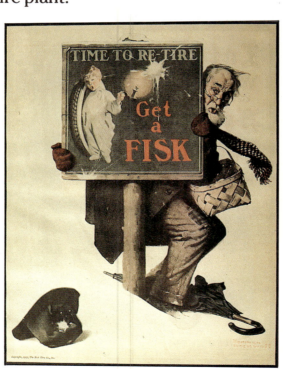

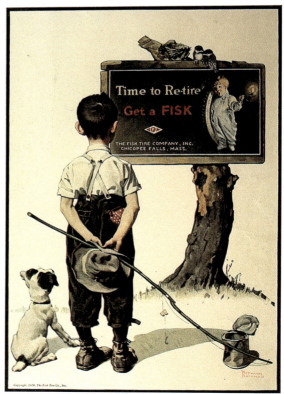

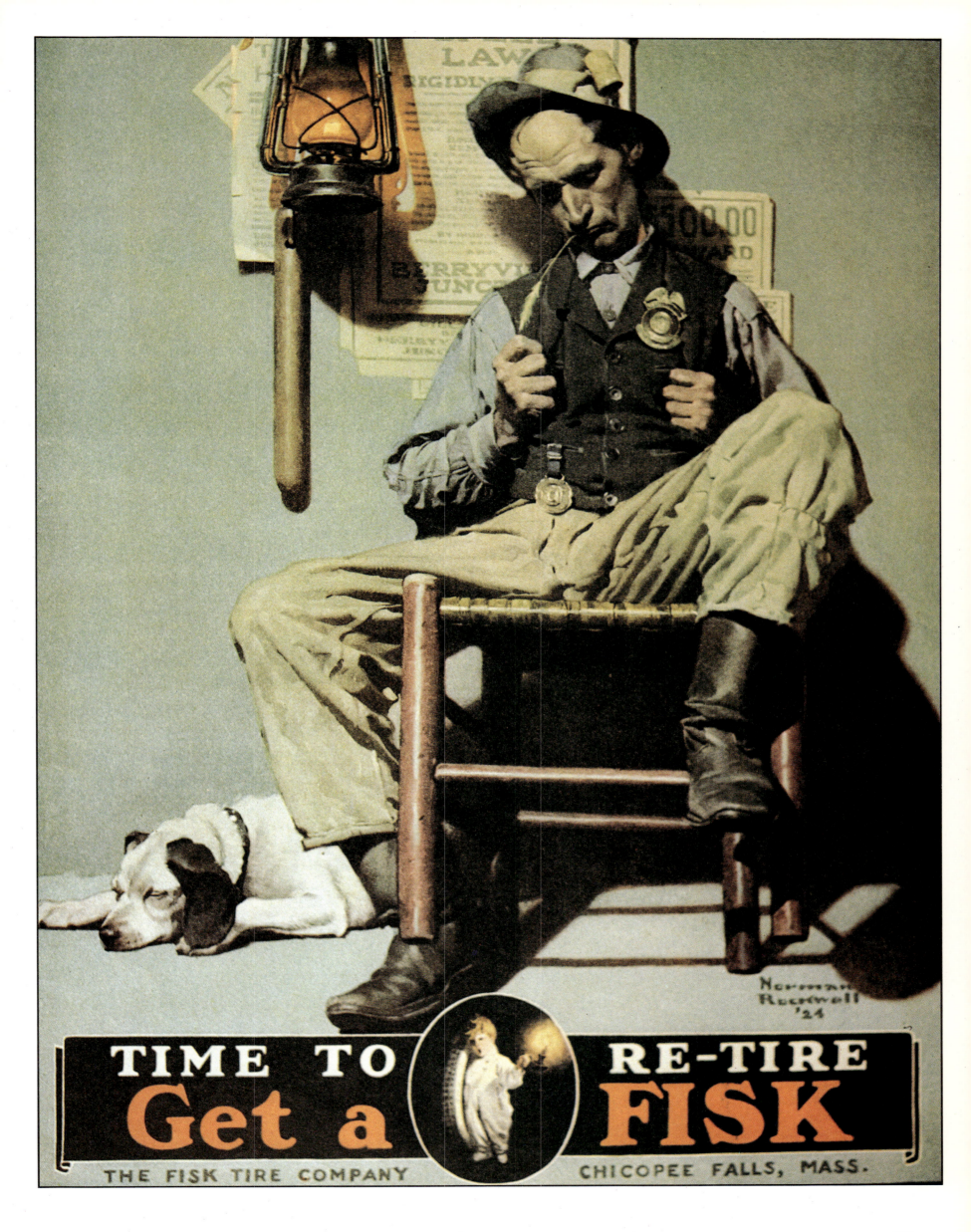

FLEISCHMANN YEAST

Sometime after the beginning of the Civil War in 1861, a young Austrian by the name of Charles Fleischmann, came to America. Astonished by what he considered to be the poor taste of American bread, he went back to Austria to collect samples of the yeast being used in making Viennese bread, and later returned to the United States with his brother Maximilian. The Fleischmann brothers were intent on starting a business using Austrian yeast, and shortly thereafter, met James M. Gaff, a well-known Cincinnati distiller, and the three of them went into business as Gaff, Fleischmann and Company. In 1868 the firm began manufacturing the country's first standardized yeast, a product that would revolutionize breadmaking in America.

The advantage of the new yeast was that it was created under rigid controls. Contrary to American yeast, which was made in a haphazard manner, each batch of Gaff-Fleischmann yeast was of the highest quality, and the bread made from their yeast was far superior to the American bread.

Two years after the formation of the company, they entered the liquor field, and the Fleischmann Distilling Company began producing America's first distilled gin.

In 1876 the Fleischmann brothers showed off their yeast at a special "Vienna Bakery Booth" at the great Centennial Fair in Philadelphia. Visitors were so impressed with the product that the demand for Fleischmann yeast soared, and plans were made for a new factory in Peeksilll, New York. Shortly after the death of James Gaff, the firm's name was changed and in 1905 it became The Fleischmann Company.

In 1920 the company contracted Norman Rockwell to paint an advertisement. The wonderful picture "Bread and Ambition," which stated that nearly all bakers use Fleischmann Yeast because it makes the best bread and bread is essential for good nourishment and success, appeared in the October, 1920, issue of *Ladies' Home Journal*.

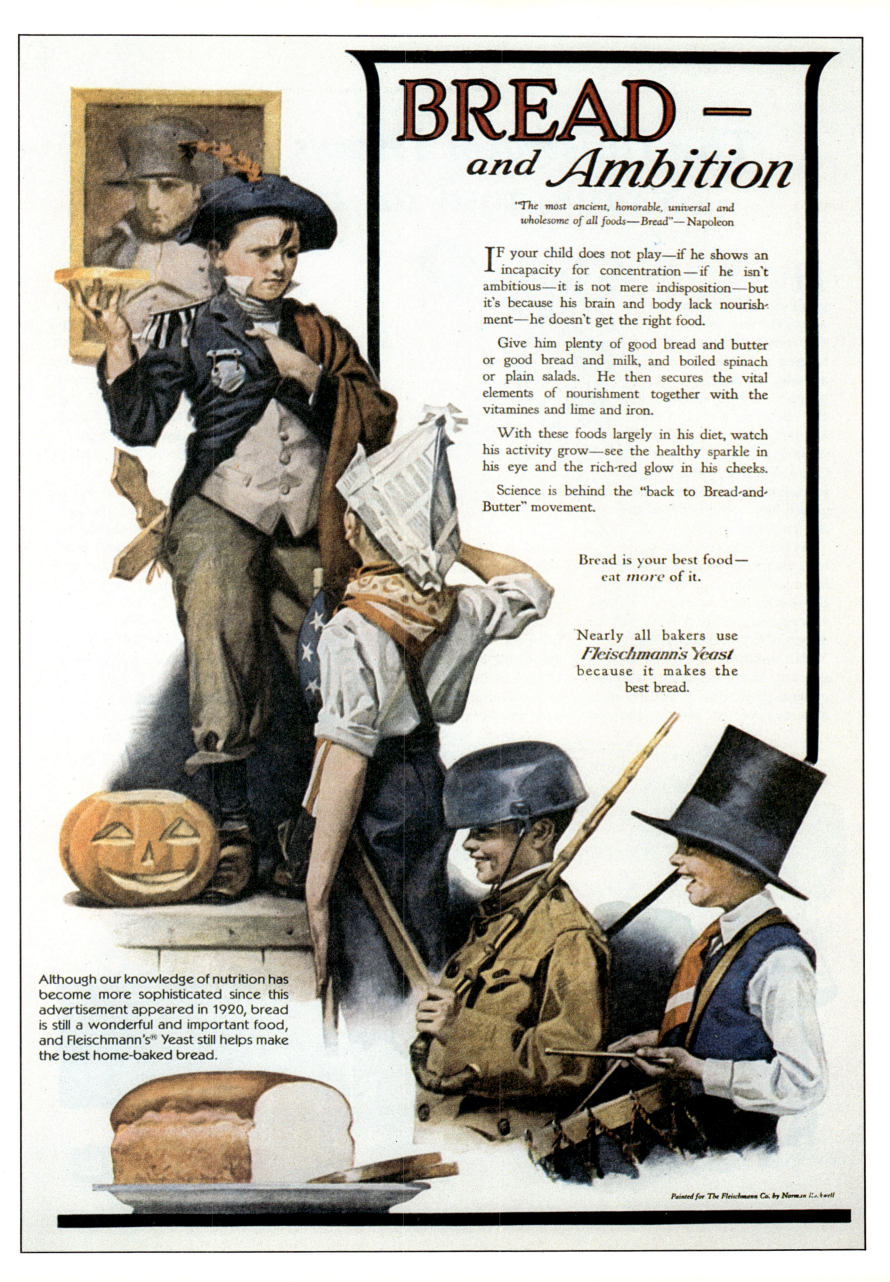

FORD MOTOR COMPANY

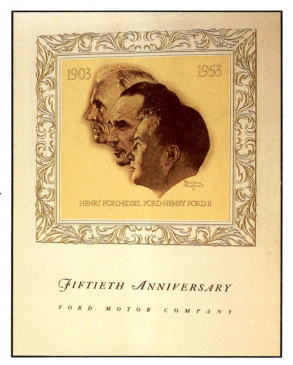

On June 16, 1903, Henry Ford and eleven associates started the Ford Motor Company in a small former wagon factory in Detroit. Their assets consisted primarily of tools, machinery, plans, blueprints, patents and $28,000 in cash. The twelve stockholders included a coal dealer, his bookkeeper, a banker, two brothers who owned a machine shop that supplied the engines and running gear for the new car, a carpenter, two lawyers, a clerk. the owner of a small store, a man who manufactured rifles, and Henry Ford.

The first car produced in this small factory sold for $850. In the first fifteen months, 1,708 Model A Fords were produced in the tiny factory.

Between 1903 and 1908, the company produced nineteen experimental cars—from Model A to Model S. The first successful car was Model N, a small four-cylinder machine that sold for $500.

In 1908 the Model T came to life. Henry Ford called it "The Universal Car," and during the first year 10,660 copies of the affectionately called "Tin Lizzie" drove out of the Ford factory. The car originally sold for as low as $260, but with extras, the average price came to about $400.

By 1913 Ford was producing about one-half of all the automobiles in the United States, but still wasn't meeting the demand. Building each car by hand was too time-consuming. After three years of trial and error, he and his staff devised the assembly line—a mass production system which made it possible to turn out all the cars people wanted at prices they could afford. During the 19 years of its production, more than 15 million Model T Fords were sold in the United States alone.

Through the decades that followed, the Ford Company continued to prosper and became a world-wide organization. Mr. Ford passed the reins of leadership on to his son Edsel in 1919, and then to Henry Ford II, his grandson, in 1943 when Edsel died. Having relinquished the company's operation to his grandson, Mr. Ford lived quietly with his wife Clara until he died on April 7, 1947, at age 83.

In 1953 the Ford Motor Company commissioned Norman Rockwell to create a series of paintings depicting the life and times of Henry Ford. In addition to appearing on the cover of several magazines distributed by the Ford Company, they also appeared as full-page ads in many major magazines in 1953. The ads appeared in *Harper's Monthly*, July 1953; *Life*, January 26, June 15 and August 3, 1953; *Newsweek*, January 19, April 6 and June 15, 1953; *The Saturday Evening Post* on January 17, March 28 and June 13, 1953. These advertisements commemorated the 50th anniversary of the Ford Company, and for that occasion Mr. Rockwell also painted a portrait of Henry Ford, Edsel Ford and Henry Ford II, which appeared in various ads and on a calendar.

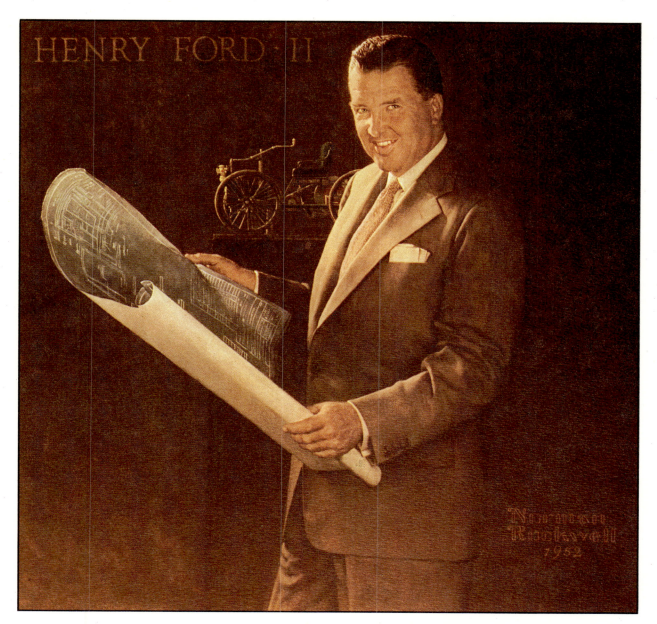

GENERAL MOTORS ACCEPTANCE CORPORATION

General Motors Acceptance Corporation, a wholly-owned subsidiary of General Motors Corporation, provides financing services to General Motors dealers and their customers. Since its formation in 1919, GMAC has extended almost $200 billion in automotive credit to help people buy more than 80 million vehicles "on time."

In the late 1930s, several Norman Rockwell paintings were used as illustrations in advertisements for GMAC's retail financing services. The "wise gentleman" was chosen to show that the smart car buyer compares financing costs and then chooses GMAC financing.

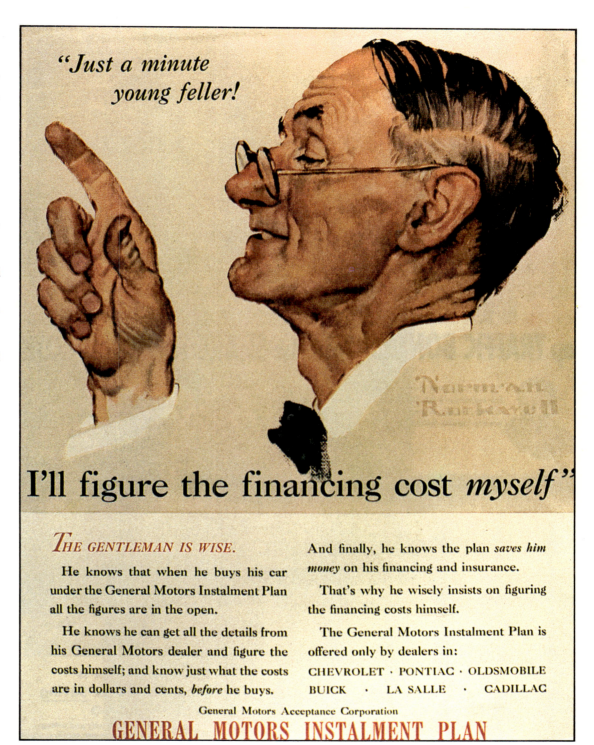

"*Just a minute young feller!*

I'll figure the financing cost *myself*"

THE GENTLEMAN IS WISE.

He knows that when he buys his car under the General Motors Instalment Plan all the figures are in the open.

He knows he can get all the details from his General Motors dealer and figure the costs himself; and know just what the costs are in dollars and cents, *before* he buys.

And finally, he knows the plan *saves him money* on his financing and insurance.

That's why he wisely insists on figuring the financing costs himself.

The General Motors Instalment Plan is offered only by dealers in:

CHEVROLET · PONTIAC · OLDSMOBILE
BUICK · LA SALLE · CADILLAC

General Motors Acceptance Corporation
GENERAL MOTORS INSTALMENT PLAN

BFGOODRICH

The first rubber company west of the Allegheny Mountains came into existence in 1870, when Dr. Benjamin Franklin Goodrich moved the machinery of a small firm from the banks of the Hudson River to Akron, Ohio. As head of the new company, Dr. Goodrich drew on the knowledge of chemistry he had gained in the study of medicine to improve and increase the firm's rubber formulas. As a result, the BFGoodrich Company soon became recognized for its technical competence and product quality.

But Dr. Goodrich soon learned that more than product quality was needed to boost sales. In 1881 he hired an advertising specialist who began sending sales letters to prospective customers. With the improvement of photoengraving and lithography in the late 1800s, the company began commissioning noted artists to produce paintings for its advertising. This program produced the long-remembered "Goodrich Girls," paintings of beautiful women that graced the company's ads, calendars, handbills and catalogs for roughly 15 years.

When the career and reputation of Norman Rockwell began to bloom in the early 1920s, it was natural for BFGoodrich to turn to him to illustrate some of its ads. It is interesting that the Rockwell ads for Goodrich were for publication in *St. Nicholas*, the magazine in which Norman Rockwell made his professional debut. His earlier illustrations in *St. Nicholas* had earned Norman Rockwell a reputation as "the artist who knows boys." It was this reputation as well as the artist's talent that BFGoodrich bought when it commissioned Norman Rockwell to create art for its bicycle tire advertising.

In conjunction with publication of two Rockwell illustrated ads in May and June of 1920, BFGoodrich distributed the Norman Rockwell illustrated *Boys' Book of Sports*, a well-known compendium of sports information.

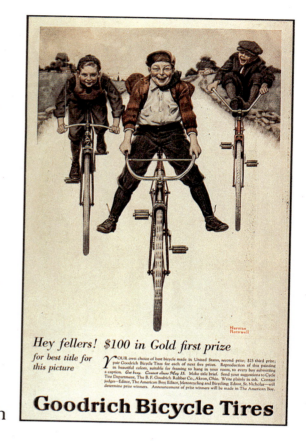

Hey fellers! $100 in Gold first prize for best title for this picture

Goodrich Bicycle Tires

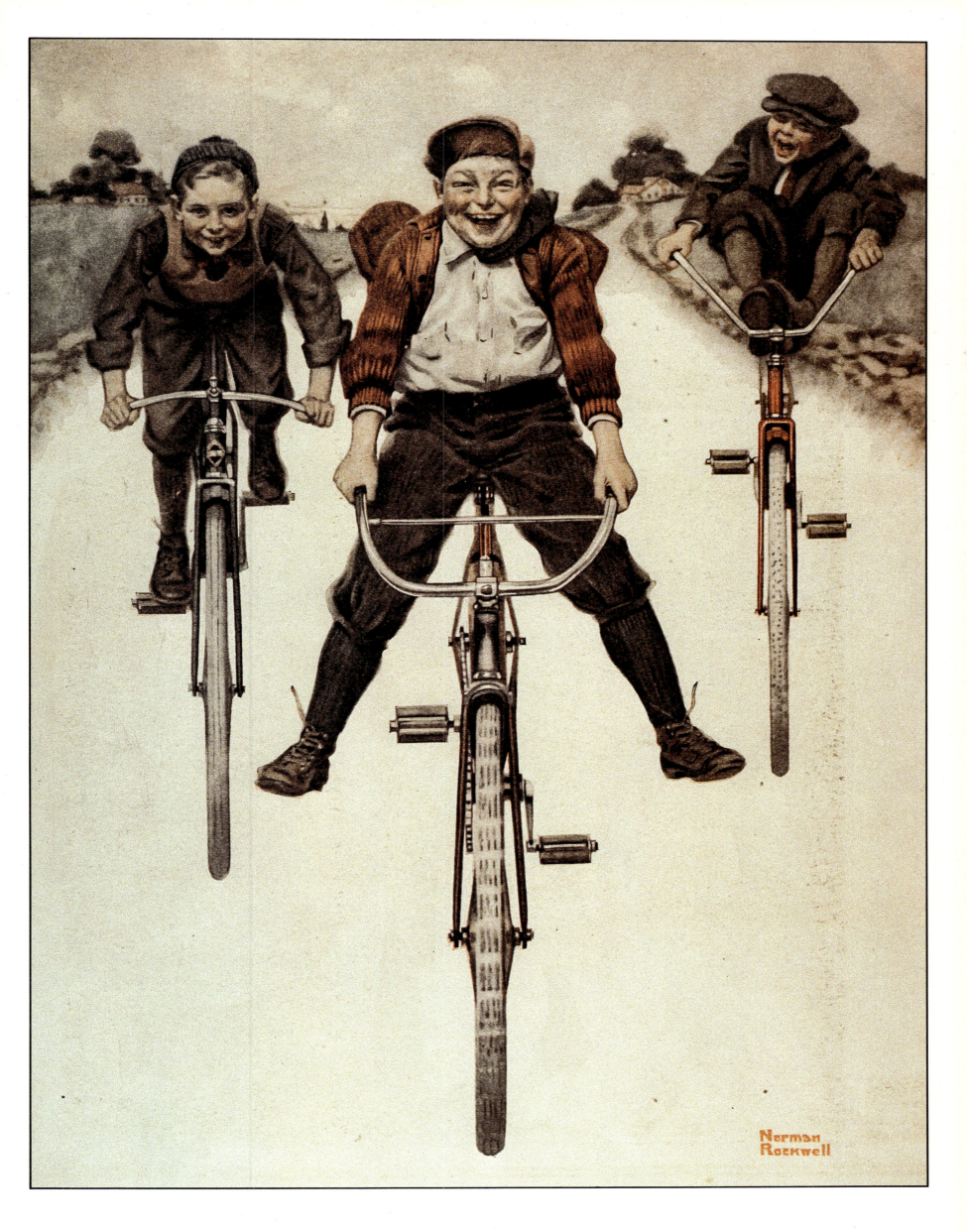

GOODWILL INDUSTRIES

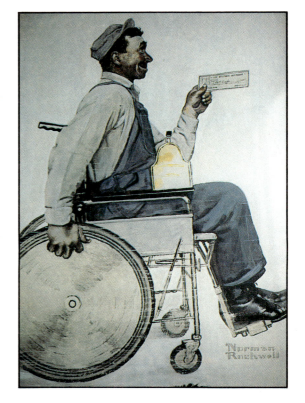

Goodwill Industries is a national organization dedicated to providing gainful employment for handicapped persons. Its headquarters is in Washington, D.C. Until 1958, the symbol for Goodwill Industries was a cartoon character named Goodwilly that was drawn by the famous cartoonist Milton Caniff, who produced "Terry and the Pirates." In 1958, the organization discussed the possible use of a new symbol and contacted Norman Rockwell. After several months of serious thought, Mr. Rockwell began his painting of a handicapped person in a wheelchair holding his first paycheck.

Bill Obanhein, a policeman in Stockbridge, Massachusetts, posed for the disabled worker, and in order to get the check as accurate as possible, Mr. Rockwell asked a local artist from Pittsfield, Massachusetts, to draw the check from "The First National Bank of Pittsfield." The check was signed by Richard L. Swanson, Executive Director of the local Goodwill Organization.

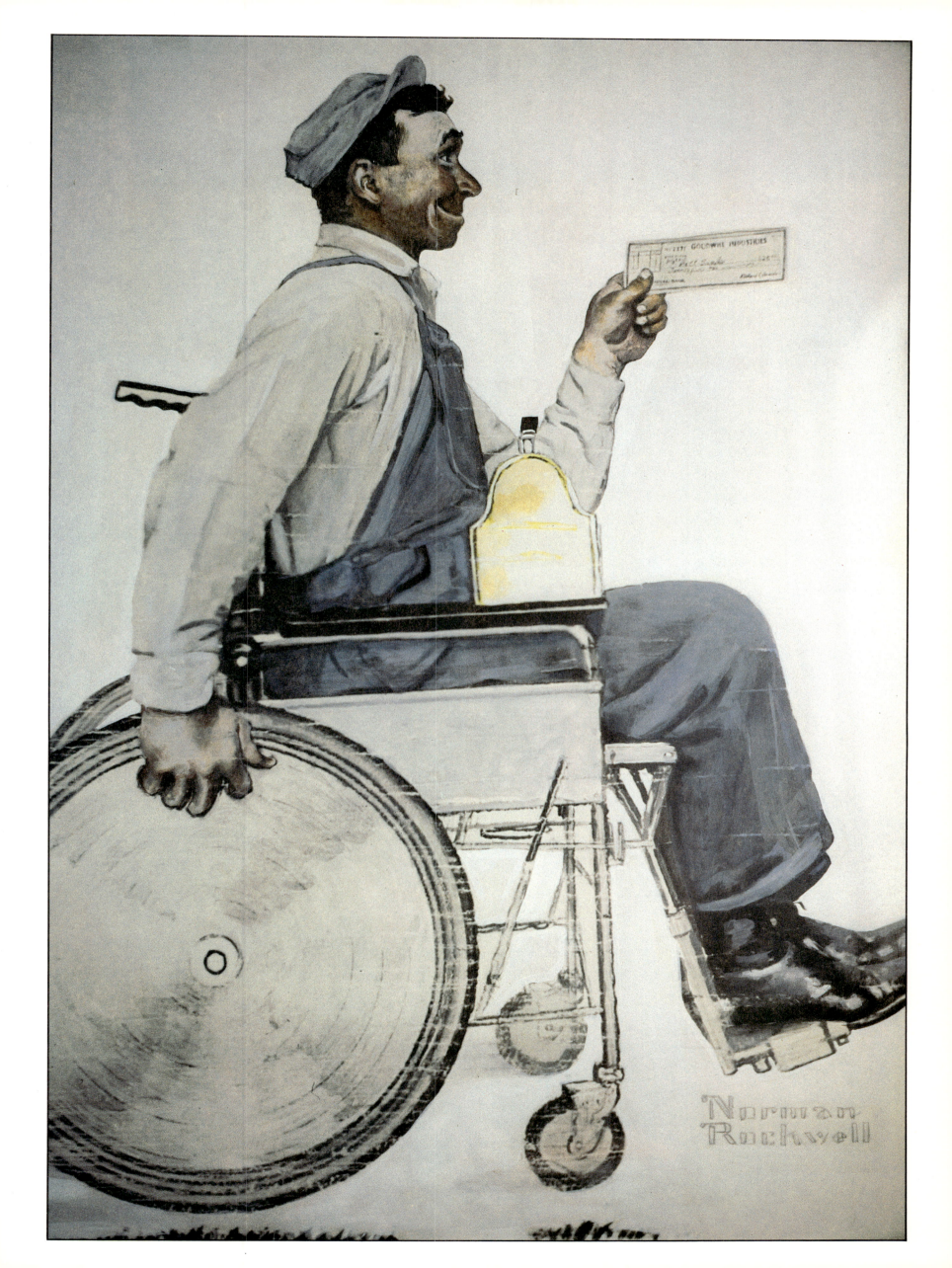

GREEN GIANT

Few companies enjoy a heritage as rich as that of Green Giant. One regrets that the group of small-town merchants who began the adventure wasn't able to witness what has happened to their $6,700 investment made back in 1903.

The rich Minnesota valley was ideally suited to the growing of sweet corn; the farmers of the area were interested in a new cash crop; and the cities of the East provided a ready market for this native American vegetable.

In the beginning it was mostly pluck and a good bit of luck that kept the company alive and growing, but then a few principles of marketing philosophy began to emerge: Strive for distinctiveness. Set Green Giant products apart from the run of commodities. Build in uniformity of quality, flavor, tenderness and nutritional value. Constantly advertise these attributes to the American homemaker. And constantly advertise they did. In 1935 Green Giant contracted for the services of an advertising agency, Leo Burnett Company, and have continued this relationship to the present.

Between 1938 and 1940 Green Giant, now a subsidiary of the Pillsbury Corporation, commissioned Norman Rockwell to prepare several paintings for their advertising campaign. They appeared in *The Post*, *McCall's*, *Good Housekeeping*, *This Week* supplement and *Life*. In the *Life* ad, readers could send in for prints of the paintings.

Corn on the cob was the subject in all three paintings. Actually, Rockwell was asked to paint canvasses featuring peas as well. He gently but firmly refused, saying that in his estimation peas were not a romantic subject.

The subject of food is central in a number of Rockwell's best-known works. Rockwell's own zest and poignancy come through vividly in his paintings. So does the sincerity, the honesty and the truth with which he portrays his subjects.

GUILD ARTISTS BUREAU

The Guild Artists Bureau, an organization composed of several hundred of the best free-lance artists, was located on 47th Street in New York City. One of the advertisements created for the Bureau was done by Norman Rockwell, which gave readers an idea of the caliber of the illustrious gentlemen who belonged to this organization.

AN AGE OF SPECIALISTS

The Free Lance Status of an artist is developed thru his ability to specialize. He is the one who originates the distinctive illustrations appearing in the editorial and advertising pages of the magazines. His work always remains outstanding, even though there may be many imitators.

The work of several hundred of the best free lance artists, members of the Artists Guild, is now easily available through the Guild Artists Bureau.

We invite you to call upon us for the work of these specialists.

THE GUILD ARTISTS BUREAU INC.
GEORGE BAKER, *President*
10 West Forty-seventh Street, New York City
LOngacre 3-2233

HALLMARK CARDS

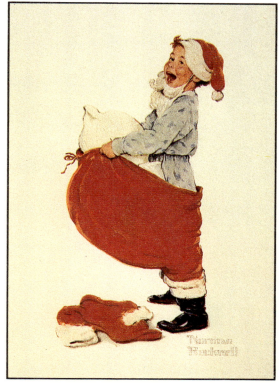

Joyce Clyde Hall was an American businessman who was born on December 29, 1891, in David City, Nebraska. While still in high school, he began selling postcards, a business which intrigued him, and after graduating in 1910, he opened up a greeting card business with his brother in Kansas City, Missouri. By 1916 the Hall brothers had purchased an engraving plant to produce their own Hallmark brand cards. In the years that followed, the company grew rapidly and because of their flair for marketing and the great popularity of greeting cards, the company continued to expand and prosper over the next several decades. By 1968 Hallmark was the largest manufacturer of greeting cards in the world, and produced more than one billion Christmas cards each year.

Hallmark was the first line of greeting cards to use the works of well-known artists. And of all their cards, the most popular were those painted by Norman Rockwell. In 1911, Mr. Rockwell began his illustrious career by painting four Christmas cards. However, as his fame grew and his commissions for magazine illustrations and advertising took up most of his work, he did not devote any more time to sketching Christmas cards, except for his own personal use, until 1948 when he was commissioned by Hallmark cards. This series was so popular that he received another commission in 1975 from Hallmark to create a new series. These cards are still extremely popular and are the most recognized and most cherished of all Christmas cards that are delivered each year.

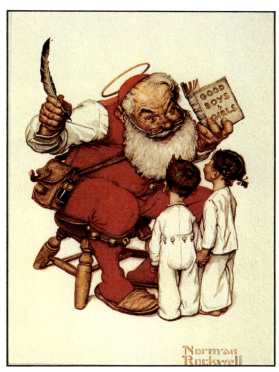

In 1951 a great flood covered Kansas City. During the crest of the flood, Norman Rockwell called Mr. Hall and asked what he could do for his friends during the catastrophe. Joyce Hall asked him to paint a picture of "The Kansas City Spirit" that would forever symbolize that something in good men's hearts makes them put service above self and accomplish the impossible. After several trips to Kansas City, Norman Rockwell and another famous *Saturday Evening Post* artist and close friend, John Atherton, created the inspired masterpiece "Kansas City Spirit," which Mr. Hall called one of the finest pictures that has ever been contributed to art in our times. After a tour of the country, the original painting was hung in Kansas City as a reminder to future leaders of all communities that not only the Kansas City spirit but the American spirit is a thing that makes our cities, our country and our individuals great.

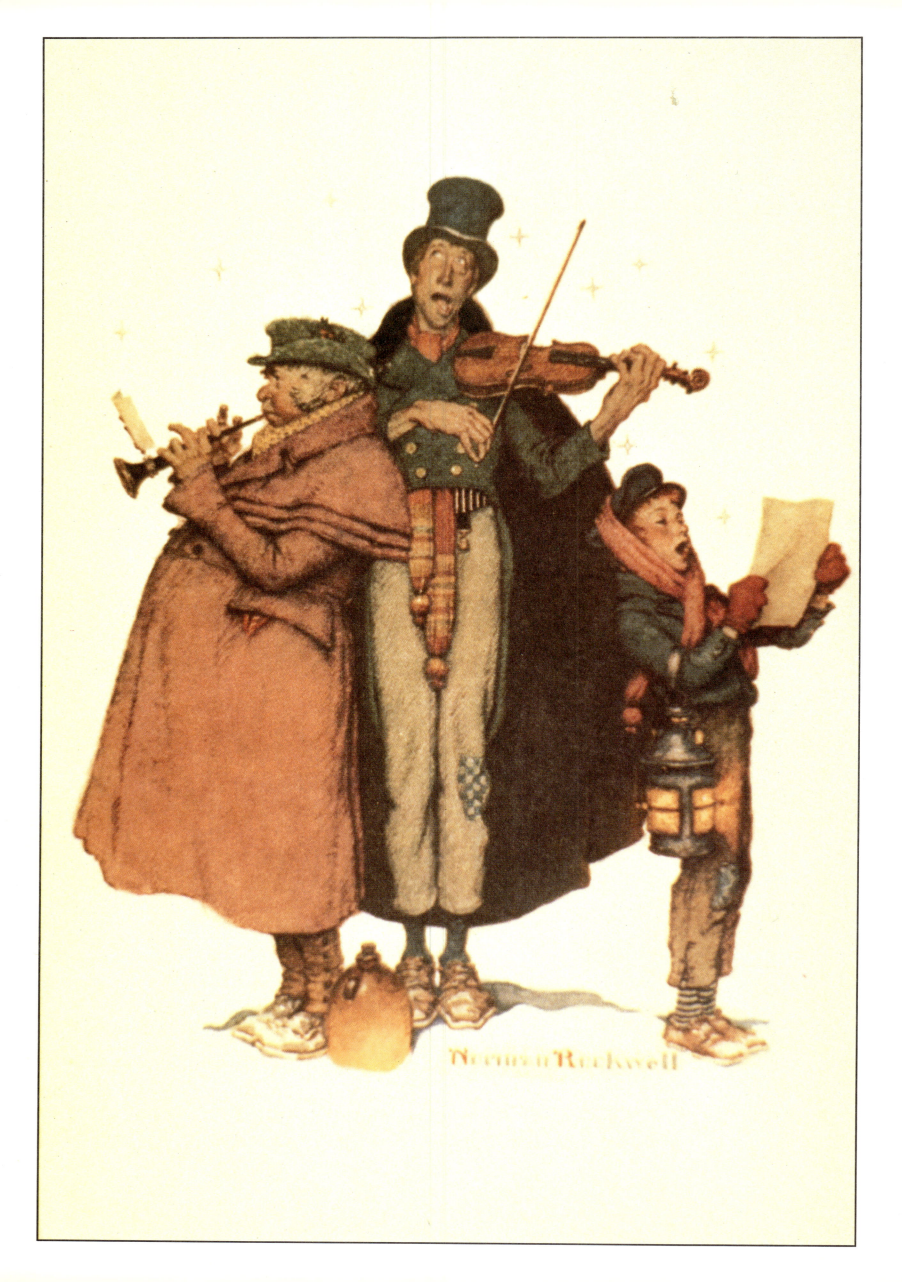

HEILEMAN BREWING

The G. Heileman Brewing Company had its beginning on January 6, 1824, when Gottlieb Heileman was born in Wurttemberg, Germany.

Trained as both a master baker and a master brewer, Gottlieb left his native land when he was 28 years old and sailed for the new world.

Residing first in Philadelphia, and then in Milwaukee, Wisconsin, where he operated a bakery for several years, Heileman then moved to La Crosse and became involved in the brewing industry. Under his guidance the "City Brewery" grew and was quite successful. On February 19, 1878, Mr. Heileman died and his wife Johanna became one of the first woman presidents of a corporation in the state of Wisconsin. She continued in that capacity until her death in 1917.

With the enactment of the Eighteenth Amendment, "National Prohibition," the company directed its attention to the production of near beer (nonalcoholic beer) and soda pop. When beer was again legalized after the passage of the Twenty-first Amendment, the brewery spent much money to rehabilitate and refit the long-inactive brewing facilities. Consequently, a Chicago-based investment company, Paul H. Davis & Company, became heavily involved in the affairs of the brewery. This continued until control was returned to the stockholders by Roy E. Kumm, who was elected president in 1956.

As the company continued to grow and production became greater every year, more money was allocated for advertising. At one point Norman Rockwell was commissioned to do a painting for Schmidt's City Club Beer, which is one of the many products produced by the House of Heileman. This beer was one of the top sellers in the state of Minnesota and with the publication of Mr. Rockwell's picture it received national acclaim.

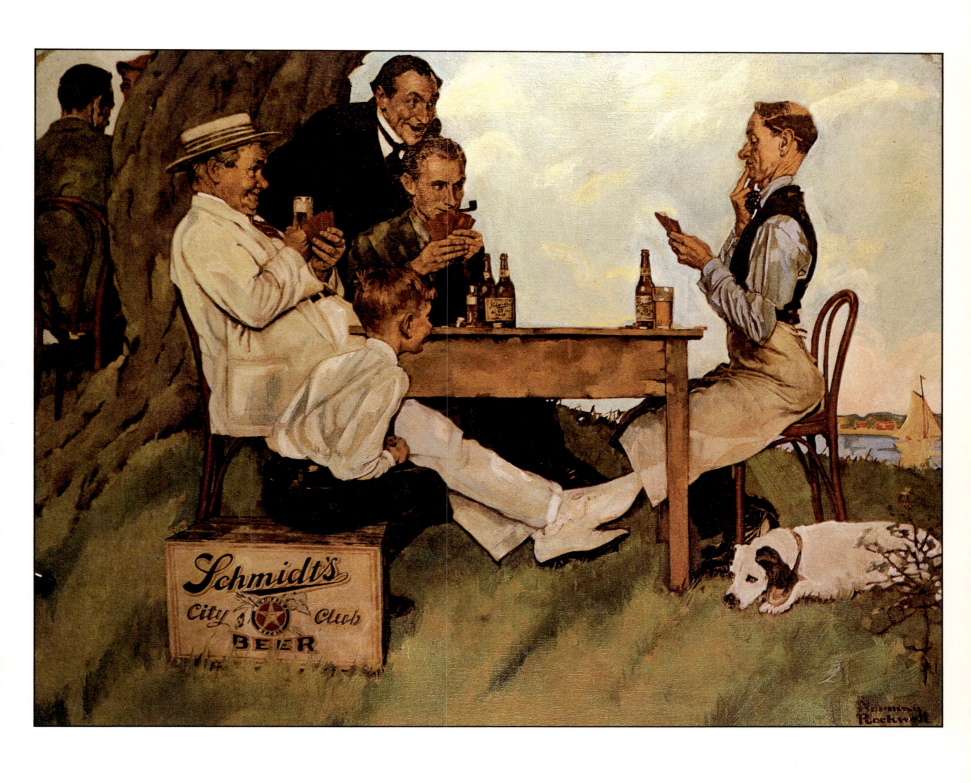

HEINZ

Henry John Heinz was born in Pittsburgh, Pennsylvania, on October 11, 1844. The son of a Pittsburgh brick manufacturer, he began working with his father and became a partner in the brick company. Although his exacting standards made him successful in this occupation, his destiny led him to another field of endeavor and in 1869 he established H.J. Heinz and Company, manufacturer of pickles, condiments, and prepared food. His earlier motto "to do a common thing uncommonly well brings success," followed him throughout his life. Not only were the things he produced uncommonly well made, but other things he did, including his church work, the repayment of debts that he incurred building his corporation, and his early fight for pure food laws, were all exceptional accomplishments.

Although Henry Heinz became extremely successful in the food industry, he never forgot his earlier vocation and would admire good brickwork on buildings wherever he would go. During his 50 years in the food preparation industry, he took his small pickling plant from a tiny business to a world-renowned industry, employing 6,000 people and having 25 factories and feed farms throughout the world. He coined the famous slogan "57 varieties," which was a hallmark for the company for many, many years. During his seventy-fifth year, a new factory was being built and he contracted fatal pneumonia on a chilly day in 1919 when he climbed a ladder to show some workmen how to pitch bricks two at a time.

In 1914 the Heinz Company contracted Norman Rockwell, then a budding new artist who was doing some work for the Boy Scouts of America, to draw an advertisement. This pen-and-ink drawing of a group of Boy Scouts enjoying Heinz Baked Beans by a campfire appeared in the 1914 *Boy Scout Handbook* and was the first advertisement painted by Norman Rockwell. This ad was published two years before Norman Rockwell began working for *The Saturday Evening Post* and was another tribute to the foresight of Henry John Heinz.

The BEST LUNCH FOR A HIKE

is the one that is easiest to carry—easiest to prepare—and at the same time most appetizing and nutritious. The food that meets all these requirements is

Heinz Baked Beans

Just punch a hole in the top of a can, set by the camp fire to heat—and by the time the coffee is cooked, you have a delicious steaming lunch.

Carry a can of Heinz Baked Beans with you on your next hike. They will satisfy hunger and give you new legs for the home stretch.

Other equally good and convenient outing foods are

HEINZ SPAGHETTI
HEINZ PEANUT BUTTER
HEINZ CREAM SOUPS
TOMATO—PEA—CELERY
HEINZ TOMATO KETCHUP
HEINZ INDIA RELISH, Etc.

Send for a copy of our booklet describing all the 57 Varieties, and you will understand why they specially meet the campers' needs.

H. J. HEINZ COMPANY
PITTSBURGH, PA., U. S. A.

HERCULES POWDER

In 1912 the Hercules Powder Company, which manufactured black powder, smokeless powder, and dynamite, filed an anti-trust suit against the DuPont Company in Wilmington, Delaware. Following settlement of the suit, the Hercules Powder Company incorporated and has remained in production since that time in Wilmington, Delaware.

Since 1912 the company has grown from a single line manufacturer to a diversified, worldwide chemical company with annual sales in excess of $2.4 billion.

As the Hercules Corporation grew from a small chemical company into an industrial giant, their major advertising thrust was to produce calendars, which were issued annually from 1918 to 1958. Through these years, many famous American artists such as N.C. Wyeth, Gail Hoskins, and Arthur Fuller painted covers for the Hercules calendars. But one of the most famous calendars created for the company was done by Norman Rockwell in 1941, and the typical Rockwell picture of a young country boy going fishing with his dog became one of the most sought-after calendars in the Hercules archives.

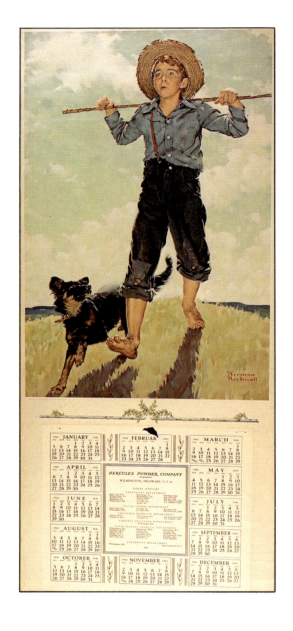

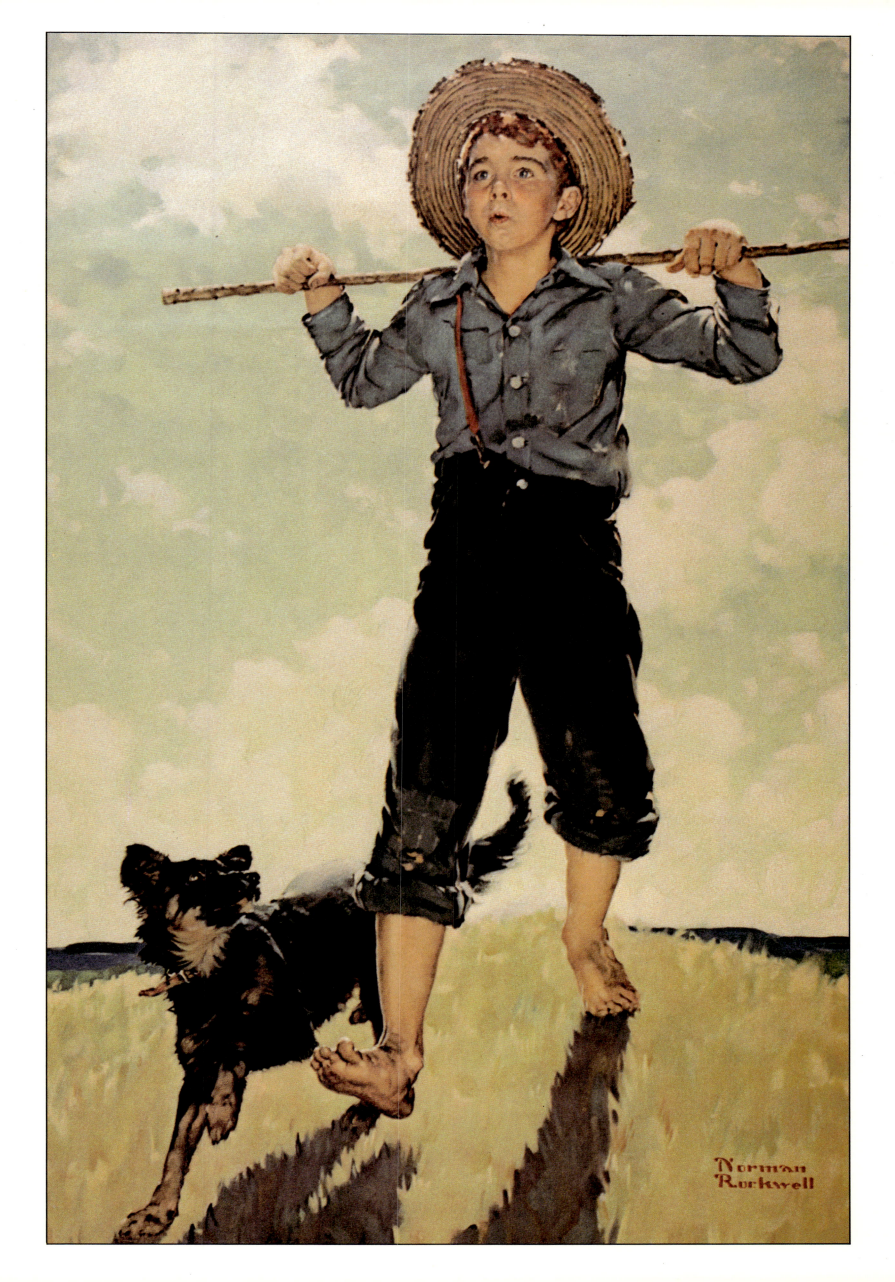

HILLS BROS. COFFEE

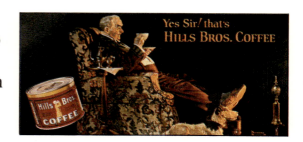

From its humble beginning in a retail stall in the Old Bay City Market in San Francisco on February 14, 1878, the firm of Hills Bros. grew to see Hills Bros. Coffee become the largest-selling brand of coffee from the Pacific Coast to Chicago by the early 1930s. With gradual expansion to the Atlantic seaboard, with plants in San Francisco and Edgewater, New Jersey, it claimed the distinction of being the largest privately owned coffee roasting company in existence and the nation's third largest selling brand.

Among its many accomplishments throughout the years, Hills Bros. holds the distinction of being the originators of vacuum-packing for coffee. In 1900, they successfully applied the vacuum process, developed by the Norton Brothers of Chicago, to roasted coffee. This revolutionary method of preserving coffee freshness, probably more than any other single factor contributed to opening the way to the marketing of national brands of coffee.

In the years of the company's most spectacular period of growth (roughly 1924 to 1936) a crew of 24 Advertising Service Representatives, in panel trucks, looped throughout every sales territory at least once a year. These representatives performed miracles in the decoration of windows and walls of grocery stores with colorful lithographed posters, banners, cutouts, and signs of all sorts adorned with fantastic creations of Mr. Dennison's finest crepe paper.

It was for this display program that Norman Rockwell created for Hills Bros. Coffee the masterpiece shown in the accompanying plate. In true Rockwell style, you could almost hear the happy, old gentleman saying …"Yes Sir! That's HILLS BROS. COFFEE." Painted in 1929, used in 1930, it was the most famous display ever created. The next year Mr. Rockwell suspended his commercial assignments for an extended period. By the time his services were available again, changing patterns in food store distribution had brought an end to extensive store display programs. So Hills Bros. never had another Rockwell, but the memory of one great Norman Rockwell painting has lived to this day.

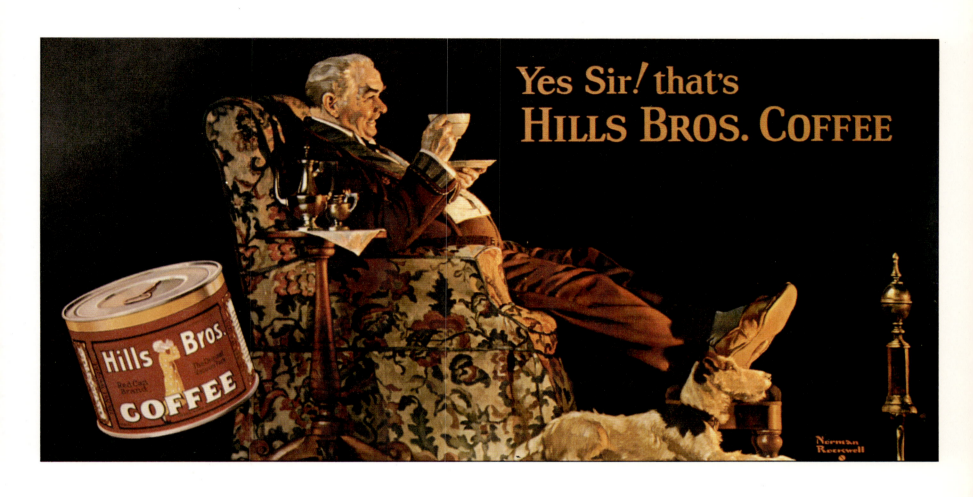

INTERWOVEN SOCKS

By the 1920s the clothing industry was one of the major advertisers in the popular magazines. Because Norman Rockwell was one of the most recognized and famous artists of the day, many of the companies tried to commission him to do their artwork. The Interwoven Stocking Company was one of the fortunate companies to have him sign a contract.

In 1922 the first painting done for Interwoven showed a young golfer examining his scorecard and revealing a fine pair of Interwoven stockings. The slogan underneath, "A long way to the first hole," captured the spirit of the picture and the advertisement was an immediate success. Following this, Interwoven commissioned Norman Rockwell on several more occasions over the next few decades and the pictures painted by him for the company turned out to be some of his best artwork and some of the cleverest ads ever printed in *American magazine*.

Although most of the ads appeared in *The Saturday Evening Post*, they were also seen in *Life* in 1948 and in *Printers, Inc.* in 1927, when the "no holes were darned" picture appeared, which depicted a little old lady looking at an Interwoven sock which needed no repairs. The ads in *The Saturday Evening Post* appeared on August 26, 1922, "The Golfer"; November 18, 1922, "The Thankful Pilgrim"; August 9, 1924, "The Traveling Man"; February 11, 1928, "The Burglar"; June 14, 1935, "Don't Forget Father's Day" (this ad reappeared in *The Saturday Evening Post* on June 12, 1948).

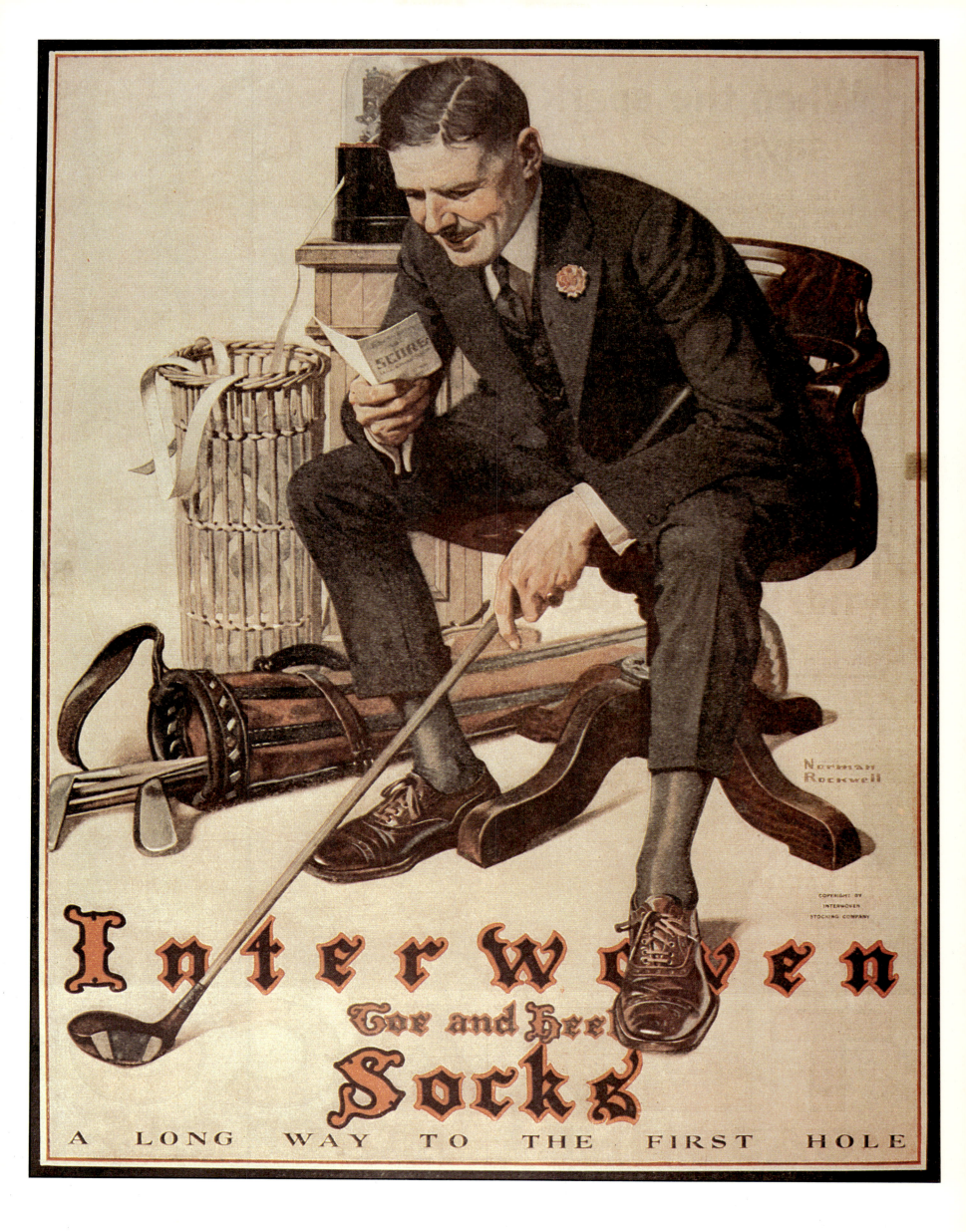

LOSE WEIGHT EASIER... FEEL BETTER!

Norman Rockwell

Drink an envelope of Knox Gelatine 3 times a day before meals

Whether you're following a definite reducing plan or just avoiding fattening foods and big portions, it's easier—you feel better the Knox way. So simple, safe and inexpensive! Just drink an envelope of Knox Unflavored Gelatine (about 5¢) before each meal in fruit or vegetable juice, bouillon or water. You relieve hunger pangs and that droopy sensation with *natural protein*, the extra supply you need to feel and look happy and healthy while you're losing weight.

KNOX Unflavored GELATINE

ALL PROTEIN — LOW IN CALORIES

© 1959 Knox Gelatine, Inc., Johnstown, N. Y.

LINCOLN MUTUAL SAVINGS BANK

In 1963 the Lincoln Mutual Savings Bank of Spokane, Washington, commissioned Norman Rockwell to do a portrait of the bank's namesake.

When the picture was completed in 1966 and forwarded to the bank, Mr. Rockwell sent along a letter stating that Abraham Lincoln was his favorite American.

He went on to say that he and his wife, Molly, went to Champaign, Illinois, not far from New Salem, where Lincoln lived, to paint the picture. With the help of a local expert, he created the beautiful masterpiece which depicted Lincoln as a 22-year-old railsplitter who devoured every book he could get his hands on. In the letter Mr. Rockwell also stated that he hoped the painting would inspire the youth of this country to appreciate this man who believed so much in the value of education.

When the portrait was received, it was put on public display at the main office of the Lincoln Mutual Savings Bank in Spokane, Washington. Although the picture has never been used for commercial purposes, it has become the logo of the bank.

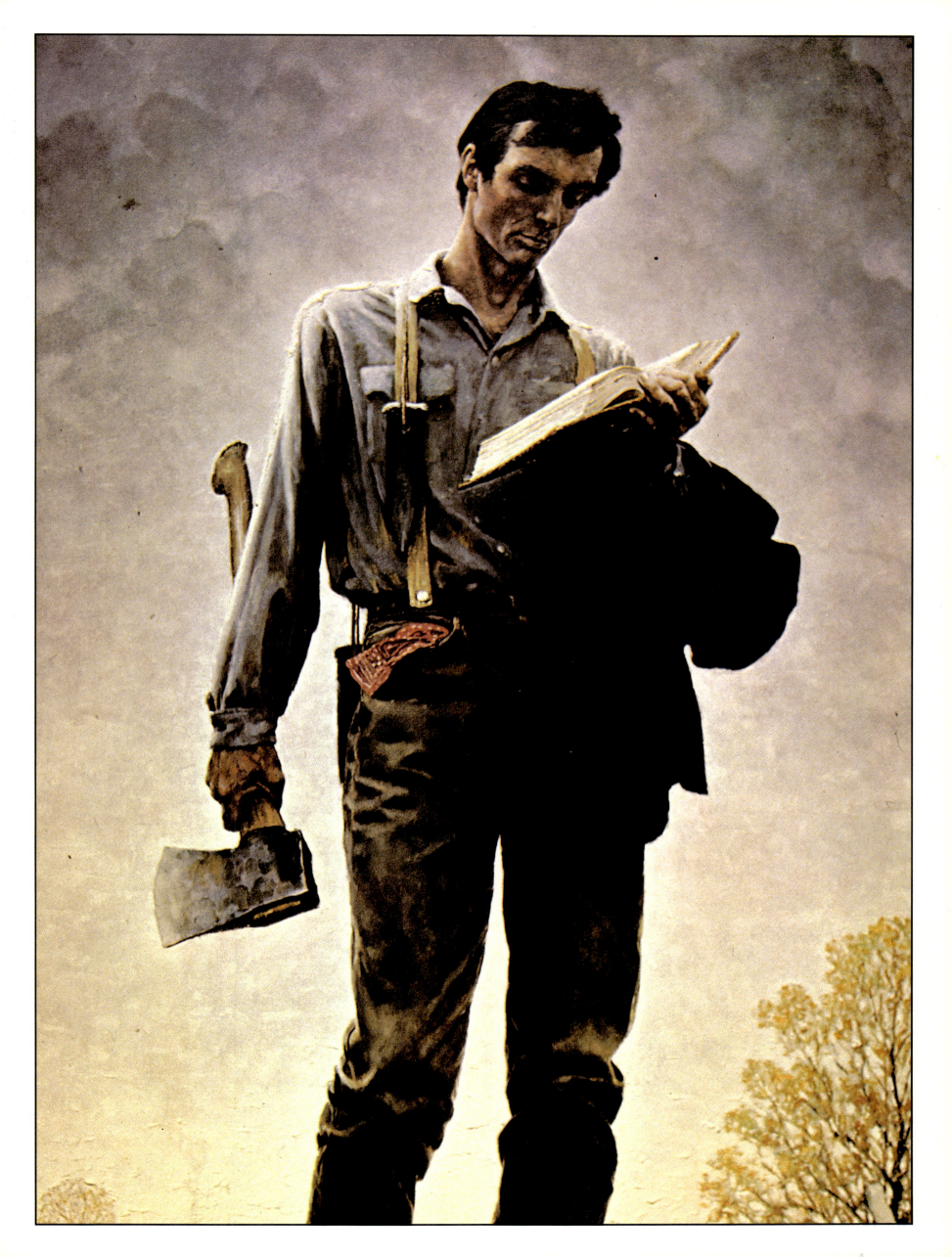

LISTERINE

William Richard Warner was a young pharmacist who graduated from the Philadelphia College of Pharmacy in 1856 and opened a drug store in the same city. Not content with making pills in the time-honored fashion and being concerned with the distaste many patients showed for current medications, he came up with the idea of coating tablets with sugar to make them more palatable. This successful idea launched him into drug making in earnest and he turned his attention to the development of new pills and compounds for the medical profession. By 1876 Mr. Warner's drug operation was occupying a six-story building which was one of the most modern and best equipped at the time. It was known as "Warner Hall" and produced an increasingly wide variety of elixirs, syrups, lozenges and medicinal wines in addition to his multicolored sugar tablets. When he died in 1901, control of the company was passed to his oldest son, following which it acquired a number of affiliate companies and continued to grow over the next several decades while producing many well-known pharmaceuticals.

During this time the Lambert Company, a small St. Louis pharmaceutical company which produced one major but well-known product, was making great strides. This company was named for Jordan W. Lambert, a St. Louis pharmacist, who in 1865 introduced an antiseptic which was extremely safe to use and yet as potent as caustic carbolic acid that Joseph Lister, the famous "Father of Antisepsis," used in his experiments. Shortly thereafter, Mr. Lambert journeyed to London to meet with Dr. Lister and tell him about his new antiseptic. So impressed was Lambert with meeting the famous scientist, he decided to call his new discovery Listerine.

This single product was the backbone of the Lambert Company and Listerine was available in every drug, variety and food store in the country.

In 1955, shortly after the Warner Company acquired Chilcott Laboratories and became Warner-Chilcott, it merged with the Lambert Company and in 1955 the Warner-Lambert Pharmaceutical Company was incorporated.

In 1922 the Lambert Company engaged Norman Rockwell to do an advertisement for Listerine. These advertisements were used between 1929 and 1943, in *American, Better Homes and Gardens, Ladies' Home Journal, Literary Digest, Modern Priscilla Magazine, Pictorial Review, Woman's Home Companion* and *The Saturday Evening Post*. The famous painting depicted a doctor with a tongue blade in the open mouth of a little boy stating, "Stay Home and Gargle with Listerine every Two Hours."

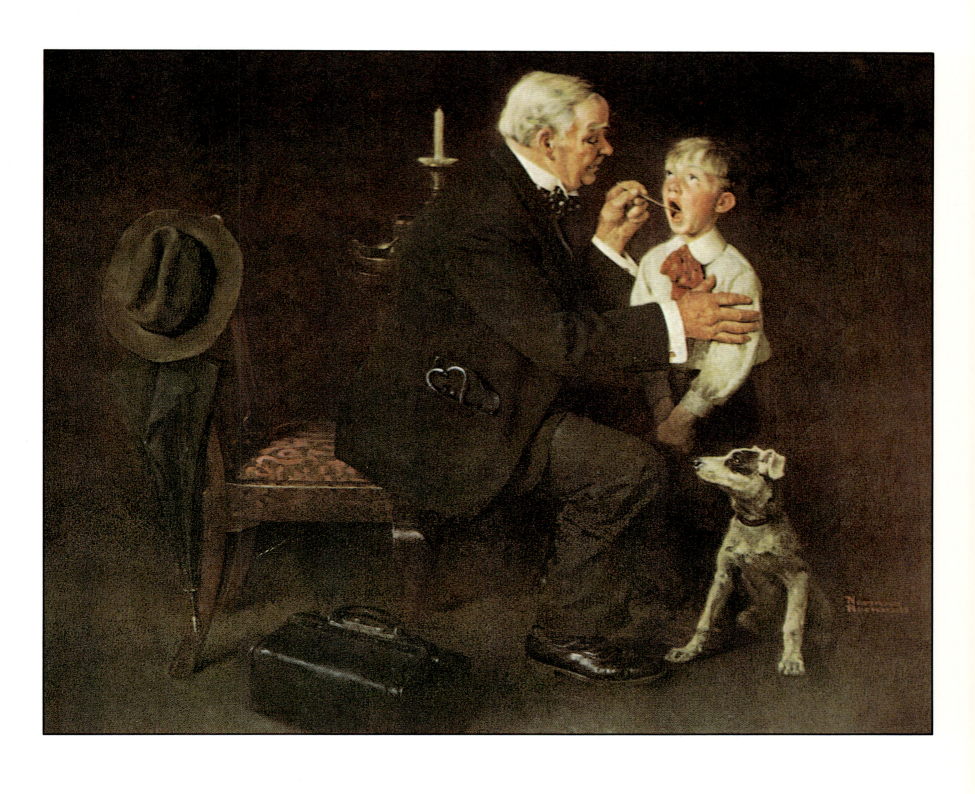

Lowe Brothers

LOWE BROTHERS PAINTS

Lowe Brothers Paints and Varnishes had their headquarters in Dayton, Ohio, but also were located in many other cities throughout the United States. In 1923 they commissioned Norman Rockwell to illustrate an advertisement for their paints. His picture "Good for Another Generation" showed the quality of their product, and the typical Rockwell portrayal of an elderly man varnishing an old grandfather clock while his wife holds the varnish. It appeared in *The Saturday Evening Post* in May 1923 and in *Atlantic Monthly*, *Good Housekeeping*, *Harper's Monthly*, and *House Beautiful* in June 1923.

"Good for Another Generation"

I T was old Colonel Dandle of New Rochelle, N.Y., who said it. He who for so many years has collected old furniture and "furbished it up." Occasionally he can be induced to part with one of his old pieces. That's how my friend McDowell and I happened to drop in, just as with the help of Granny and the cat, the Colonel was giving the last brush stroke to his old treasure clock.

"There, Granny," he said contentedly, "this

Neptunite
Varnish

makes it good for another generation".

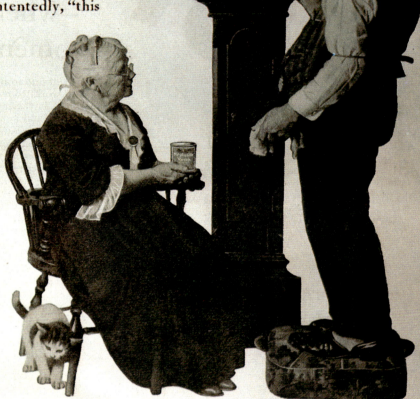

Friend McDowell was at that time building a new house at Bronxville, which you recall is but a short distance from New Rochelle. He promptly concluded that if Neptunite Varnishes were good enough for particular Colonel Dandle, they were exactly what he was in search of for that house.

But now comes the really interesting part. He and his wife Katharine did most of the floors, woodwork and walls, themselves. They tell all about it in a crisp, delightful way, in what they call:

The Diary of The House in The Woods

We induced them to let us publish it. And now it's ready in its unique Mellotone tint cover, charming color illustrations, helpful sketches and informative text. Just the sort of thing, in fact, that is invaluable to you, if building a new house, or doing over any room in your present one.

Being told as it is, by both Katharine McDowell and her husband, you have two sides of the question. We are going to ask you to enclose 10 cents with your welcome request for one. Send direct to our Main Office at Dayton, Ohio.

The LOWE BROTHERS Company
560 EAST THIRD STREET, DAYTON, OHIO

| Boston | Philadelphia | Jersey City | Chicago | Atlanta |
| Memphis | Kansas City | Minneapolis | Omaha | Toronto |

Norman Rockwell

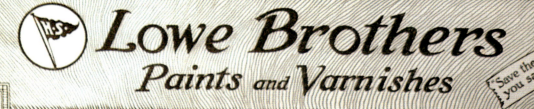

Lowe Brothers
Paints and Varnishes

"Save the surface and you save all *Paint & Varnish*"

MASSACHUSETTS MUTUAL

Numbering eighty in all, the Massachusetts Mutual Life Insurance Company's collection of original Norman Rockwell drawings is acknowledged to be among the largest presently in the hands of private collectors. The black-and-white illustrations, commissioned by Mass Mutual for a series of national consumer advertisements, appeared in the nation's leading magazines throughout the 1950s and early 1960s.

So popular were the illustrations that Mass Mutual decided to place its collection on loan to museums across the country. Public exhibits of the tastefully matted and framed groupings have attracted people of all ages and from every walk of life. Many, in fact, have come to identify the company's name with Rockwell's art. Because of the widespread interest in the works following Mr. Rockwell's death, Mass Mutual has also reproduced the drawings in quantity and has made them available to the exhibit sponsors, who may use them in a variety of ways to add an extra dimension of popular appeal to their local showings.

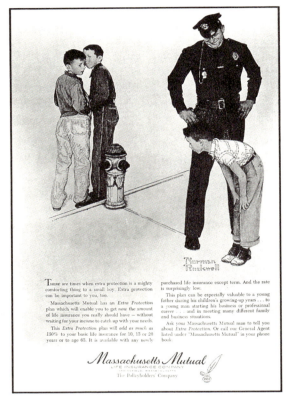

Two originals in the collection, those depicting Thanksgiving and Easter, were used annually in the company's advertisements for several years after they were first acquired. Recognition of the advertising program was given by the Freedoms Foundation at Valley Forge, which awarded its George Washington medal to Mass Mutual in 1959 for the Thanksgiving ad specifically, with its now traditional Rockwell illustration.

Mr. Rockwell is best known for his drawings commissioned for the cover of the old *Saturday Evening Post*, the first having made its appearance in the May, 1916, issue. The universal appeal of his illustrations seems to come from the easily recognizable and believable traits of each of the artist's characters and scenes. Simple themes of family life, children, pets and everyday life experiences are all familiar ones, holding special memories for each one of us.

Despite the vast number of paintings and drawings that Mr. Rockwell produced during his lengthy career, he remained a perfectionist in every detail. As he once said, "Maybe as I grew up and found the world wasn't the perfectly pleasant place I had thought it to be, I unconsciously decided that, even if it wasn't an ideal world, it should be, so I painted only the ideal aspects of it."

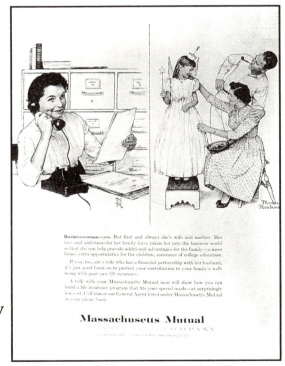

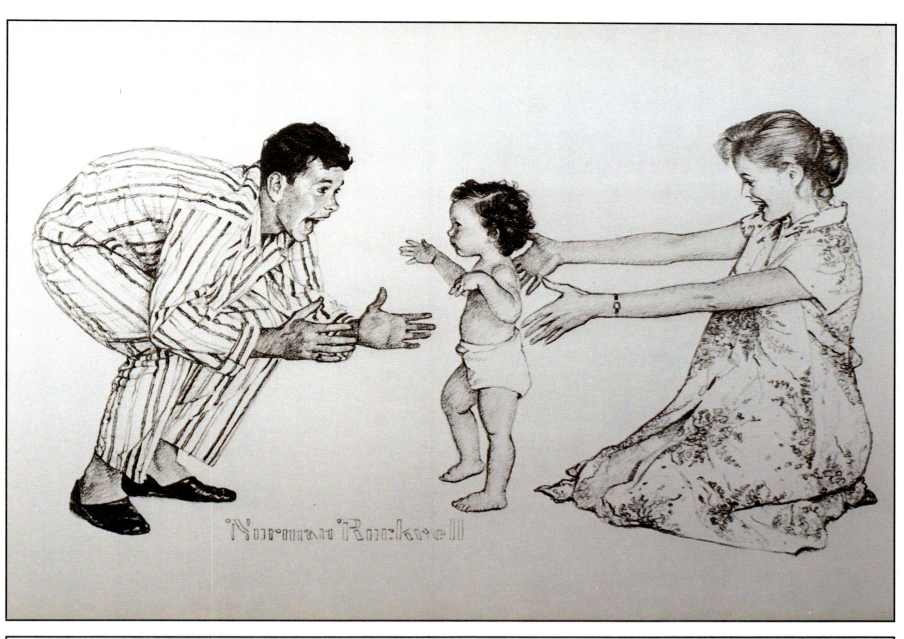

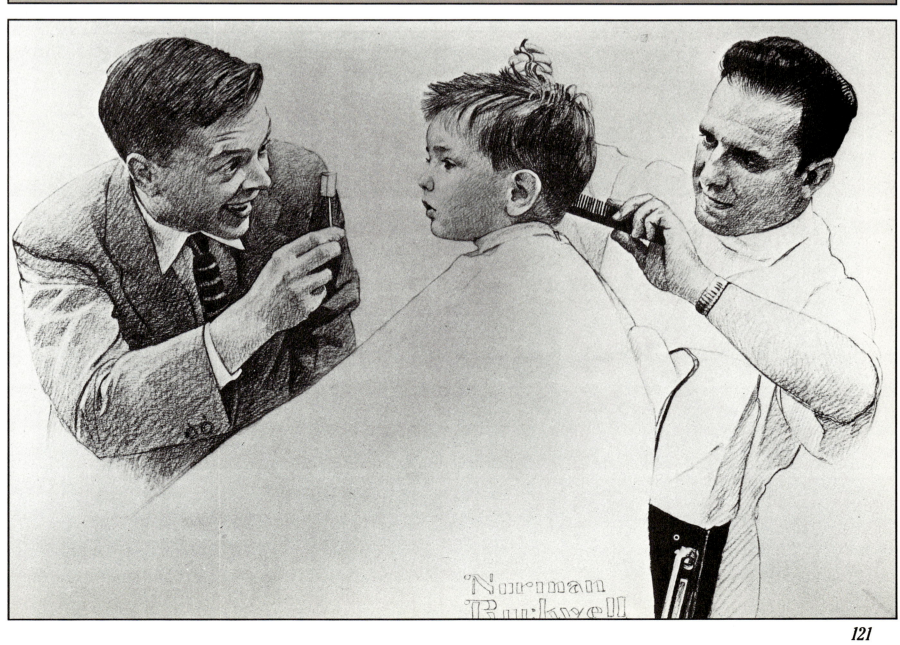

MAXWELL HOUSE COFFEE

Many years ago, a fine hotel in the old South became famous for its excellent coffee.

Down in that land of good living, of traditional grace and hospitality, the old Maxwell House held a high place in popular favor. Here the aristocratic men and women of the South gathered at brilliant banquets and balls, here distinguished travelers—presidents of the United States, Army and Navy officers, statesmen, journalists and foreign diplomats—were entertained.

Travelers from all parts of the United States praised the wonderful food at the old Maxwell House and, in particular, the rich, mellow flavor of Maxwell House coffee.

Southerners themselves bragged about it. They said no single coffee grown could taste so delicious. The story has it that a Southern gentleman known as the "Old Colonel," who was an expert in coffees, first worked out the choice blend which has appealed to men and women for decades. He traveled through many lands to find the richest grades of coffee grown in the tropics, and spent years of patient, skillful labor combining all different types of choice blends to get the perfect, smooth, full-bodied taste of Maxwell House coffee.

In order to advertise their famous coffee, Norman Rockwell was chosen as the artist to best depict the enjoyment of a good hot cup of coffee. He was commissioned by the Maxwell House Company to paint an advertisement for various magazines and the result was the delightful picture of his favorite model, James VanBrunt, having a relaxing cup of coffee with an old friend.

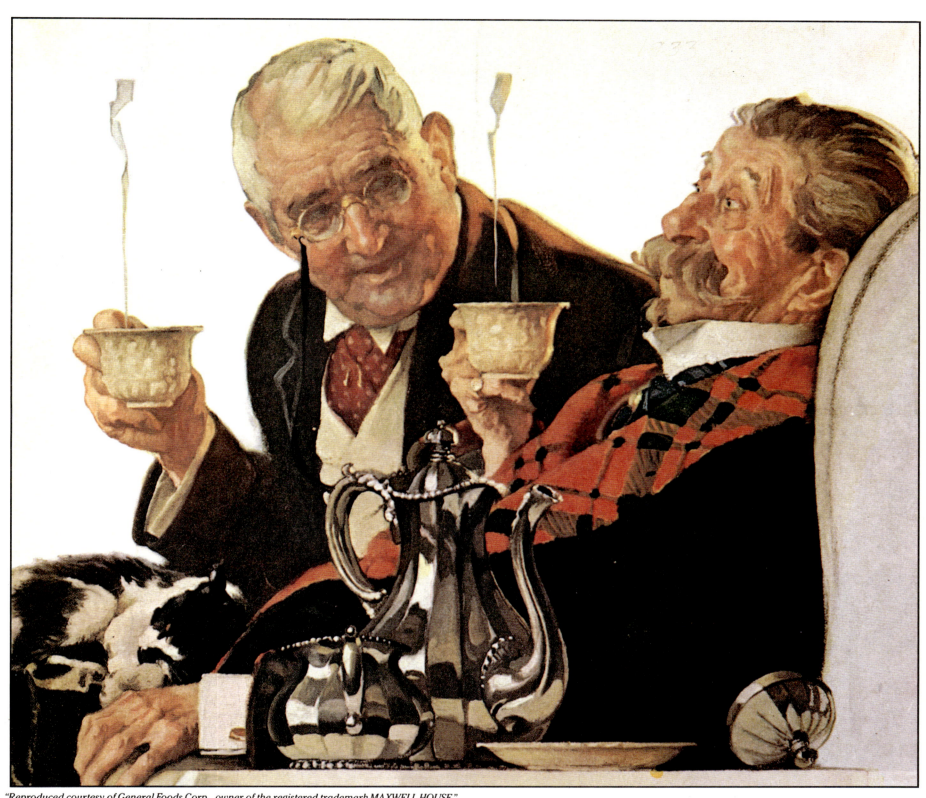

McDONALD'S

During the 1920s Richard and Maurice McDonald moved from New Hampshire to southern California because of their great attraction to Hollywood and the movie industry. They spent several years back-stage, moving scenery, driving trucks and doing odd jobs. In 1932, they bought a rundown theater and began to show movies. Their favorite part of the business was serving popcorn and other snacks to the patrons of the theater. Several years later they closed the theater and opened a self-service restaurant, selling only hamburgers, fries and drinks, where people could walk up to a window, pick up their orders, and enjoy a quick, inexpensive meal.

At first business was slow, but because of the fast service and cheap price (15¢ for a hamburger and 10¢ for fries) business slowly began to increase. Richard and "Mac" decided that in order to streamline their business, they needed new equipment to make hamburgers faster and asked the General Electric Company to produce a stainless steel grid-dle, 6 feet long. The brothers also developed a dispenser that would put mustard and ketchup on six buns a second. To make sure no one would miss their stand, the brothers hired a signmaker to create two giant neon arches.

In 1954, Ray Kroc, a 52-year-old salesman from Chicago, was traveling around the country selling a device called the Prince Castle multi-mixer, a gadget that could make six milkshakes at the same time. When he heard of the small restaurant in California that had just ordered eight of his machines, he wanted to see what kind of place needed to make forty-eight milkshakes at the same time. When Mr. Kroc got a glimpse of the McDonald brothers' hamburger stand and the crowds of hungry people that were waiting in line for a hamburger, french fries and milkshake, he decided immediately that a fortune was to be made. He convinced the McDonald brothers to allow him to sell franchises across the country and for the next six years, due to great effort and persistence, the name McDonald's began to pop up throughout America. In 1960, Mr. Kroc bought out the McDonald brothers for $2.7 million.

The rest, of course, is history, and McDonald's has become a house-hold word across America and throughout the world. By 1973 over 12 billion hamburgers had been sold and the busiest McDonald's restaurant was in Tokyo, Japan, where only a few years earlier the Japanese did not know what a hamburger was.

As the business grew, so did the advertising budget. One of the most popular ads ever produced for the McDonald Corporation was that of an oil painting by Norman Rockwell depicting a McDonald's employee serving milkshakes to a crowd of happy youngsters.

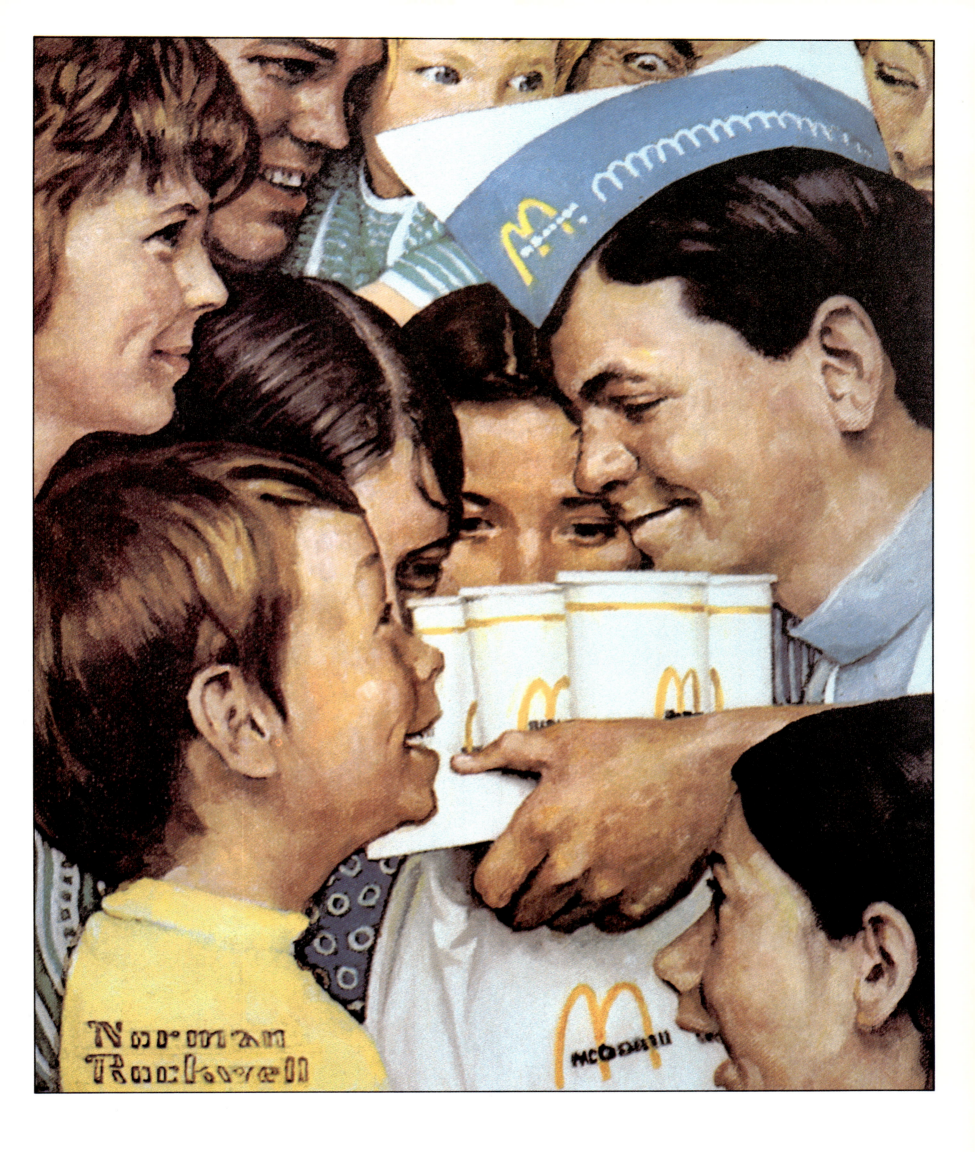

MELNOR INDUSTRIES

Throughout the years, as the American public had a continuing love affair with the art of Norman Rockwell, the thing that attracted most people to his pictures, in addition to his exacting detail, was his unsurpassed sense of humor. And most advertisers realized that although a picture was created to enlighten the public about a product, a humorous picture would not only create a good feeling about the item, but also cause it to be remembered. Melnor Industries was one of the companies that took full advantage of Mr. Rockwell's artistic and whimsical talent.

Melnor Industries is the leader in the lawn and garden industry. They create a complete line of lawn sprinklers, garden aids and accessories. In 1962 Norman Rockwell was contracted to create an advertisement for the company. A comical picture of a suburban gardener who has just hooked up a Melnor Lawn Sprinkler as he feels the first drops of rain was a huge success and became a classic in Rockwell advertising art.

The picture was initially used in 1962 on the Melnor Industries Product Catalog cover. In the early 1970s the photograph of the painting was retouched to change the packaging to an oscillating lawn sprinkler so that it could be used again on the cover of the catalog for that year.

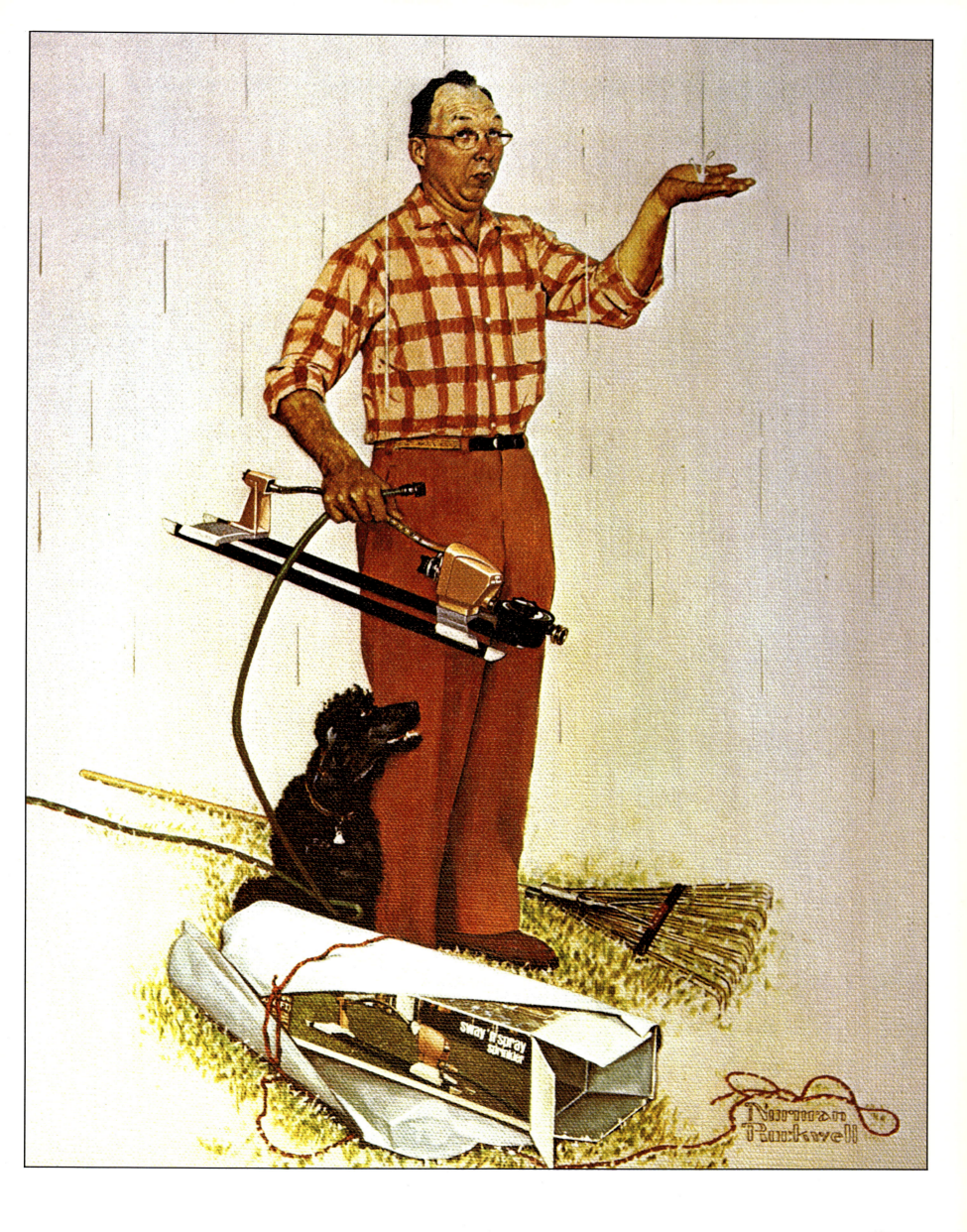

Sway 'n spray sprinkler

Norman Rockwell

MSD

MERCK SHARP & DOHME

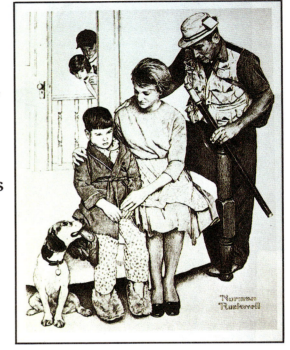

Merck Sharp & Dohme of West Point, Pennsylvania, is the United States Pharmaceutical Division of Merck and Company, Inc. of Rahway, New Jersey. Merck is a world-wide corporation dealing in products to improve or sustain human and animal health and enhance the environment. The company's forebears opened the first apothecary in Darmstadt, Germany, in the seventeenth century, and the first Sharp and Dohme Apothecary in Baltimore, Maryland, in 1845.

In 1971 Merck Sharp & Dohme contracted Norman Rockwell to do some advertising work for mumps vaccine. The result was two sketches of youngsters with puffy cheeks and unhappy faces, who were suffering from mumps. Of course, since the advent of the vaccines and the widespread immunization across the United States, mumps has become a very rare disease. The popular advertisements appeared in every medical journal in 1971 and 1972.

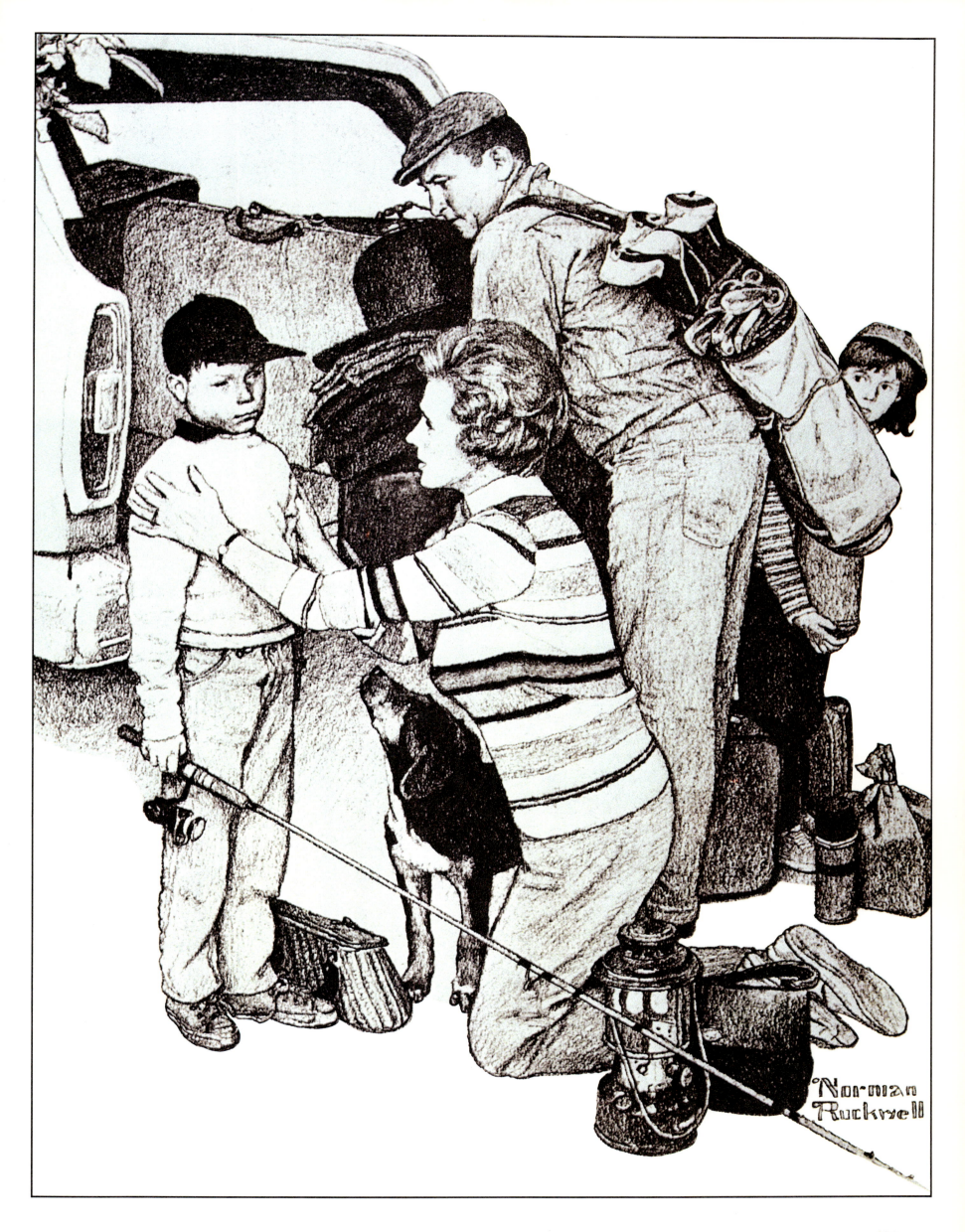

MGM/UA

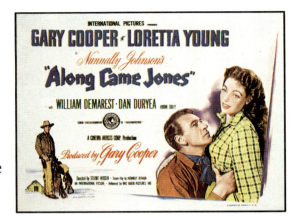

The genealogy of MGM/UA resembles a royal Hollywood family tree which begins with Sam Goldfish, a Polish refugee and ex-glove salesman. With his brother-in-law Jesse Lasky and young Cecil B. DeMille, he produced his first movie, *Squaw Man*, in an old barn at the intersection of Sunset and Vine. The young company then merged with the legendary Adolph Zukor's Famous Players. Goldfish, unwilling to share leadership with Zukor, joined in a brief partnership with the Selwyns. When he left, he took half their name with him and formed the Samuel Goldwyn studio.

By 1924 Sam had left, but the company named for him remained. Marcus Lowe, a powerful theatre owner and principal at Metro, a rival studio, proposed a merger, giving birth to Metro-Goldwyn.

Lowe, in search of new executives, met and was impressed by Louis B. Mayer and his young assistant, Irving Thalberg. An ex-junkman refugee with little behind him but chutzpa, Mayer added his name to the company to form Metro-Goldwyn-Mayer. He and Thalberg ruled The Industry from the huge MGM studio in Culver City.

MGM had the finest collection of artistic and technical talent available. Under Thalberg's guiding hand, Erich von Stroheim, King Vidor and David O. Selznick directed such stars as John Gilbert, Greta Garbo, Jean Harlow, Joan Crawford, Fred Astaire and Clark Gable.

Some of the greatest movie classics were made during this period: *Ben Hur, Grand Hotel, The Thin Man, Mutiny on the Bounty* and *A Night at the Opera*. Three years after Thalberg's premature death in 1936, MGM went on to make two of the most cherished movies of all time: *Gone With the Wind* and *The Wizard of Oz*.

During the 40's and 50's MGM musicals became legendary. With the contract system the studio was able to maintain a stable of stars who worked on pictures such as *Till the Clouds Roll By, Kiss Me Kate, The Easter Parade* and the ever-popular *Singin' in the Rain*.

In the 60's Cinerama and the 70mm motion picture screen, as well as stereo sound, were introduced. Pictures like *2001—A Space Odyssey* benefited from these innovations.

More recently, MGM acquired United Artists, which had been founded in 1919 by Mary Pickford, Charlie Chaplin, Douglas Fairbanks, D.W. Griffith and William S. Hart. United Artists had a prestigious roster of films, including Buster Keaton's *The General, Around the World in 80 Days, Tom Jones* and the James Bond series.

Gary Cooper posed as the "Gun Shy, Girl Shy, Great Guy" hero of *Along Came Jones*, whom Norman Rockwell painted for this 1945 poster.

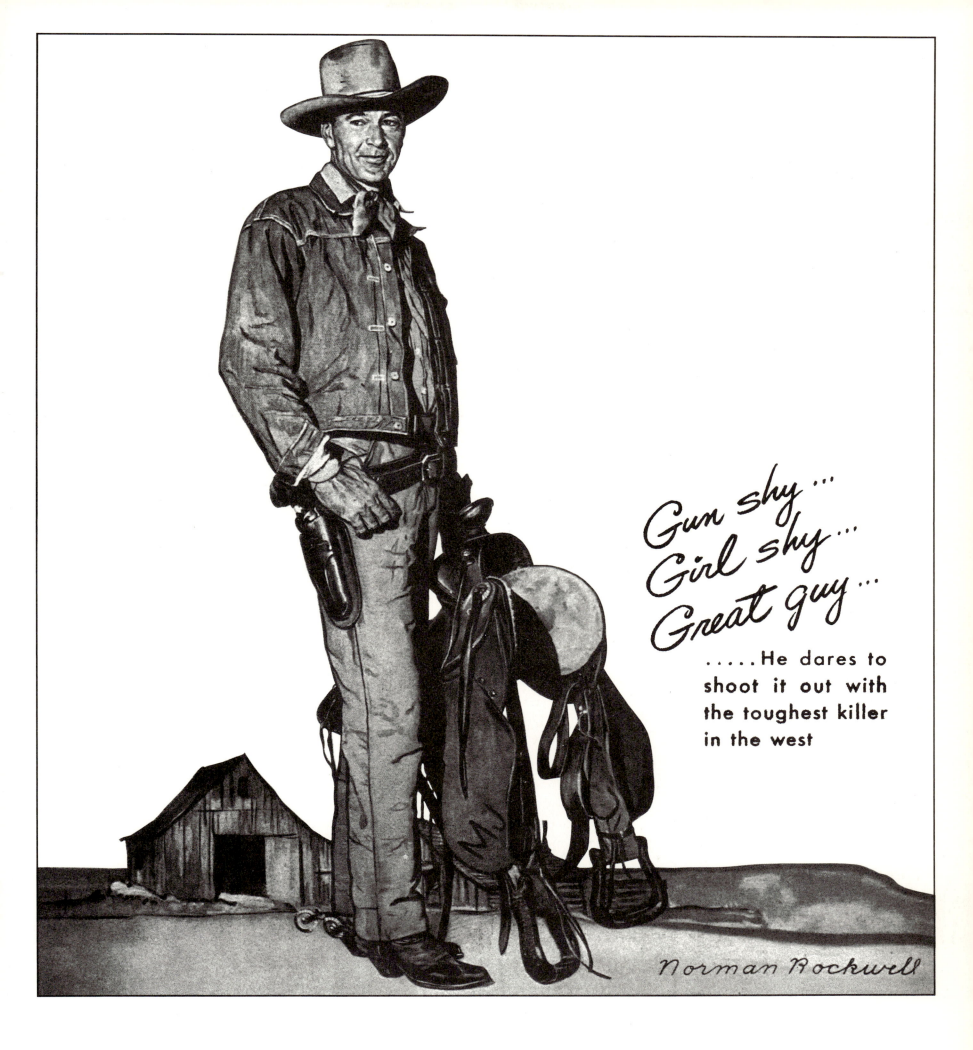

Gun shy...
Girl shy...
Great guy...

.....He dares to
shoot it out with
the toughest killer
in the west

Norman Rockwell

131

MOBILOIL

In 1859 Colonel Edwin L. Drake discovered oil in Titusville, Pennsylvania, and the United States petroleum industry had its birth. Six years later, in Rochester, New York, a carpenter and a grocer saw in the infant industry a chance for commercial success.

The carpenter, Matthew Ewing, who was also an inventor, had devised a method to make kerosene by distilling crude oil in a vacuum. Ewing thought his method would produce more kerosene from a barrel than any of the other refining methods of that time. Although nobody agreed with him, Ewing persuaded Hiram Bond Everest to invest in this project. Everest was a 35-year-old grocer who showed a remarkable talent for investing in businesses that failed. He had two tree farms that were destroyed by frost and a sawmill that was burned to the ground. His new investment was no better; Ewing's system produced no more kerosene than other methods.

On careful examination, Everest noticed there was an oily residue remaining after the kerosene and naphtha had been distilled. More important, the oil that remained was not charred or burnt and had no odor. In this product he saw a better petroleum lubricant than existed at that time. He and Ewing patented the method, and on October 4, 1866, the Vacuum Oil Company was incorporated in Rochester, New York.

By the late 1870s the Vacuum Company had become a leader in the lubricant industry and in 1879, the controlling interest in the company was sold to John D. Rockefeller, the President of the Standard Oil Company. The company continued to prosper and in 1922 the name was changed to "Socony"—the Standard Oil Company of New York. Its product was called Mobiloil.

During this period Mobiloil achieved an astounding reputation. In 1903 it was used for the Wright brothers' daily flights; in 1910 it was used by Barney Oldfield when he set the land speed record at Daytona Beach; in 1915 it helped win the Indianapolis 500 for Ralph DePalma; in 1926 it was used by Admiral Byrd for his flight to the North Pole; in 1927 it was used as a lubricant for "The Spirit of St. Louis" by Charles Lindberg; and in 1928 it was used by Amelia Earhart—the first woman to fly the Atlantic. Even today Mobiloil is used on our nuclear-powered submarines and our modern jet aircraft.

In 1955 the company changed its name to the Socony Mobiloil Company and two years later became Mobil, as we know it today.

Over the years the name Mobil on billboards and service station signs has become familiar to everyone, but in the 1940s the logo of the company was a flying red horse. In 1941 the Mobil Company commissioned Norman Rockwell to paint a magazine advertisement. The classic picture of a horse looking up at a Mobil gas sign and admiring her hero appeared in *Life* on May 26, 1941, and in *The Saturday Evening Post* on June 14, 1941.

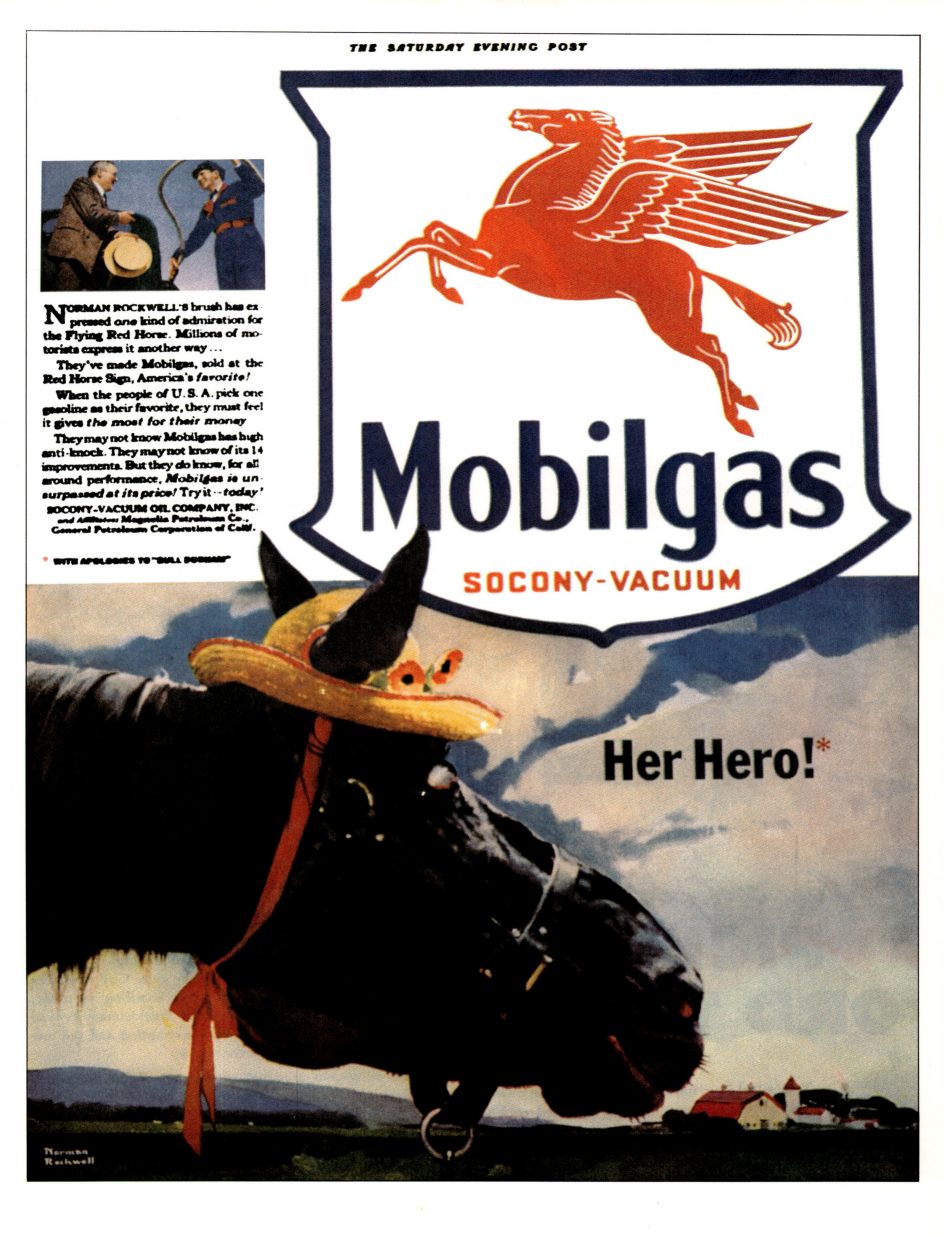

MONTGOMERY WARD

Aaron Montgomery Ward was born in Chatham, New Jersey, on February 17, 1843. Being a bright and industrious young man, he left home early to seek his fortune in the business world. As a traveling salesman in the Middle West, he conceived the idea of buying merchandise from manufacturers in large quantities for cash and selling it directly to farmers for cash.

In 1872 he and his partner, George R. Thorne, began a small mail order business in the loft of a livery stable. Together they had $2,400 in capital and a single sheet catalog listing a few dry goods items. This small company, which began in Chicago, was the first mail order house to sell general merchandise. Over the next four decades the company slowly grew and then began to flourish. By the time Mr. Ward died in 1913, the annual sales of Montgomery Ward & Company had risen to $40 million. Today it ranks second to Sears, Roebuck & Co., the largest mail order firm in the world.

When the large present-day mail order firms were established, most of their customers lived in small towns and on farms. After World War I the mail order business began to decline. Improved roads and increased use of automobiles made it easier for country people to travel to larger towns and cities to do their shopping. This led the larger firms to open retail stores.

In spite of the decreasing country population and increasing urban development, the mail order business began to grow again after World War II. Older firms developed new sales techniques as newer firms began selling specialized goods. One of the most important items was the mail order catalog, which offered everything from the latest fashions for the city folks, to farm equipment for the farmers. Because of the importance of the mail order catalog, Montgomery Ward & Company chose Norman Rockwell to paint one of their catalog covers. This popular cover shows an elderly woman sitting next to her hope chest admiring the items that she has purchased through a mail order catalog through the years.

ORTHO DIAGNOSTICS

Shortly after the turn of the century a boy was born in Kletsk, Russia, who was destined to change the world of laboratory research and become a legend in modern medical science.

Arriving in the United States with his family and settling in Brooklyn, New York, Philip Levine became an American citizen in 1917 and entered Cornell Medical School in 1919, getting his medical degree in 1923. While in medical school he became intrigued with the mysteries of blood and this fascination was the guiding light for a lifetime of important contributions in the fields of hematology, immunology and laboratory medicine.

Over the next half century Dr. Philip Levine wrote over 200 scientific papers, received countless awards and honors and made numerous discoveries. His most important work was the discovery of the human Rh antigen, which greatly advanced the science of blood transfusion.

In 1944 Dr. Levine joined the Ortho Research Foundation, where he continued his work and received worldwide acclaim.

In 1973 Norman Rockwell was commissioned to paint a portrait of Dr. Levine and during those few historic hours the true genius of American art and science sat together with mutual respect and admiration. Though their skills had guided their lives along different paths, both men have made a lasting impression on the life of every American.

OVERLAND

At the turn of the century, Thomas B. Jeffrey, an English-born bicycle manufacturer, began building one-cylinder automobiles in the United States. His first car was introduced at the Chicago Auto Show on March 1, 1902, and was called a Rambler.

About that time Charles W. Nash, one of the great automotive pioneers, was running a carriage and wagon factory in Flint, Michigan. Shortly after, he became head of the Buick Division of General Motors and president of General Motors in 1912. In 1916 he resigned from General Motors and purchased the Thomas Jeffrey Company in Kenosha, Wisconsin.

As the company expanded, other car companies were acquired, and all the automobiles bore the Nash name. During the time this was taking place, an American automobile manufacturer by the name of John North Willys was creating the Willys-Overland Company following the purchase of the Overland Automobile Company in 1907. His company sales rose from 50 automobiles the first year to over 300,000 about 20 years later.

At the same time these two automotive giants were organizing, a department store founder in Detroit, Michigan, by the name of Joseph L. Hudson, was backing his niece's husband in the production of a new automobile, which was subsequently named after Mr. Hudson. This small company also met with success and in 1929 shipped over 300,000 cars, two-thirds bearing the name of Essex. This was the first closed automobile offered at a price that was competitive with other models.

In 1936 Charles Nash, age 72, was looking for his successor, and his search led him to George W. Mason, who was then the president of the Kelvinator Corporation of Detroit. After several months of negotiations, the two companies merged and on January 4, 1937, the Nash-Kelvinator Corporation was born; Mason was its president and Nash the Chairman of the Board. The headquarters for the new company was in Detroit. The company continued to flourish until the early '40s when, following the war, sales began to dwindle, and a consolidation was suggested. Early in 1954, the Hudson Motor Car Company merged with Nash-Kelvinator and the American Motors Corporation was created. As the company continued to grow, new mergers and acquisitions were made, and one was the Willy-Overland Company, which had become not only quite successful but well known as the producers of the Jeep, the four-wheel-drive military vehicle of World War II.

Although American Motors used many excellent artists through the years to illustrate their advertisements, none became so famous as Norman Rockwell, who was commissioned to do the Willys-Overland ads in 1919. One appeared on November 22 in the *Literary Digest*, with the title, "The Main Thing on Main Street" and the other in *The Saturday Evening Post* on March 17, 1923.

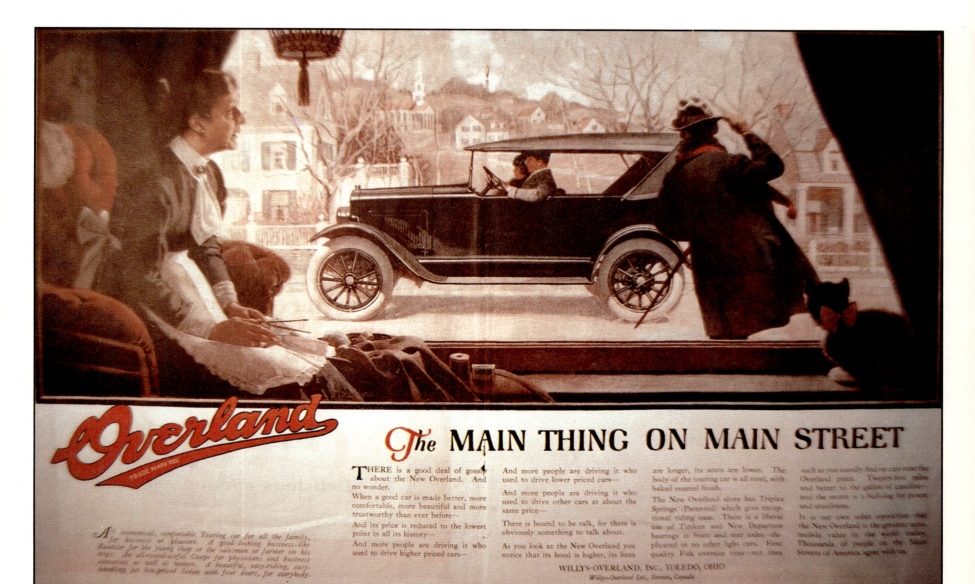

Overland

TRADE MARK REG.

An economical, comfortable Touring car for all the family, for business or pleasure. A good-looking business-like Roadster for the young chap or the salesman or farmer on his trips. An all-round-useful Coupe for physicians and business executives as well as women. A beautiful, easy-riding, easy-handling yet low-priced Sedan with four doors, for everybody.

The MAIN THING ON MAIN STREET

THERE is a good deal of gossip about the New Overland. And no wonder.

When a good car is made better, more comfortable, more beautiful and more trustworthy than ever before—

And its price is reduced to the lowest point in all its history—

And more people are driving it who used to drive higher priced cars—

And more people are driving it who used to drive lower priced cars—

And more people are driving it who used to drive other cars at about the same price—

There is bound to be talk, for there is obviously something to talk about.

As you look at the New Overland you notice that its hood is higher, its lines are longer, its seats are lower. The body of the touring car is all steel, with baked enamel finish.

The New Overland alone has Triplex Springs (Patented) which give exceptional riding ease. There is a liberal use of Timken and New Departure bearings in front and rear axles—duplicated in no other light cars. First quality Fisk oversize tires—not tires such as you usually find on cars near the Overland price. Twenty-five miles and better to the gallon of gasoline—and the motor is a bull-dog for power and sturdiness.

It is our own sober conviction that the New Overland is the greatest automobile value in the world today. Thousands of people on the Main Streets of America agree with us.

WILLYS-OVERLAND, INC., TOLEDO, OHIO

Willys-Overland Ltd., Toronto, Canada

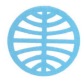

PAN AM

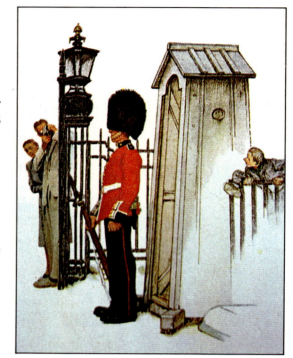

Pan American began airline service on October 28, 1927, when a Fokker trimotor inaugurated the international airline's first route, the 90 miles from Key West, Florida, to Havana, Cuba. Gradually, the airline extended its route system from island to island through the Caribbean, to Central America and down the Atlantic coast of South America. To expand, Pan Am needed more advanced aircraft and it needed bases along its routes. It challenged America's aircraft builders to design planes to its specifications, and the competition to construct Pan Am Clippers produced the Sikorsky flying boats that opened up South America, then the Martin Clippers that first crossed the Pacific in 1935, and the Boeing flying boats that flew the Atlantic in 1939. Latin America was the laboratory where Pan Am developed the over-water navigation, air-to-ground radio, and other long-range flying techniques to fly the oceans.

In 1947 Pan Am was the first airline to operate a scheduled commercial round-the-world service. Pan Am led the way with the American-built jets, offering the first scheduled trans-Atlantic service with the Boeing 707 in 1958. Pan Am's order for 25 of the wide-bodied Boeing 747s enabled Boeing to go ahead with construction of the new aircraft, which Pan Am was first to put into service in 1970.

Norman Rockwell was able to show what Pan Am's routes and service were like through a series of advertisements in the 50's. He said, "My Pan Am tour of the world was exciting, but my trip abroad will give you a new look at some wonderful people. And there's no better way to go than on the wings of a Pan Am Clipper."

Eyes that see around the world

The look of experience is something all Clipper* pilots have.

It comes from watching the weather through all the Seven Skies over all the Seven Seas—year in and year out.

It's the look you want in your pilot when you fly overseas. And it's one great reason why more people choose Pan American when they fly overseas.

For on every Clipper flight deck there are as many as three qualified over-ocean pilots—trained to American standards; there are no standards more rigid or exacting in the world.

And beneath every Flying Clipper, all around the world, there extends the great supporting network of watchful experts—the vast ground forces of Pan American, 17,600 strong—maintenance men, weathermen, chefs and engineers.

In the skies, or on the ground in over 600 offices, these are the people who make possible the fastest, most frequent service from the U. S. to anywhere in 80 countries.

When you fly the Clippers, the finest of America flies with you.

*Trade-Mark. Reg. U. S. Pat. Off.

Master Pilot John Mattis, one of the Clipper Captains who has logged over 500 transatlantic flights.

PAN AMERICAN

WORLD'S MOST EXPERIENCED AIRLINE

PARAMOUNT PICTURES

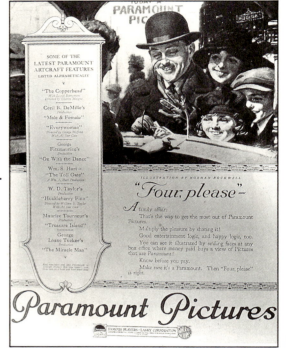

Some time after the turn of the century, a young man named Adolph Zukor was the proprietor of a penny arcade in New York City. Always fascinated with movies, he imported a film about Queen Elizabeth which starred Sarah Bernhardt; this was one of the first full-length movies shown in the United States. In 1912, following his theatrical debut, Mr. Zukor founded the Famous Players Company to "make films in New York." At about that time, four Hollywood showmen, Jesse Lasky, Cecil B. De Mille, Dustin Farnum and Samuel Goldwyn, founded the Jesse Lasky Feature Play Company and William W. Hodkinson organized a film distribution firm called Paramount Pictures. Zukor agreed to supply films for Hodkinson to distribute.

Four years later Zukor merged with Lasky and they purchased the Paramount Pictures Distributing Company and formed what was known as the Famous Players Lasky Corporation. Their major asset was an actress named Mary Pickford.

Adolph Zukor became the first president of Paramount and is credited with choosing the company trademark, a mountain high above the clouds surrounded by stars.

Over the years, Paramount Pictures has used many famous artists to illustrate magazines and billboards to advertise their movies. One of the lesser-known illustrations was done by Norman Rockwell to promote a group of pictures released by Paramount. The illustration, "Four, Please," which shows a happy family arriving at the movie box office expecting to see an exciting Paramount film, appeared in *The Saturday Evening Post* and several other national magazines.

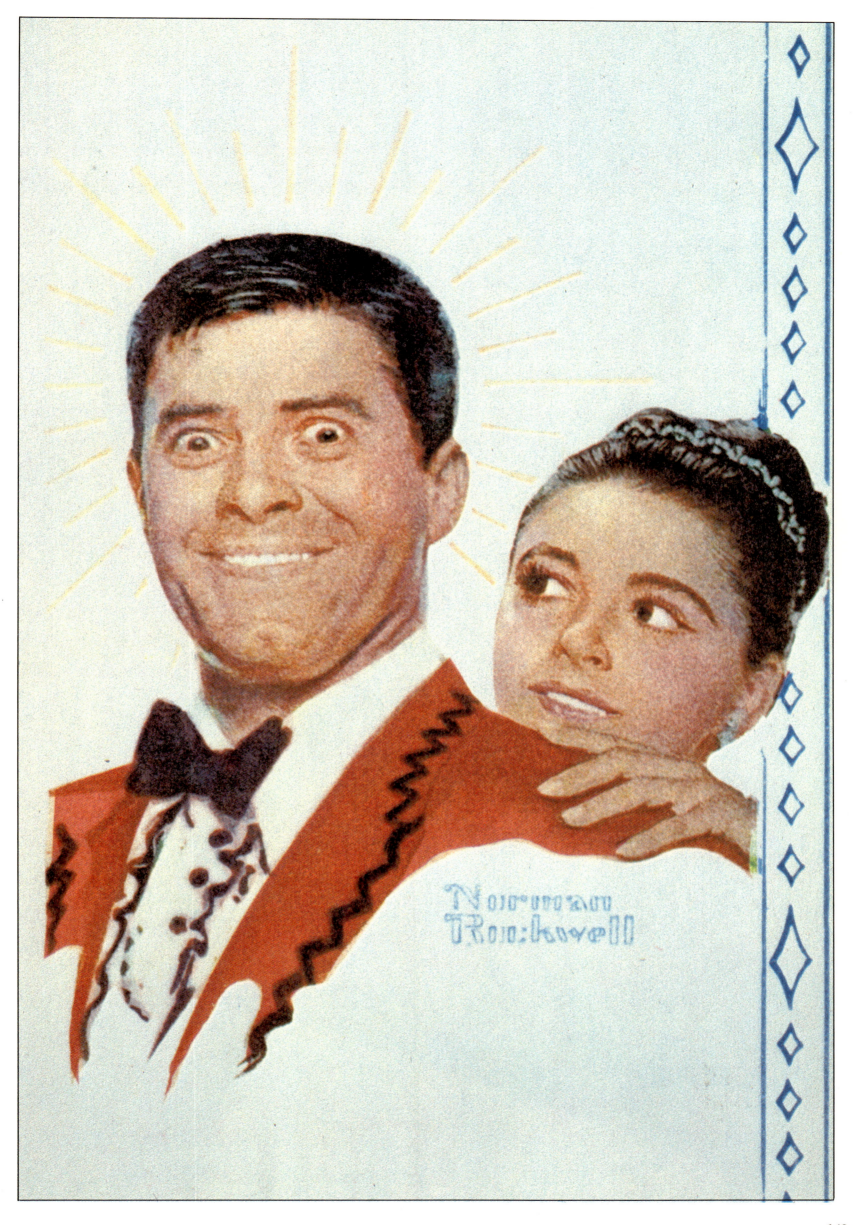

PARKAY MARGARINE

Kraft, Inc., originally known as National Dairy Products, was founded in 1923 with the merger of two dairy companies. Through the years numerous other dairy and food companies were acquired. The most famous of these organizations was the cheese company founded by J.L. Kraft in Chicago in 1903.

In October 1960, with the new advertising theme of "nourishing goodness" for its Parkay margarine, Kraft hired Norman Rockwell to illustrate four print ads for the campaign. Mr. Rockwell was at the stage of his career when he was turning down a dozen commercial assignments for every one that he accepted. When approached on behalf of Kraft, Mr. Rockwell said he would "really enjoy doing some work for Kraft because they make good things." And Kraft was pleased to have the work of this famous painter, since he represented the epitome of wholesomeness and good taste—which, by policy, are long-standing characteristics of Kraft advertising.

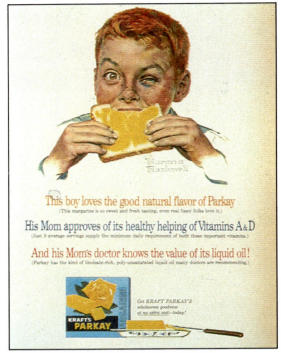

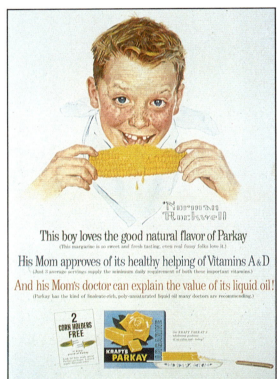

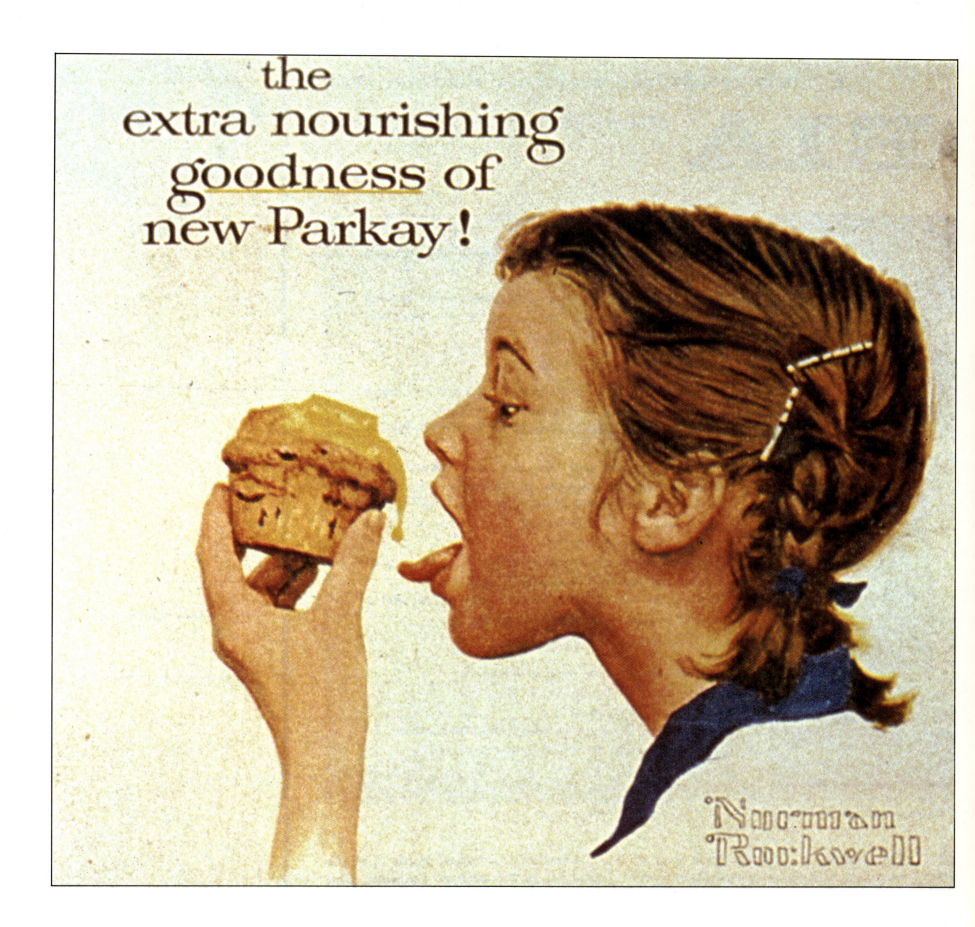

the
extra nourishing
goodness of
new Parkay!

145

PARKER PENS

The Parker Pen Company was founded in 1888 by George S. Parker, a Janesville, Wisconsin, telegrapher who developed a new kind of fountain pen. His invention met with such enthusiasm that he gave up telegraphy to go into the pen business. His first product, the "Lucky Curve" pen, remained virtually unchanged for thirty years.

Shortly after opening his doors, Mr. Parker set out to show the world that his pens could "write in any language." By 1903 he had exported products to Scandinavia, and by 1923 had established his first subsidiary in Canada.

Almost from the beginning, Parker has used national advertising to promote its products, associating itself with some of the world's finest agencies and artists to produce arresting, graphic messages. Such was the case in 1959 when Parker commissioned Norman Rockwell to do a series of warm, human portrayals of the Parker 61 as a gift of lasting value. The works depicting gift-giving situations were used that year in pre-Christmas advertising, and subsequently in other Parker promotional pieces.

The three Norman Rockwell oils commissioned by Parker now hang in the lobby of the company's headquarters in Janesville, Wisconsin.

147

PEPSI-COLA

In 1893, a young pharmacist named Caleb Bradham owned and operated a small drug store at the corner of Middle and Pollock Streets in New Bern, North Carolina. Mr. Bradham had a true American background: one of his great, great, great grandfathers was an officer in George Washington's army. He was raised in Chinquapin, North Carolina, and attended North Carolina University, after which he entered Medical School at the University of Maryland. But in 1891, his father's business failed and he left school to become a pharmacist.

Because of his personality, his pharmacy became a gathering place for many of his friends. When he wasn't mixing prescriptions, he was concocting various soft drinks for his friends. At some point in the mid-1890s he came up with a new beverage of his own creation and began serving it at his fountain. His customers loved it and named it "Brad's drink" in his honor. Sales and popularity of the new drink flourished and by August 28, 1898, young Bradham himself gave it the name "Pepsi-Cola".

At first, Pepsi was sold only at soda fountains, and in the first three months 2,008 gallons were produced. Production and sales increased rapidly and by 1907 104,000 gallons were made. However, distribution at soda fountains was not enough for the industrious Bradham and it was apparent to him that in order for his company to flourish Pepsi-Cola had to be put in bottles. Before long, bottling plants started production at Richmond, Norfolk and many other southern cities. Caleb Bradham's operation was rapidly becoming national in scope and by the end of 1909 his bottlers not only numbered 250 but there were bottling plants in 24 states. By 1915 Bradham, who was 48 years old, had reached the peak of his career. He was wealthy, successful, extremely popular and occasionally mentioned as a political possibility.

As the company grew, so did the advertising budget, and Pepsi-Cola ads were seen on billboards and in magazines everywhere. In 1965 the company contracted Norman Rockwell to do an advertisement to be used on highway billboards and in store windows. The result was the jovial, bouncy Santa Claus holding up a bottle of Pepsi-Cola and telling everyone around the world to "have a Pepsi Day."

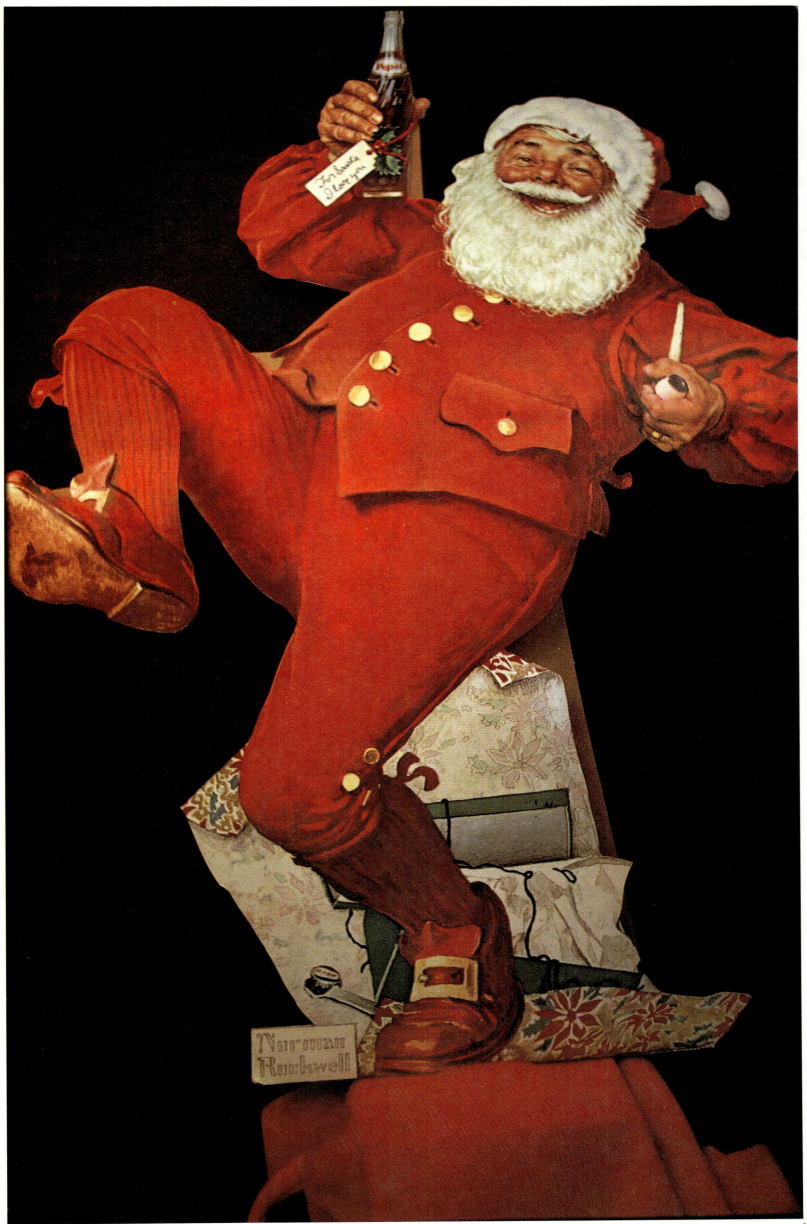

PERFECTION OIL HEATERS

By October 27, 1917, Norman Rockwell had already painted eight covers for *The Saturday Evening Post* and was receiving wide acclaim as a favorite among *Post* artists. Many companies, realizing the accuracy and popularity of his work, tried to contract him to do advertisements for their products. One of those was the Cleveland Metal Products Company of Cleveland, Ohio.

Mr. Rockwell did several paintings for the company, each one being informative, a bit humorous and beautiful and each showing the importance of having an oil heater.

On October 27 a full-page ad for Perfection Oil Heaters showed a young gentleman about to take a shower in a bathroom that was cozy warm from his inexpensive and easy-to-use new oil heater. The ad, along with previous ones, was so successful that Mr. Rockwell was commissioned to do another ad for Christmas of that year. This appeared on December 8, 1917, and showed a little boy dressed as Santa Claus presenting his parents with a new Perfection Oil Heater for Christmas.

The ad appeared in *Literary Digest* while most of the ads were in *The Saturday Evening Post*.

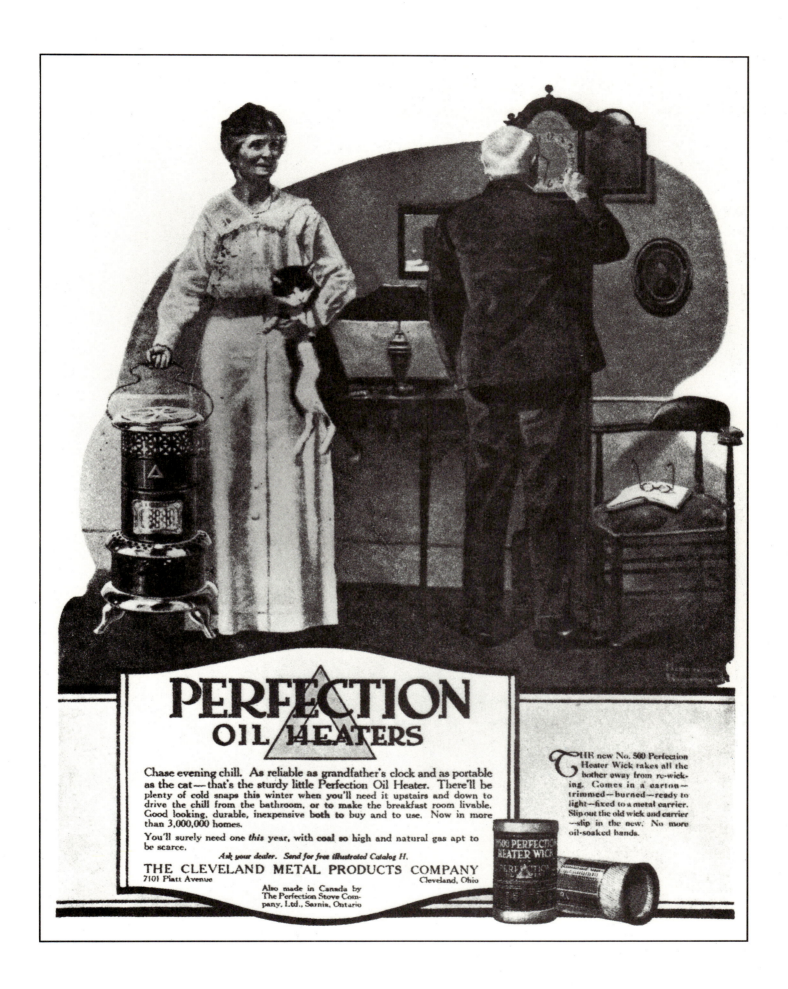

PERFECTION
OIL HEATERS

Chase evening chill. As reliable as grandfather's clock and as portable as the cat—that's the sturdy little Perfection Oil Heater. There'll be plenty of cold snaps this winter when you'll need it upstairs and down to drive the chill from the bathroom, or to make the breakfast room livable. Good looking, durable, inexpensive both to buy and to use. Now in more than 3,000,000 homes.

You'll surely need one *this* year, with coal so high and natural gas apt to be scarce.

Ask your dealer. Send for free illustrated Catalog H.

THE CLEVELAND METAL PRODUCTS COMPANY
7101 Platt Avenue Cleveland, Ohio

Also made in Canada by
The Perfection Stove Com-
pany, Ltd., Sarnia, Ontario

THE new No. 560 Perfection Heater Wick takes all the bother away from re-wick-ing. Comes in a carton—trimmed—burned—ready to light—fixed to a metal carrier. Slip out the old wick and carrier—slip in the new. No more oil-soaked hands.

PISO'S COUGH SYRUP

One of the first companies to contract Norman Rockwell to paint a full-color advertisement for their product was Piso's Cough Syrup. The advertisement first appeared in the early form of *Life* on February 17, 1921, and was one of the classical Rockwell advertisements that was instrumental in opening the door for many future years of commercial work.

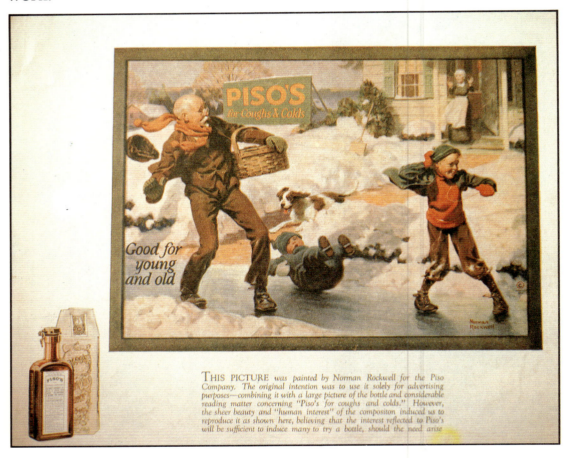

THIS PICTURE was painted by Norman Rockwell for the Piso Company. The original intention was to use it solely for advertising purposes—combining it with a large picture of the bottle and considerable reading matter concerning "Piso's for coughs and colds." However, the sheer beauty and "human interest" of the compositon induced us to reproduce it as shown here, believing that the interest reflected to Piso's will be sufficient to induce many to try a bottle, should the need arise

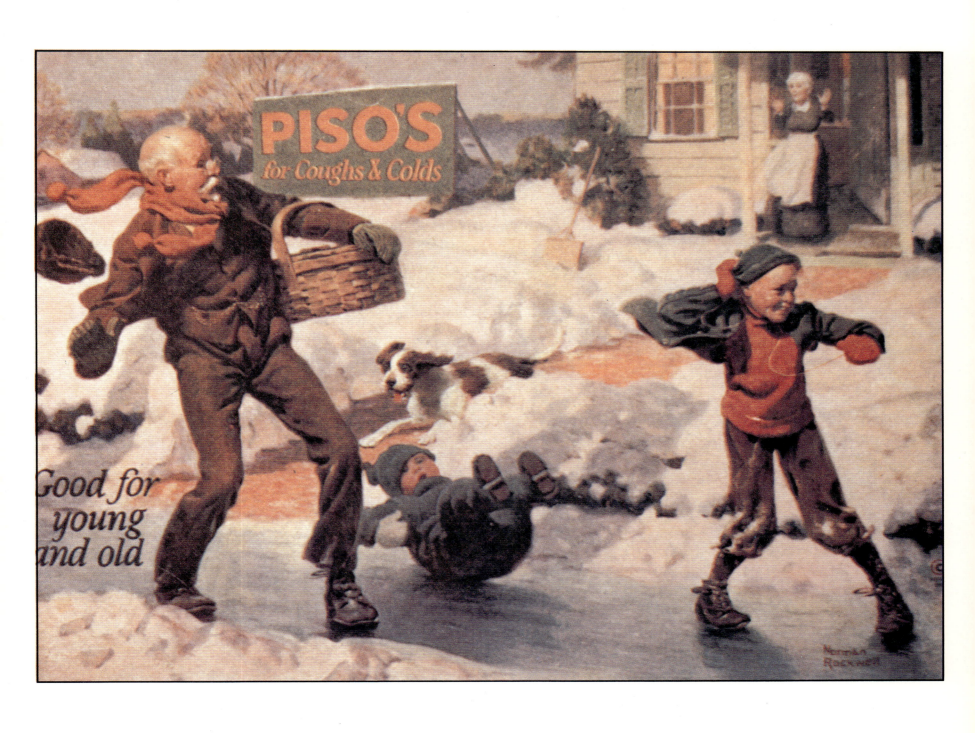

PLYMOUTH

The first Chrysler automobile, designed and built by Walter P. Chrysler, was shown to the public in 1924 at the Commodore Hotel during the New York Automobile Show. On June 6, 1925, Chrysler Corporation was formed when Walter P. Chrysler and his associates purchased the Maxwell facilities for the purpose of establishing a company to manufacture an entirely new concept of automobiles, which was later acclaimed as being an innovation in engineering and styling. Through the years Chrysler has maintained its high standard of engineering and styling improvements with the famous "Chrysler firsts" which were initially introduced in Chrysler automobiles and now used by many automobile manufacturers.

In 1950 the Chrysler Corporation hired Norman Rockwell to paint a picture for a Plymouth advertisement. During the holiday season, the wonderful ad appeared in many magazines and was met with great enthusiasm. The picture, entitled "Merry Christmas, Grandma...we came in our new Plymouth!" was followed the next Christmas 1951 with another Rockwell masterpiece, "Oh Boy! It's Pop with a new Plymouth!" The ads appeared in *Collier's*, *Life*, *National Geographic*, *Pathfinder*, *Time* and *The Saturday Evening Post*.

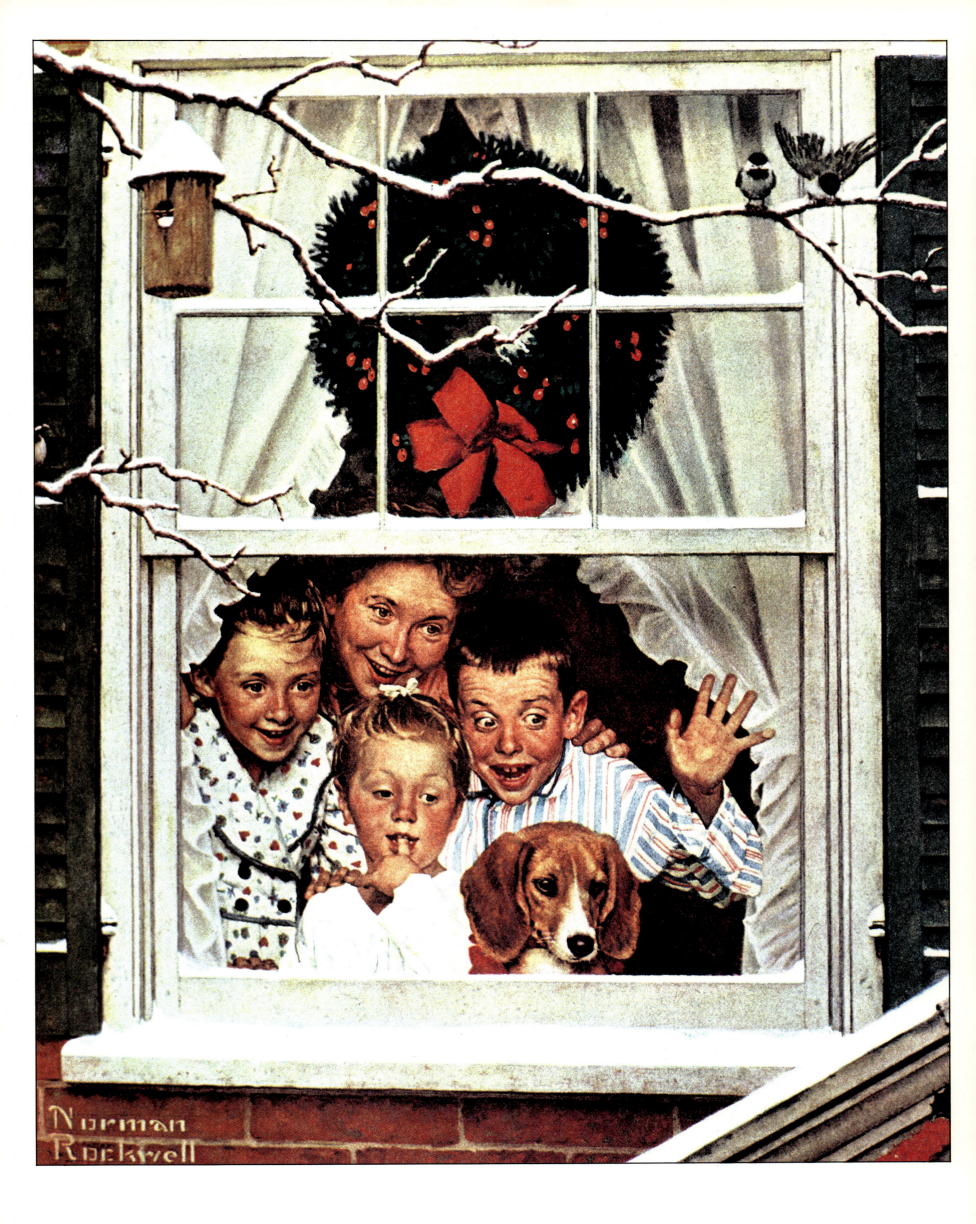

PURINA CAT CHOW

William H. Danforth, an industrious young farmboy, was born in southeast Missouri in 1870. Upon graduating from Washington University in St. Louis, Missouri, in 1892, he found a job with a brick company, which proved unsatisfactory because it was seasonal work. He realized that one business which remained active throughout the entire year was that of feeding animals, so in 1894 he and a friend began mixing formula feeds for farm animals. Two years later, a tornado wiped out their mill. Will Danforth negotiated a bank loan solely on the strength of his determination to make good, started up again and in the next few years sales flourished.

Although most people weren't very knowledgable about nutrition in those days, Will Danforth was convinced that food had a great effect on health. On one of his buying trips, Mr. Danforth met a miller who had discovered a way to prevent grain cereals from becoming rancid. He felt that this type of food was pure and nourishing, and was soon selling it under the name "Purina Whole Wheat Cereal" to St. Louis grocers. The word "Purina" had been coined from the company slogan "where purity is paramount." At about the same time, in a book entitled *Life Building*, a local doctor recommended a whole wheat cereal similar to the Purina product. Mr. Danforth approached Dr. Ralston, who agreed to endorse the Purina cereal, provided it was named Ralston Wheat Cereal. The agreement benefited both men, and by 1902 the names had become so widely known that the firm was changed to the Ralston Purina Company.

In looking for a trademark for his company and a distinctive dress for his products, Mr. Danforth remembered that as a young boy in Charleston, Missouri, he had always admired a family by the name of Brown who came to town every Saturday all dressed in red and white checks. It was convenient for Mrs. Brown to make the entire family's clothes from the same bolt of checkerboard cloth, and easier to round up her children when it came time to go home. The red and white checkerboard trademark identified Mr. Danforth's products just as boldly as it had the Brown family. The pattern has been part of the Ralston Purina Company since its beginning and even the headquarters in St. Louis is known as Checkerboard Square.

During World War I, Mr. Danforth served with the Third Division in Europe. He noted that the word "chow" appealed to soldiers in the field more than "food," so when he returned to his business after the war, he applied the name chow to all his poultry and livestock feed. Thus came into being the famous "Purina Chows" known to farmers throughout the United States and the world.

In 1968 the Ralston Purina Company sponsored a contest for Purina Cat Chow. First prize, a portrait of the winner and her cat painted by Norman Rockwell, went to Mrs. Jennie Myers, shown here.

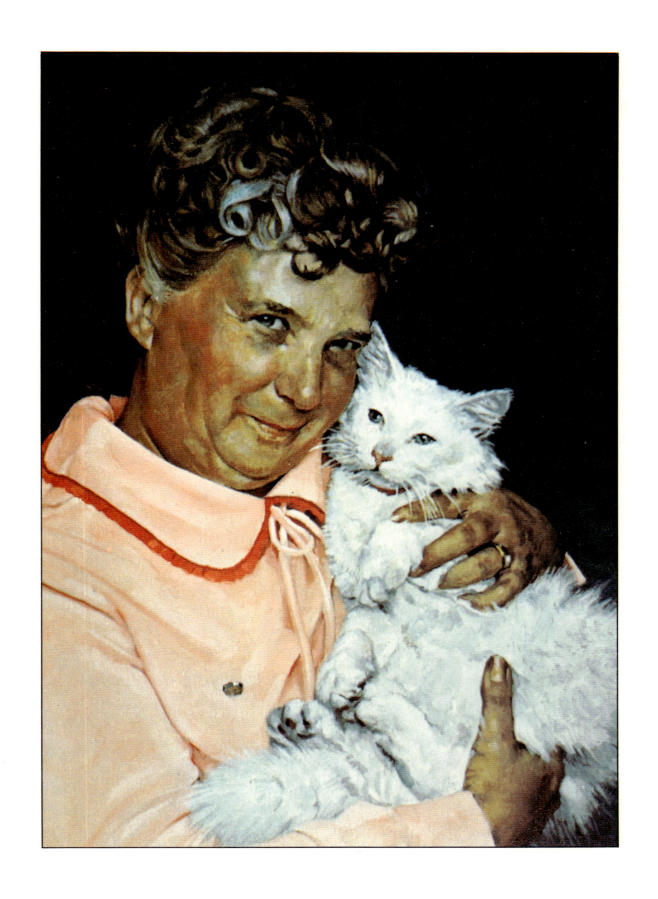

QUAKER

In 1850 a German immigrant by the name of Ferdinand Schumacher came to America and started a grocery store in Akron, Ohio. Within a few years, he was to change the eating habits of the entire country. Until that time, most Americans had a breakfast diet that included sausage, ham, steak, pies, and fried potatoes. Although oatmeal was eaten from time to time, it took too long to cook and few housewives took the trouble to prepare it. But oats were plentiful in America and were grown everywhere since the earliest colonies were founded. Although oats provided food for oxen and horses, Schumacher was disturbed that so little of the grain was consumed by humans, and decided to find a way that would take less time to cook. After solving the problem, he packed it in jars and told his customers to serve it with syrup or molasses and later, with cream and sugar.

Oatmeal's popularity as a breakfast food soared and before long Schumacher's success inspired many other oatmeal companies to begin packaging the breakfast food. However, competition became great and soon the principal oatmeal millers decided to merge to survive. After a series of consolidations, seven of the largest mills became The Quaker Oats Company.

The name Quaker Oats was conceived by two of its founders. Henry D. Seymour combed the encyclopedia for an idea for a name. He chose the name Quaker because the only Quakers who came to America had the qualities of his company: purity, sterling honesty, strength and manliness.

Mr. Seymour's partner, William Heston, is credited with having chosen the Quaker trademark. It seems that one day while walking through the streets of Cincinnati, he saw a picture of William Penn dressed in Quaker garb. Being of Quaker ancestry himself, he immediately decided that the image of William Penn would make an ideal trademark.

As the popularity of the company grew, several other breakfast grains were added to its line: Quaker Puffed Wheat and Quaker Puffed Rice rapidly joined the oat cereal in breakast bowls across the nation.

In 1924 the Quaker Oats Company commissioned Norman Rockwell to create an advertisement for Puffed Wheat and Puffed Rice. His portrayal of a bright, energetic, handsome young man who starts every day with a delicious and nutritious Quaker Oats Rice or Wheat cereal appeared in many magazines across the country. These included *The Christian Herald*, April 19, 1924; *Ladies' Home Journal*, April, 1924; *McCall's*, September 1924; *Needlecraft*, October 1924; and *Youth's Companion*, March 13, 1924. The ad was so popular and the boy with "that million dollar smile" became such a successful ad that it was used again in August 1938, in *Woman's Home Companion*.

Norman Rockwell

That million dollar Boy *of yours*

—do this to give him strength to meet life's later problems

Much of your boy's future depends on how well you build his body now. For without health and strength, early manhood will find him handicapped. He must have whole grains. He must have calcium to build bone. He must have vitamines.

Quaker Puffed Wheat is *whole wheat* with the lure of a confection. Airy grains of nut-like flavor, steam exploded to eight times their normal size, with food cells broken for quick digestion.

The wheat supplies the calcium. Also the needed bran. The milk, all three vitamines.

So here is the ideal food. And best of all, good food in a form that children love: luscious and enticing.

As a food for brain workers, too, it stands without compare, supplying quick nutrition without imposing on digestion —an ideal bed-time dish.

Quaker Puffed Rice—Kernels of rice, steam exploded like Puffed Wheat. Each grain an adventure, delicious and enticing. The daintiest of breakfast dishes.

Professor Anderson's Invention

Quaker Puffed Wheat and Puffed Rice are the famed inventions of Professor Anderson—foods shot from guns, the most thoroughly cooked grain foods known.

Quaker Puffed Wheat Quaker Puffed Rice

PRATT & LAMBERT

Pratt & Lambert was founded in 1849 when Alfred W. Pratt began manufacturing Pratt's Patent Liquid Dryer in a small factory on Long Island. The liquid dryer was revolutionary at the time, replacing a powdered drier that caused paint to dry with a gritty film.

In 1874 Henry S. Lambert joined the company as treasurer and in 1885 the firm changed its name from A.W. Pratt & Co. to Pratt & Lambert, Inc. At this time the principal products sold were architectural varnishes, carriage varnishes, and industrial finishes. In 1894 "61 Floor Varnish" was first marketed.

Much of Pratt & Lambert's growth came about around 1910 and stemmed from the sale of airplane dope, a composition that made the cloth that stretched over the plane frame taut so that airplanes could fly. During World War I, 75% of the U.S. combat planes were believed to have been coated with their airplane dope. This product paved the way for entry into the lacquer business, a related industry.

In the 1920s Pratt & Lambert supplied lacquer for Hudson, Pierce-Arrow and Reo automobiles as well as for Stewart trucks.

It was during the middle of this decade that Pratt & Lambert commissioned Norman Rockwell to illustrate a number of advertisements that appeared in *The Saturday Evening Post*, *House Beautiful*, *American*, *Good Housekeeping* and *MacLean's*. The original paintings were acquired by Pratt & Lambert, many of which hang in the executive offices today.

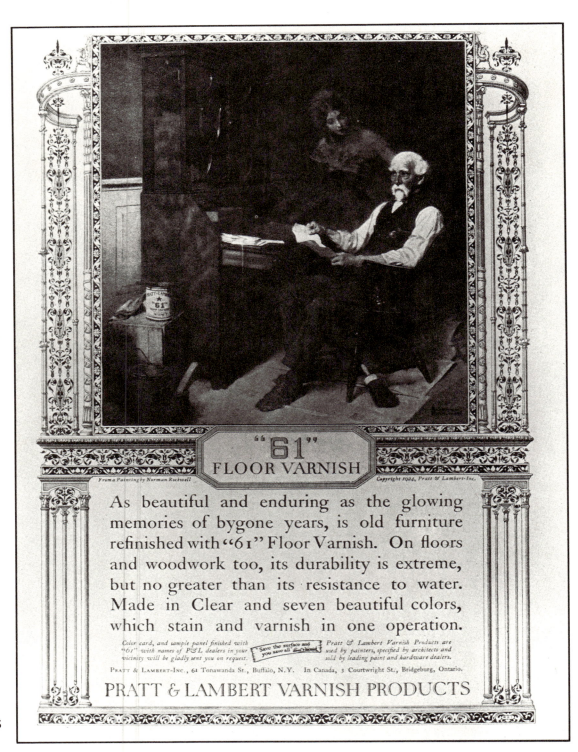

"61" FLOOR VARNISH

From a Painting by Norman Rockwell *Copyright 1924, Pratt & Lambert-Inc.*

As beautiful and enduring as the glowing memories of bygone years, is old furniture refinished with "61" Floor Varnish. On floors and woodwork too, its durability is extreme, but no greater than its resistance to water. Made in Clear and seven beautiful colors, which stain and varnish in one operation.

Color card, and sample panel finished with "61" with names of P&L dealers in your vicinity will be gladly sent you on request. *Pratt & Lambert Varnish Products are used by painters, specified by architects and sold by leading paint and hardware dealers.*

PRATT & LAMBERT-INC., 61 Tonawanda St., Buffalo, N.Y. In Canada, 3 Courtwright St., Bridgeburg, Ontario.

PRATT & LAMBERT VARNISH PRODUCTS

RED WING SHOES

The advertisement created by Norman Rockwell for the Red Wing Shoe Company was typical of the exacting detail and home-spun humor brought together by Mr. Rockwell to create a memorable piece of art. The advertisement showing the mailman and the garageman each wearing a new pair of Red Wing Shoes, certainly got the point across that the Red Wing product was created for the working man. But more important, it illustrated a typical everyday event in the life of an average American, and this is to whom the Red Wing Company wanted to appeal.

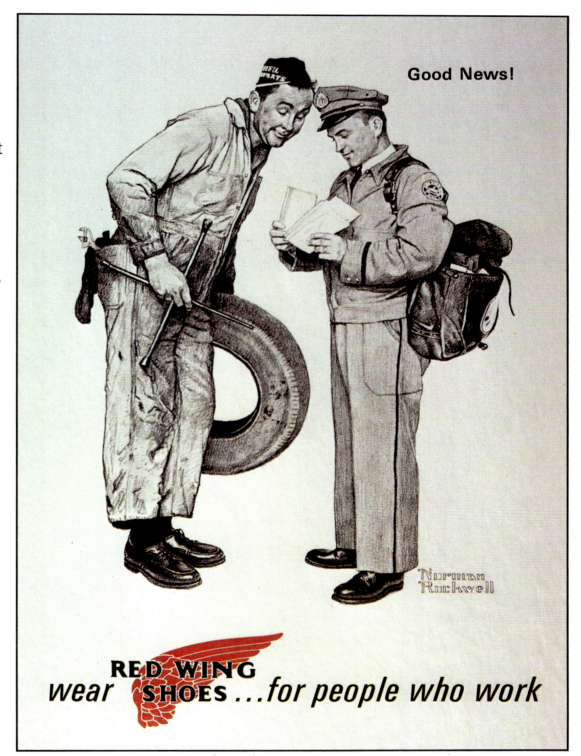

RAYBESTOS

In 1922 the Raybestos Company commissioned Norman Rockwell to do several paintings to advertise their brakes and brake linings. At that time the Raybestos Company, with factories in Bridgeport, Connecticut, and Peterborough, Ontario, Canada, was a large producer of automobile brakes. Their brakes had asbestos linings, which were felt to be one of the surest, safest brake linings available.

In order to advertise their product and to inform the American public of the need for driving safety, Mr. Rockwell created six advertisements which appeared on January 7, March 4, April 1, September 9 and October 7, 1922, and on January 12, 1924 in *The Saturday Evening Post*. These colorful and clever ads warned people that good brakes were essential when driving on hills, in bad weather, and in heavy traffic.

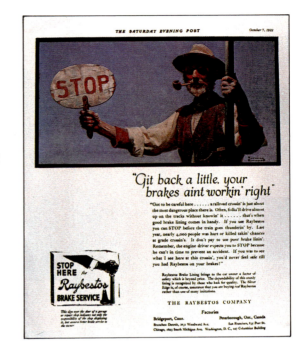

Comfort in Safety

THE automobile manufacturer builds into his particular car those units which he knows will give satisfactory service for the life of the unit. The brakes are designed to provide you with "comfort in safety", but only so long as the brake lining is in *perfect condition*.

The manufacturer does his utmost to assure safety. Yet, *his* responsibility is limited. After the car is in *your* hands, the responsibility rests upon you. Brakes need occasional adjustment and, in time, brake lining will become worn and require renewal.

To obtain *the same measure of safety* which the manufacturer intended should be yours, you must have the brakes inspected and adjusted periodically.

Your garageman can readily render this service, and if new silver edge Raybestos brake lining is needed he will apply it by the Raybestos Method which means— "COMFORT IN SAFETY!"

If you will forward the coupon, we shall be glad to tell you the name of the serviceman in your vicinity who will inspect, adjust and reline your brakes with Raybestos by the Raybestos Method.

THE RAYBESTOS COMPANY

FACTORIES: Bridgeport, Conn. Peterborough, Ont., Canada
 Stratford, Conn. London, England
BRANCHES:
Detroit, 2631 Woodward Avenue San Francisco, 835 Post St.
 Chicago, 1603 South Michigan Avenue

THE RAYBESTOS COMPANY, BRIDGEPORT, CONN.

GENTLEMEN: Please send me your booklet "BRAKES—Their Care and Upkeep," and the name of the nearest serviceman who will inspect, adjust or reline my brakes by the Raybestos Method.

Name _____

Address _____

I drive a _____

RCA RECORDS

In 1901 the Victor Talking Machine Company was founded by Eldrige Johnson. The infant phonograph industry became a huge business almost overnight through his leadership.

Johnson's promotion techniques included the famous fox terrier "Nipper" listening to "His Master's Voice". The revolutionary process of stamping duplicate records from electroplated master-disks was further developed, record quality dramatically improved, and a new repertoire of recorded performances built up.

In 1920, with the advent of public broadcasting, RCA began to sell "radio music boxes". In 1925 the electrical recording was born, and the microphone replaced the recording horn.

Radio Corporation of America established the nation's first radio network in 1926—the National Broadcasting Company. Soon afterwards RCA acquired the Victor Talking Machine Company.

RCA Victor was the perfect marriage—radio became the star salesman for records by bringing popular music to people in all walks of life.

The illustration on the cover of the *Pure Prairie League* album was originally done for *The Saturday Evening Post*'s cover of August 13, 1927, and in 1972 reproduced on the RCA Records album. RCA Records continues to issue some of the finest recorded music of our times.

PURE PRAIRIE LEAGUE

VICTOR STEREO

RCA LSP-4650

Woman—Tears—Country Song—It's All on Me—Harmony Song—You're Between Me—Take It Before You Go—Doc's Tune

RED ROSE TEA

In many countries of the world, the name "Brooke Bond" is synonymous with tea. In Britain, where the per capita consumption of tea is still one of the highest in the world, blended and packaged tea was first introduced to the consumer by Arthur Brooke, who, in 1869, having seen the need for a standard quality product, opened a shop in Manchester, England, where he devoted much of his time to developing consistently high-quality blended tea which he sold in small packages. The idea was so successful that he formed a company under the name of Brooke Bond & Company.

In 1912 his son, Gerald Brooke, succeeded his father as Chairman and started opening offices in the tea-producing countries: Calcutta, India, in 1901; Colombo, Sri Lanka, in 1920. In 1925 he pioneered the growing of tea in Kenya.

Through business, Mr. Gerald Brooke had established a friendship with Mr. T.H. Estabrooks, who, like Gerald's father, had developed a tea business in Canada based on high-quality blended tea, which he sold under the name Red Rose—the first packaged tea to be sold in the Maritime provinces in Canada.

In 1932, on the retirement of Mr. Estabrooks, Mr. Brooke was encouraged to acquire the Red Rose business and so Brooke Bond entered the North American market and continued to expand the tea business under the Red Rose name.

By 1954 Brooke Bond, now under the leadership of Mr. John Brooke, Gerald's son, was selling tea all over the world. North American progress had kept pace and Red Rose tea, which was now being exported from Canada to the United States, achieved wide acceptance.

In 1958 Norman Rockwell was persuaded to paint six pictures of people enjoying Red Rose tea—in typical situations where they are obviously in need of a cup of the brew that relaxes.

As can be seen, Norman Rockwell has captured in these pictures the words of a famous British Prime Minister, Mr. Gladstone, who said, "If you are cold, tea will warm you—if you are too heated, it will cool you—if you are depressed, it will cheer you—if you are excited, it will calm you."

The colored reproduction opposite, under the title "How to revive a tired shopper," well illustrates how these pictures were used to advertise Red Rose Tea. This particular one was used in 1958 in *Weekend* magazine, a photogravure magazine which was distributed with the Saturday issue of a number of daily papers across Canada.

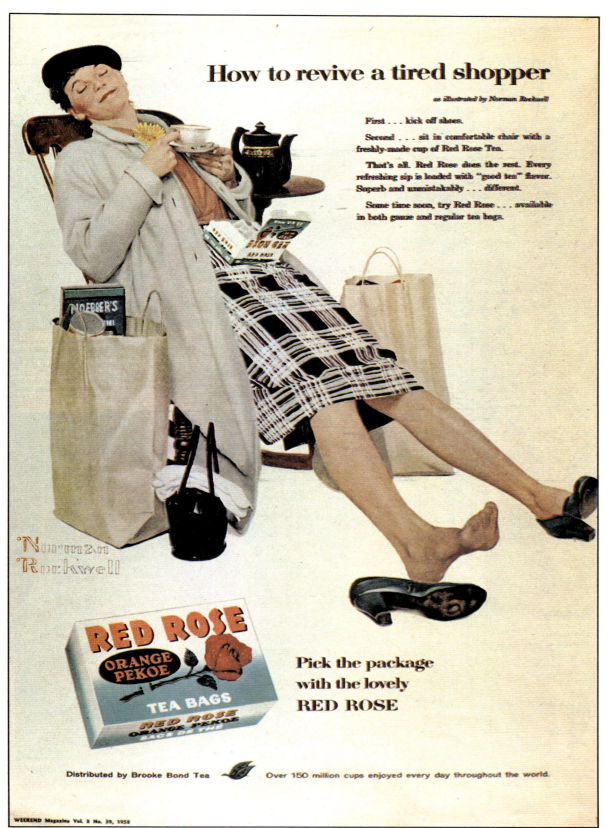

RKO GENERAL PICTURES

In 1883, more than a decade before the first motion pictures were shown to a curious public, B.F. Keith founded the first of his variety theaters in a remodeled storefront in South Boston. This 15 x 35 foot theater became the nucleus of the mighty Keith-Allbee Orpheum Vaudeville circuit. The birth of motion pictures caused the demise of vaudeville. One of the companies that capitalized on the exciting new movie industry was the English firm of Robertson-Cole. This company began as an exporter of Hollywood films and built their own studio in 1920. In 1922 it reorganized as the Film Booking Office of America, Inc. The president of the company was Joseph P. Kennedy. In 1928 the Keith-Orpheum Company went into negotiations with RCA and on October 25, 1928, the Radio-Keith-Orpheum Corporation ("RKO") was incorporated in Maryland. In 1929 RCA purchased control of the studio and merged it with the KAO Vaudeville Circuit. This circuit provided the exhibition outlets required by the new corporation. The company soon after acquired Pathe Newsreels and the famous Selznick Studio in Culver City where *Gone With The Wind* was filmed.

On March 11, 1948, Howard Hughes purchased control of RKO Radio Pictures and on July 25, 1955, he sold the company to the General Tire Corporation.

During its illustrious lifespan, RKO produced some of the best known of all motion pictures. These included *Stage Door*, *Citizen Kane*, *The Bells of St. Mary*, *I Remember Momma*, *Gunga Din*, *Top Hat*, *Of Human Bondage*, *The Hunchback of Notre Dame*, *She Wore a Yellow Ribbon*, and *Mr. Blandings Builds His Dream House*.

Throughout the many years that RKO was producing its classic pictures, many famous artists were called upon to advertise the movies. One of the best-known RKO pictures, *The Magnificent Ambersons*, which was adapted from a novel by Booth Tarkington, had its advertising posters created by Norman Rockwell. In this picture, which appeared on billboards and in several magazines, six members of the cast had their portraits illustrated by the famous artist and both the movie and the advertisement caught the fancy of the American public.

FROM THE MAN WHO MADE "THE BEST PICTURE OF 1941"

ORSON WELLES'

MERCURY PRODUCTION OF BOOTH TARKINGTON'S GREAT NOVEL

The
Magnificent
Ambersons

Norman Rockwell

with JOSEPH COTTEN · DOLORES COSTELLO · ANNE BAXTER · TIM HOLT

AGNES MOOREHEAD · RAY COLLINS · ERSKINE SANFORD

and RICHARD BENNETT

Screen Play, Production and Direction by Orson Welles

ROCK OF AGES

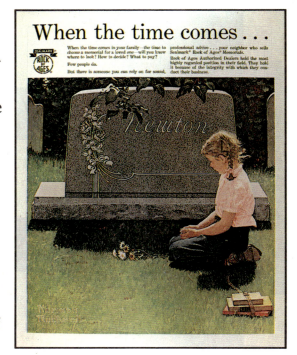

The Vermont granite industry got its start at the beginning of the nineteenth century. But not until the beginning of the twentieth, with the formation of the Boutwell, Milne & Varnum Company did granite become the foremost industry in Barre, Vermont.

The Boutwell, Milne & Varnum Company was formed in 1905 when the granite developments owned solely by George Milne merged with the extensive dark granite properties held jointly by James Boutwell and Harvey Varnum. The merger placed the operation of large deposits of granite under a central management able to expand the quarrying and distribution of Barre granite.

In 1919 Boutwell, Milne & Varnum began to advertise "Rock of Ages" nationally as a dark Barre granite unsurpassed as a family memorial. By 1925 the demand for "Rock of Ages" had increased dramatically and Boutwell, Milne & Varnum was renamed the Rock of Ages Corporation, strengthening its image with the public. A model of the original Rock of Ages quarry, on display at the Smithsonian Institution in Washington, D.C., has preserved these beginnings of the granite industry.

The Craftsman, painted by Norman Rockwell in 1962, symbolizes the tradition of quality granite craftsmanship. Earlier, in 1955, Rockwell touchingly painted *The Kneeling Girl* and captured the love and remembrance of a family memorial.

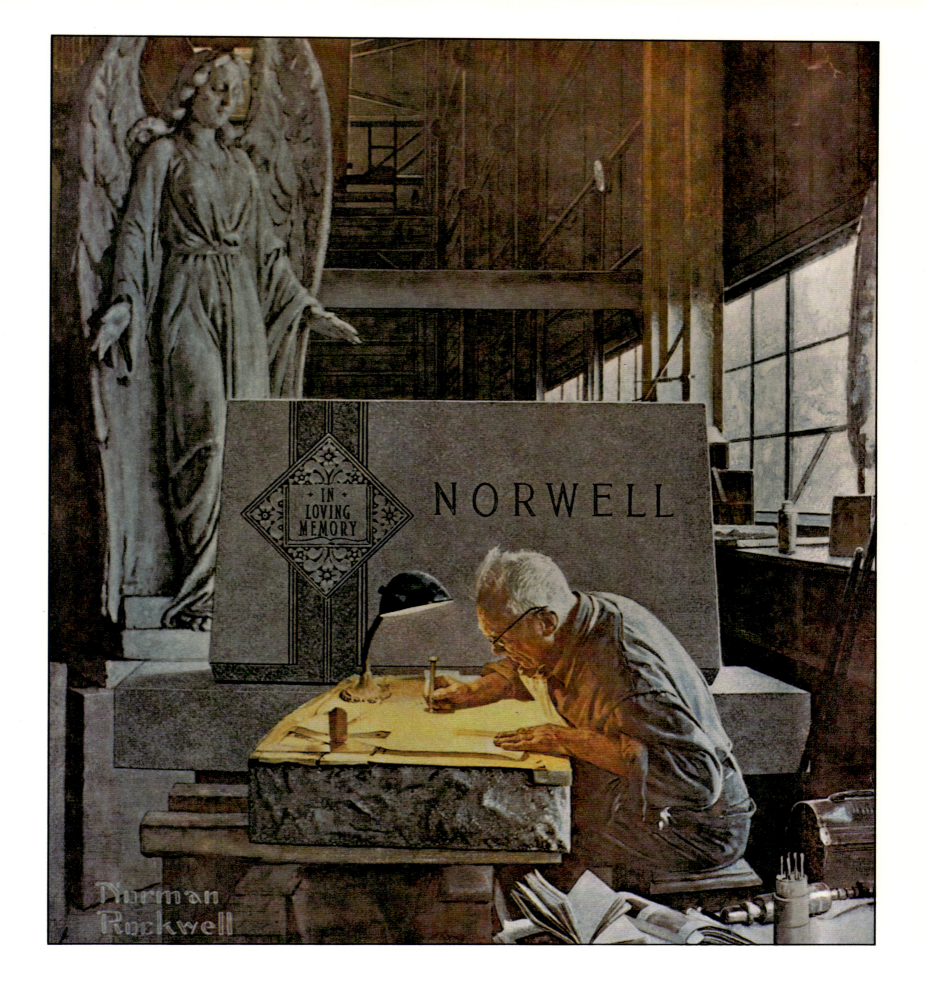

ROEBLING STEEL

John A. Roebling Corporation of Trenton, New Jersey, was one of the large manufacturers of steel wire. Mr. Rockwell's illustration of a contractor trying to decide which brand of steel to use appeared in the 1953 issue of *Oil and Gas Journal*, *World Oil*, *Drilling Contractor* and *Petroleum Engineer*.

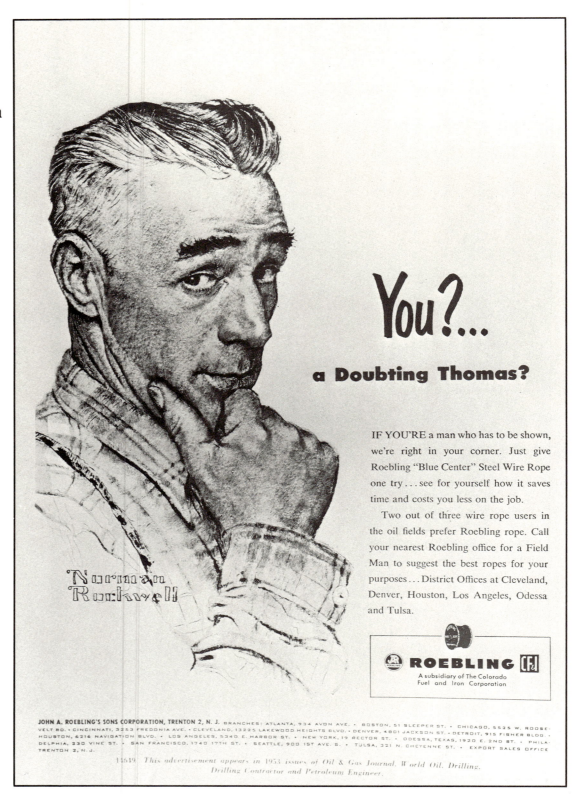

You?...

a Doubting Thomas?

IF YOU'RE a man who has to be shown, we're right in your corner. Just give Roebling "Blue Center" Steel Wire Rope one try... see for yourself how it saves time and costs you less on the job.

Two out of three wire rope users in the oil fields prefer Roebling rope. Call your nearest Roebling office for a Field Man to suggest the best ropes for your purposes... District Offices at Cleveland, Denver, Houston, Los Angeles, Odessa and Tulsa.

ROEBLING CFI

A subsidiary of The Colorado Fuel and Iron Corporation

JOHN A. ROEBLING'S SONS CORPORATION, TRENTON 2, N. J. BRANCHES: ATLANTA, 934 AVON AVE. • BOSTON, 51 SLEEPER ST. • CHICAGO, 5535 W. ROOSEVELT RD. • CINCINNATI, 3253 FREDONIA AVE. • CLEVELAND, 13225 LAKEWOOD HEIGHTS BLVD. • DENVER, 4801 JACKSON ST. • DETROIT, 915 FISHER BLDG. • HOUSTON, 6216 NAVIGATION BLVD. • LOS ANGELES, 5340 E. HARBOR ST. • NEW YORK, 19 RECTOR ST. • ODESSA, TEXAS, 1920 E. 2ND ST. • PHILADELPHIA, 230 VINE ST. • SAN FRANCISCO, 1740 17TH ST. • SEATTLE, 900 1ST AVE. S. • TULSA, 321 N. CHEYENNE ST. • EXPORT SALES OFFICE TRENTON 2, N. J.

14519 *This advertisement appears in 1953 issues of Oil & Gas Journal, World Oil, Drilling, Drilling Contractor and Petroleum Engineer.*

ROMANCE CHOCOLATES

In 1923, as it has been ever since, the most popular gift a young man can give a young lady is a box of chocolates. Romance Chocolates were created by the Cox Confectionery Company of East Boston, Massachustts and in 1923 sold for a dollar a pound. To advertise their product, Norman Rockwell was commissioned to paint a handsome young couple tasting the delicious chocolates, and the classic Rockwell painting along with other advertisements for Romance Chocolates, appeared in *Atlantic Monthly*, March, 1923, *Century*, March and April 1923, *Harper's Monthly*, March and April 1923, *The Saturday Evening Post*, February 24 and April 23, 1923, and *World's Work Magazine* in April of 1923.

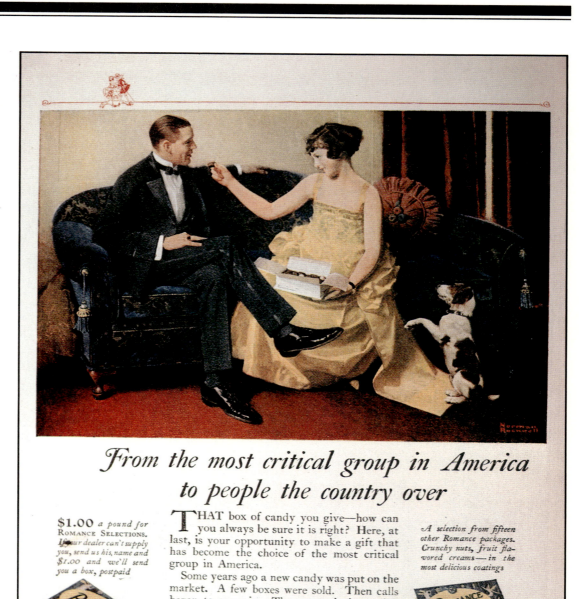

From the most critical group in America to people the country over

$1.00 a pound for ROMANCE SELECTIONS. If your dealer can't supply you, send us his, name and $1.00 and we'll send you a box, postpaid

THAT box of candy you give—how can you always be sure it is right? Here, at last, is your opportunity to make a gift that has become the choice of the most critical group in America.

Some years ago a new candy was put on the market. A few boxes were sold. Then calls began to come in. They came in increasing numbers. People were telling their friends, were giving the new candy as gifts.

Today Romance Chocolates can be offered to a wider public. Your confectioner or your druggist has them. New flavors from exclusive recipes! Creamy chocolate coatings over meaty nuts and luscious fruit and cream centers! 80c to $1.50 a pound. Cox Confectionery Company, East Boston, Mass.

A selection from fifteen other Romance packages. Crunchy nuts, fruit flavored creams— in the most delicious coatings

ROMANCE CHOCOLATES

Sears

SEARS, ROEBUCK

In 1886 a Chicago jewelry company accidentally shipped some gold-filled watches to a jeweler in a small town in Minnesota. The jeweler had no need for the watches and took them back to the railroad station to be shipped back to Chicago. A sixteen-year-old telegrapher working at the station purchased the watches and in turn sold them at a nice profit to other railroad employees up and down the line of the Minneapolis and St. Louis railway. This was the beginning of the R.W. Sears Watch Company in Minneapolis—an enterprise destined to become one of the most dramatic success stories in American business.

The following year Richard W. Sears moved his business from Minneapolis to Chicago and inserted a classified ad in *The Chicago Daily News* for a watchmaker. An Indiana lad, Alvah C. Roebuck, answered the ad. He convinced Richard Sears that he knew watches and he was hired. Here began the association of two men, both still in their twenties, that was to make their names famous. In 1893 the corporate name of their firm became Sears, Roebuck and Company.

From that simple beginning emerged the greatest mail order company that the world has ever known. And although their earliest catalogs featured only watches, by 1895 Sears was producing a 532-page catalog which offered shoes, women's garments, wagons, fishing gear, stoves, furniture, china, musical instruments, saddles, firearms and many other items.

Under the guiding genius of Richard Sears the firm grew rapidly, keeping pace wth the growth of the United States. Catering mostly to rural Americans, the Sears catalog became a household word and merchandise distribution centers began to spring up across the country. The business expanded so fast that it outgrew one building after another and in 1906 opened a mail order plant in Chicago that was the largest business building in the world. In the decades that followed the business continued to grow and Sears stores and sales offices opened in many foreign countries. In 1970 the company began constructin of the Sears Tower in Chicago for its national headquarters. The building, completed in 1974, was and still is the largest private office building in the world.

In 1927 Sears, Roebuck and Company chose Norman Rockwell to create a cover for their Spring–Summer catalog. The result was the beautiful painting of a young couple reading the famous ad book while a typical Rockwell dog watches. Almost 40 years later Mr. Rockwell was called upon again to illustrate an advertisement. The 1964 picture was a back-to-school ad with a family preparing a young fellow for his first day at school, and of course, the Rockwell pup is an important part of the family scene.

SHARON STEEL CORPORATION

The company, incorporated in 1900, was organized to manufacture narrow steel bands.

In 1917 Sharon acquired additional melting facilities and a blast furnace at Lowellville, Ohio, and in 1945 purchased the Farrell, Pennsylvania, works of Carnegie-Illinois. That plant, now named the Victor Posner Works for its Chief Executive Officer, is the country's thirteenth largest steel producer, with a capacity for producing approximately one percent of the nation's steel.

In 1968 The Sharon Steel Corporation commissioned Norman Rockwell to paint a series of pictures depicting various facets of steel production to be used in magazine advertisements. These colorful and powerful pictures appeared in *Fortune* throughout 1968 and in *Industry Week* in 1974.

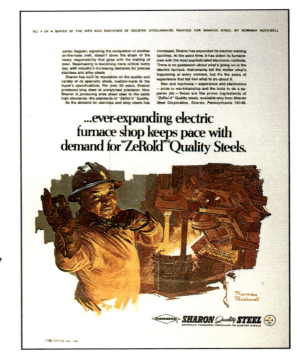

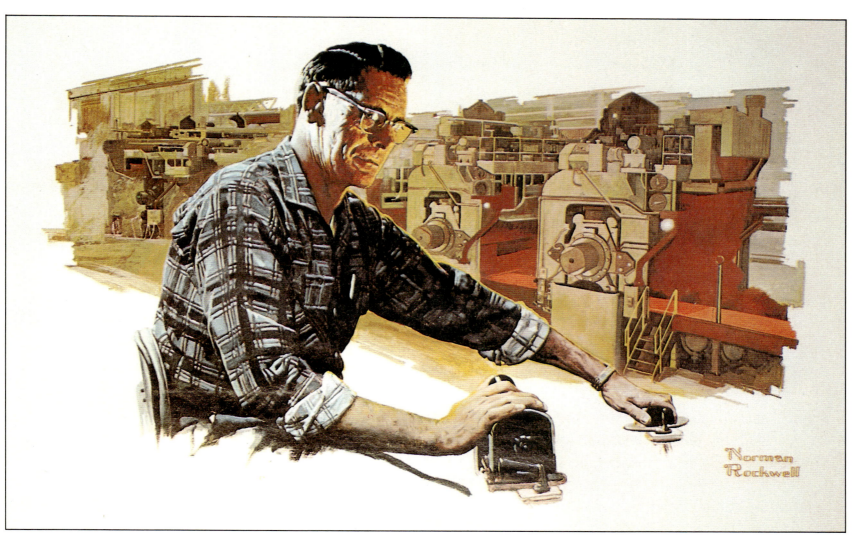

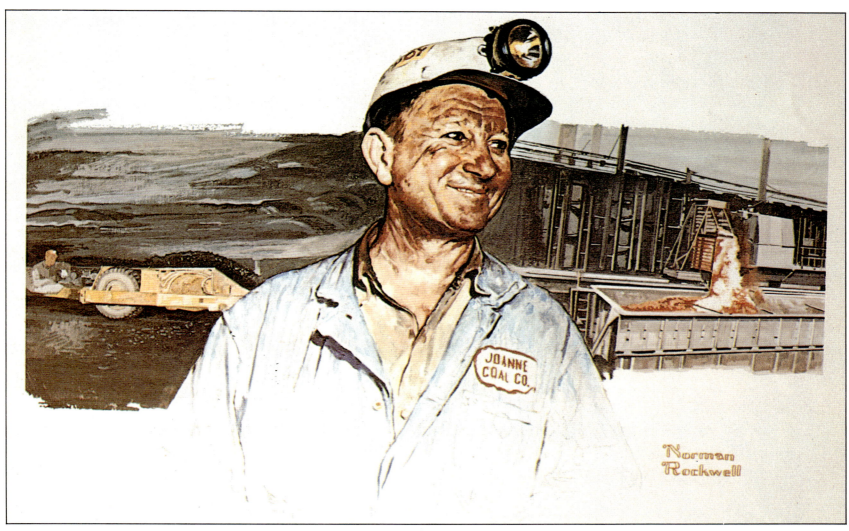

SHEAFFER PENS

History shows that the earliest writing instruments were probably brushes and sharp pieces of metal or bone. As early as 300 B.C. the Greeks and the Egyptians made pens from hollow sheaths into which they poured ink that they squeezed onto a surface. About 50 B.C. men discovered that sharpened goose quills made excellent writing instruments. The word *pen* itself comes from the Latin word *pinna*, which means feather. Metal tips were later added to the quills, which were widely used until the mid-1800s.

In 1884 Lewis Waterman, a U.S. inventor, introduced one of the first practical fountain pens. This pen was filled with ink squeezed from an eyedropper.

In 1913 W.A. Sheaffer developed a lever-fill fountain pen that revolutionized the industry. This invention helped make the Sheaffer Company one of the leading producers of writing instruments in the world. Mr. Sheaffer's fountain pen was the mainstay of schools, businesses and anyone who had to write until the first ballpoint pens were developed in the mid-1940s.

In 1955 the advertising division of the Sheaffer Company contracted Norman Rockwell to do an advertisement for Christmas of that year. The heart-rending painting of a young couple returning home for the holidays appeared in *National Geographic* and *Better Homes and Gardens* in 1955 and was used again in the *Sheaffer-Eaton Times* in the winter issue of 1976. Charlotte Markham, the younger woman in the painting, was a neighbor of Mr. Rockwell's and she still remembers how he asked her to pose in her heavy winter coat for almost two hours while he shot dozens of photographs. The final rendering revealed a scene that takes place in every home on Christmas Day and certainly one of the packages carried by the young gentleman is a brand-new Sheaffer fountain pen.

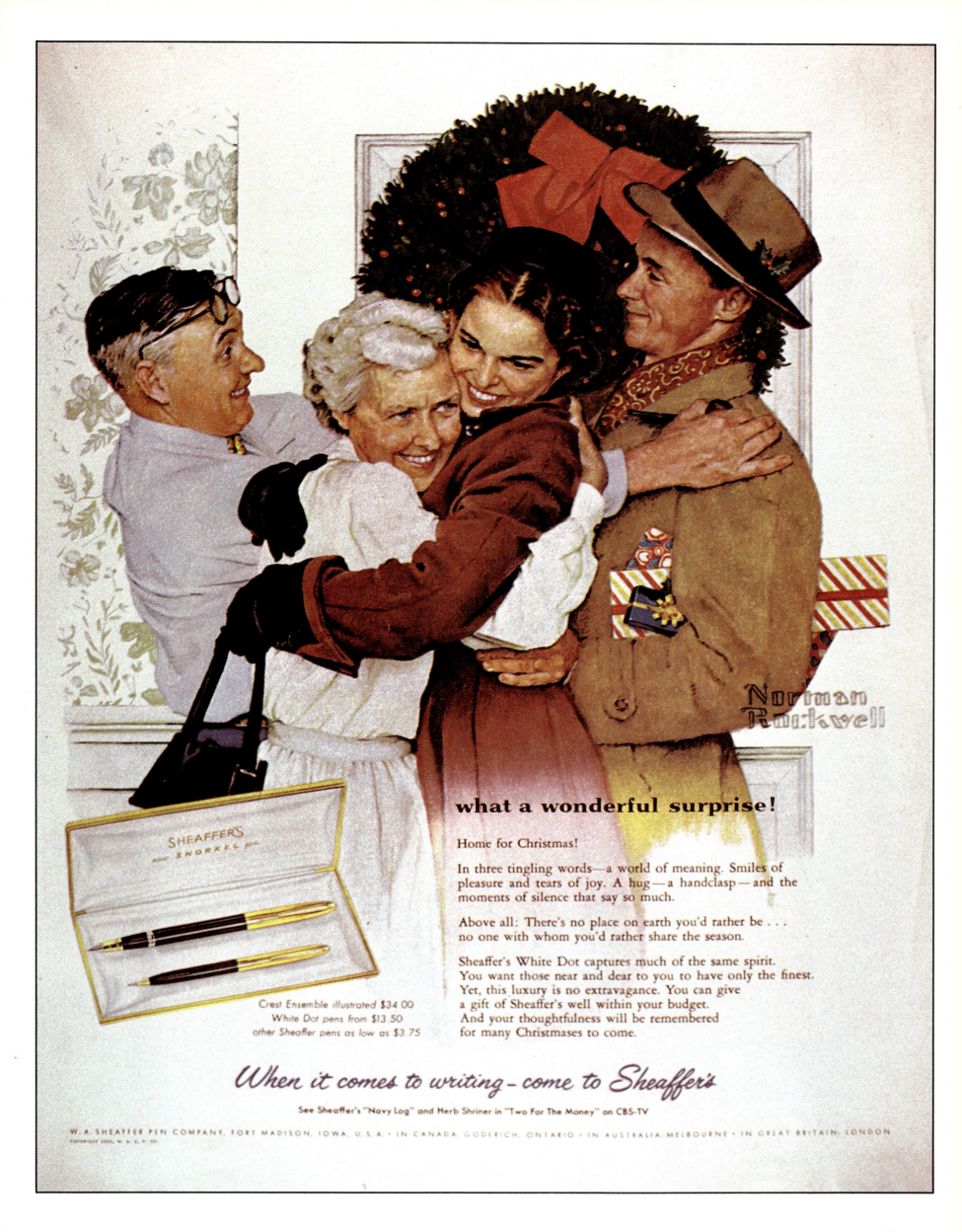

what a wonderful surprise!

Home for Christmas!

In three tingling words—a world of meaning. Smiles of pleasure and tears of joy. A hug—a handclasp—and the moments of silence that say so much.

Above all: There's no place on earth you'd rather be . . . no one with whom you'd rather share the season.

Sheaffer's White Dot captures much of the same spirit. You want those near and dear to you to have only the finest. Yet, this luxury is no extravagance. You can give a gift of Sheaffer's well within your budget. And your thoughtfulness will be remembered for many Christmases to come.

Crest Ensemble illustrated $34.00
White Dot pens from $13.50
other Sheaffer pens as low as $3.75

When it comes to writing—come to Sheaffer's

SHREDDED WHEAT

Just before the turn of the century, a Denver lawyer by the name of Henry Perky was en route by train to Watertown, New York, to try to convince a friend, William Ford, to join him in a new venture.

Perky, a 47-year-old attorney and part-time inventor, was in search of a method for processing corn so it would remain edible after being dehydrated. With his experimentation, he developed a machine that could press wheat into thin delicious biscuits. He called these biscuits "Shredded Wheat."

By the autumn of 1893, Perky was operating a small bakery in Denver to make his shredded wheat biscuits. He also opened a restaurant to serve them, and a fleet of wagons to sell them door to door. The demand was so great that his production grew quickly to national distribution and as the new century dawned, he bought a ten-acre site in Niagara Falls, New York, and put up a $2 million modern plant, which he called "The Palace of Light." In May of 1901, the Shredded Wheat Company had its birth.

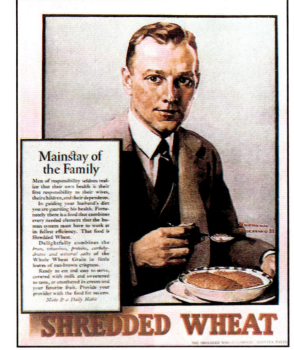

Over the next few decades, the company prospered and it was acquired by The National Biscuit Company. In 1926 the company commissioned Norman Rockwell to do an advertisement for Shredded Wheat. The two ads, which showed a young mother serving a hot, nourishing meal and a young father having his Shredded Wheat before he leaves for work, appeared in December of 1926 in *Good Housekeeping*, *Household Magazine* and *People's Home Journal* and in April of 1927 in *Ladies' Home Journal* and *Woman's Home Companion*.

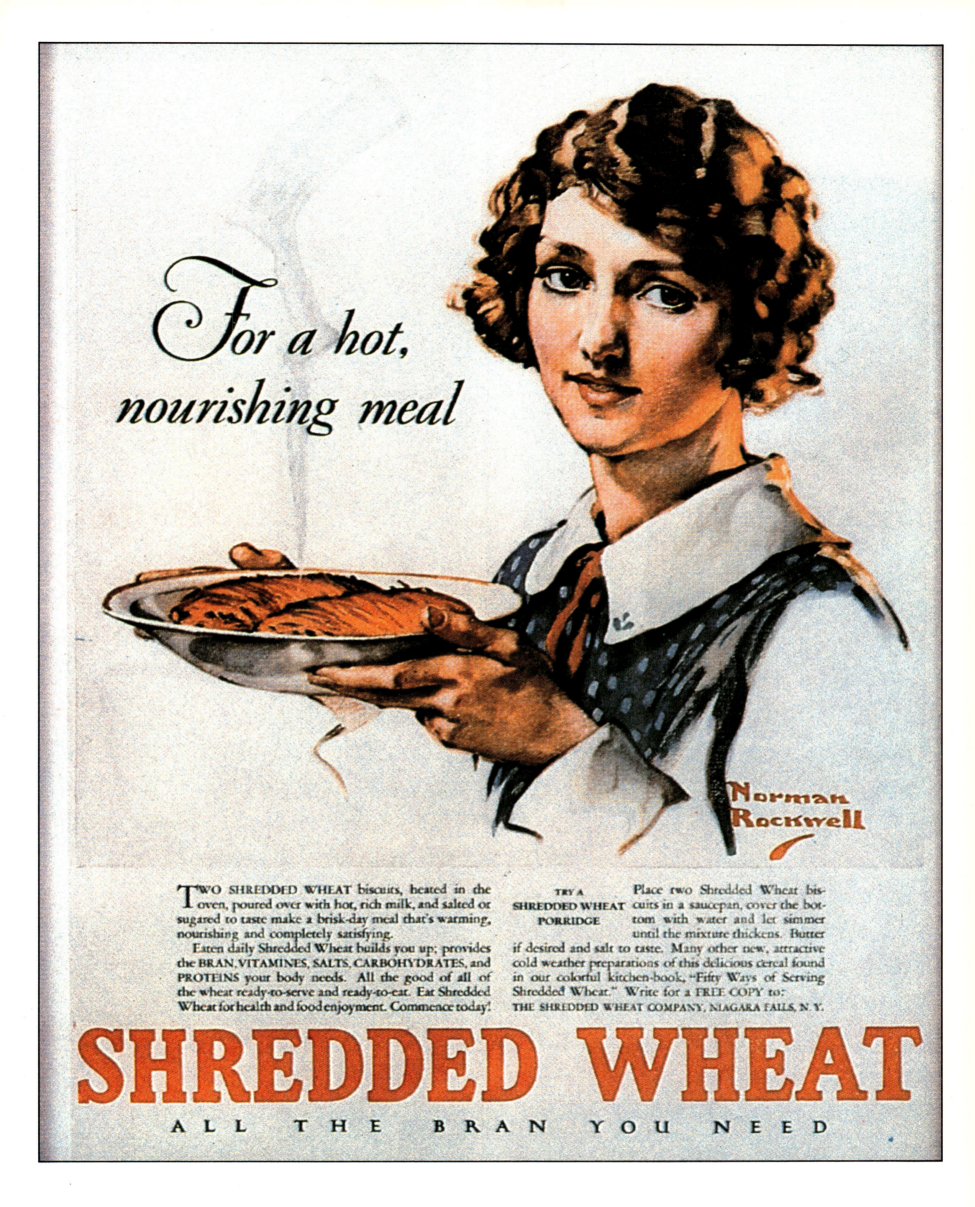

For a hot, nourishing meal

Norman Rockwell

TWO SHREDDED WHEAT biscuits, heated in the oven, poured over with hot, rich milk, and salted or sugared to taste make a brisk-day meal that's warming, nourishing and completely satisfying.

Eaten daily Shredded Wheat builds you up; provides the BRAN, VITAMINES, SALTS, CARBOHYDRATES, and PROTEINS your body needs. All the good of all of the wheat ready-to-serve and ready-to-eat. Eat Shredded Wheat for health and food enjoyment. Commence today!

TRY A
SHREDDED WHEAT
PORRIDGE

Place two Shredded Wheat biscuits in a saucepan, cover the bottom with water and let simmer until the mixture thickens. Butter if desired and salt to taste. Many other new, attractive cold weather preparations of this delicious cereal found in our colorful kitchen-book, "Fifty Ways of Serving Shredded Wheat." Write for a FREE COPY to: THE SHREDDED WHEAT COMPANY, NIAGARA FALLS, N. Y.

SHREDDED WHEAT
ALL THE BRAN YOU NEED

SKIPPY PEANUT BUTTER

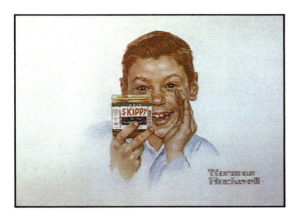

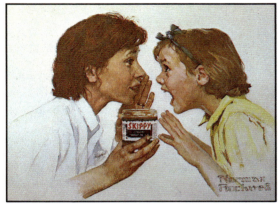

Over the years, the word *Skippy* has become synonymous with peanut butter. The favorite food of almost every kid is either peanut butter and jelly sandwiches or peanut butter crackers. And, of course, for parents, peanut butter has become indispensable food in every household.

While peanuts have been grown in America for a thousand years or more, peanut butter made its appearance only about 1890. It was then, the unconfirmed story goes, that a St. Louis physician invented it as an easy-to-digest, high-protein food for his patients. The original was simply roasted peanuts run through a kitchen grinder with a little salt. By 1914 there were commercial peanut butters sold from tubs in grocery stores, with hand-dipped to order.

It wasn't until sometime between 1922 and 1923 that the present-day version appeared. J.L. Rosefield of Alameda, California, developed what he called "churned" peanut butter. In this new process, the oil stayed homogeneously distributed throughout, unlike the original where the oil would float to the top. Nine years later, in 1932, Mr. Rosefield started his own brand, Skippy, using this special process. Today, this type of peanut butter remains the most popular, though old-fashioned peanut butter is making a comeback in some parts of the country.

Over the years, the Skippy Peanut Butter Company has stated that their product is hard to beat because it is high in protein and has no cholesterol, it is very nutritious, and most of all, it is good tasting.

In 1963 the Skippy Company asked Norman Rockwell to illustrate these facts in a full-color advertisement. They knew that nobody could create pictures of happy kids better than Mr. Rockwell, and no kids could be happier than those enjoying Skippy Peanut Butter. The results of this advertisement appeared in *The Saturday Evening Post* on May 28, 1963, *Ladies' Home Journal* in June, 1963, and also appeared on supermarket billboards across the country. The ad was so successful that it was also used for a sweepstakes contest promoted by Skippy Peanut Butter.

SUN·MAID

In September of 1873 a devastating heat wave struck California's San Joaquin Valley, leaving the area's grape crop shriveled on the vines. Facing disaster, one enterprising grape grower shipped his "dried grapes" to San Francisco, where they were advertised as "Peruvian delicacies." They sold out immediately, creating a demand that helped bring forth the world-famous California raisin industry.

As this new, specialized industry developed, a group of California growers joined together to produce and market the world's finest raisins. In search of a descriptive trademark, a very special name and personality came into being...SUN-MAID.

Realizing that their product was famous for its wholesome, natural, sun-dried goodness, Sun-Maid constantly sought the best ways to advertise these famous features. In the 1920s, recognizing his professional, fresh and natural style, Sun-Maid commissioned Norman Rockwell to illustrate a series of advertisements. They appeared in most of the leading national publications of the period, including *The Saturday Evening Post*, whose covers were made famous by Rockwell's work. A statement in one of the Sun-Maid advertisements sums up why Sun-Maid and Norman Rockwell got together. "What a wonderfully amusing way Norman Rockwell has of telling a story." The Sun-Maid story was indeed told very well by the Rockwell illustrations.

What a wonderfully amusing way Norman Rockwell has of telling a story! In this picture as in his cover illustrations for the Saturday Evening Post.

Here he lets us in on the fun of a darling tea party—and gives us a pointer on cooking: Puddings are improved by lots of Sun-Maid raisins.

Thousands of families agree with him on that. And it's so easy to add the raisins; no extra work at all, I often wonder why every housewife doesn't do it every time.

If your pudding recipes don't call for raisins—rice, bread, tapioca and chocolate puddings, the tempting hot weather ones made with gelatine—*all* kinds—and you don't know just how to fix them, let me help you. Write me in care of Sun-Maid, Fresno, California.

Mary Dean

The more raisins the better the pudding

And good raisins cost so little in this Sun-Maid bargain sack

The simplest puddings will be popular at your house if they hold plenty of plump, meaty raisins. A few raisins aren't enough. And good raisins are essential.

Both are reasons for buying the Sun-Maid "Market Day Special" bag.

In this bag you get *4 lbs. or 2 lbs.* of fine *seedless raisins* and you get them at a

And (new size) 2 lbs.

surprisingly low price. It's a value that only Sun-Maid can offer for Sun-Maid alone can select from the crop just the finest raisins, perfect *those*, and profitably dispose of the rest that do not meet its standards. Sun-Maid methods and equipment are exclusive.

Ask your grocer for the blue bag with the Sun-Maid girl on it. Use these raisins generously in cakes, pies, cookies, cereals *and puddings*. See how the folks enjoy your treats.

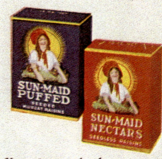

Your grocer also has:
A wonderful new kind of seedless raisins—with the fragrance, flavor and plump tenderness of fresh grapes! Ask him for Sun-Maid Nectars.

And Sun-Maid Puffed—*seeded* raisins that aren't sticky! With all the flavor of the *Muscat* grape!

Grown and packed by

Sun-Maid Raisin Growers

OF CALIFORNIA

A cooperative association of 17,000 individual growers

SWIFT & COMPANY

Gustavus Franklin was born in 1839 and started working for his brother in their New England butcher shop when he was 14 years old. At age 17, he went into business for himself, and before he was 35 he was a cattle exporter and a wholesale meat dealer. Association with the meat business since 1855 made him an expert judge of cattle. He saw the need to eliminate expensive transportation costs in the meat packing business, and in 1875 he moved to Chicago, where he started his first slaughterhouse. At first the activity had to be confined to the cooler months, but the use of a refrigerator car made it a year-round business.

On April 1, 1885, Swift & Company was formed and, following Gustavus Franklin's leadership, was guided by two generations of family members. Today Swift & Company, a division of Esmark, still ranks as one of the largest food processors of diversified food and marketers of consumed packaged products and fresh meats in the United States.

In the mid-1950s, if anyone were to ask a mother what kind of food she fed her baby, her answer might very well be, "Swift Baby Food, naturally." By that time, the small New England firm that rose from a local butcher shop to world leadership in the meat industry was producing much of all the canned baby food. And who could paint babies and their mothers' mutual love and beauty better than Norman Rockwell? For this reason, Mr. Rockwell was chosen for several magazine advertisements for Swift and Company. These advertisements appeared in 1955 and 1956 in *Better Living*, *Ladies' Home Journal*, and *True*. The pictures were extremely popular, as expected, and very successfully celebrated the centennial anniversary of Swift and Company, marking 100 years since the opening of the little butcher shop.

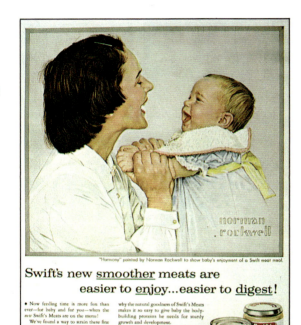

SANFORD CORPORATION

The Sanford Corporation has been in business since 1857. It was in that year that Professor Fredrick W. Redington, a professor of Latin and Greek, called on the Sanford Brothers of Worcester, Massachusetts. Dr. Redington was well acquainted with the superior writing ink which the Sanford Brothers had developed and were selling in the Northeast, because he had used it in the Academy at Fredonia, New York, where he taught. Looking for an occupation that would provide a better income, the professor bought the company.

Building on the business foundation that the Sanford Brothers had established, Dr. Redington expanded distribution from his base in Worcester. In 1866, though, lured by the potential of new markets, he moved the business to Chicago and established his new factory just outside of what is now the Chicago Loop. That original Chicago factory escaped the Chicago fire of 1871, but then burned to the ground in 1899. A new building erected in 1900 was the first factory building in Chicago made entirely of steel and concrete. Sanford grew at that location until 1947, when a new factory was constructed in Bellwood, Illinois, a

To celebrate its 70th birthday, Sanford Corporation commissioned Norman Rockwell to create a painting to be used to advertise their writing products. The ad appeared in several magazines in 1927 and is a favorite among the legal profession.

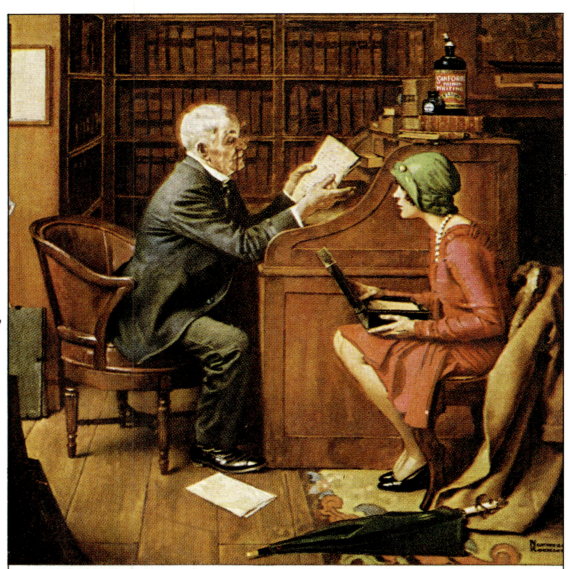

"It's lucky for you, child, your Gran'dad wrote this will with Sanford's Ink!"

TIME may crumple and yellow the paper on which Sanford's Ink is used. But the original writing remains clear and legible for generations. That is why documents that must endure should always be inscribed with Sanford's Blue Black, fadeless, smooth-flowing writing ink which has stood the test of TIME.

TOP VALUE STAMPS

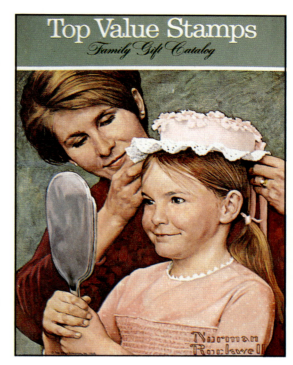

Top Value Enterprises, Inc. is now the second largest trading stamp company in the United States. Back in the early 1960s not many people knew about trading stamps. Even fewer people knew about Top Value. It was a young company which had been formed only in 1955. A long and extensive search was undertaken for a way to give the company a sense of identification. Top Value wanted to express itself as a company with special warmth, with a bit of humor and fun and as a company serving a broad segment of the American people.

The search led directly to Norman Rockwell, and Top Value ended up with Norman Rockwell paintings on the cover of its stamp redemption catalog for nine straight years. What began as a strictly business relationship turned into a fond association with many memories. Stories abound from those fortunate enough to have worked with Norman Rockwell. They all tell about an uninhibited, gentle man with a heart as big as a bucket.

In addition to the special memories which he left, the covers painted by Norman Rockwell have now become collectors' items. Top Value receives dozens of requests each year to purchase the catalogs which were once given away free. Unfortunately, these catalogs are long since out of print. But Top Value is proud of its association with Norman Rockwell.

NORMAN ROCKWELL

194

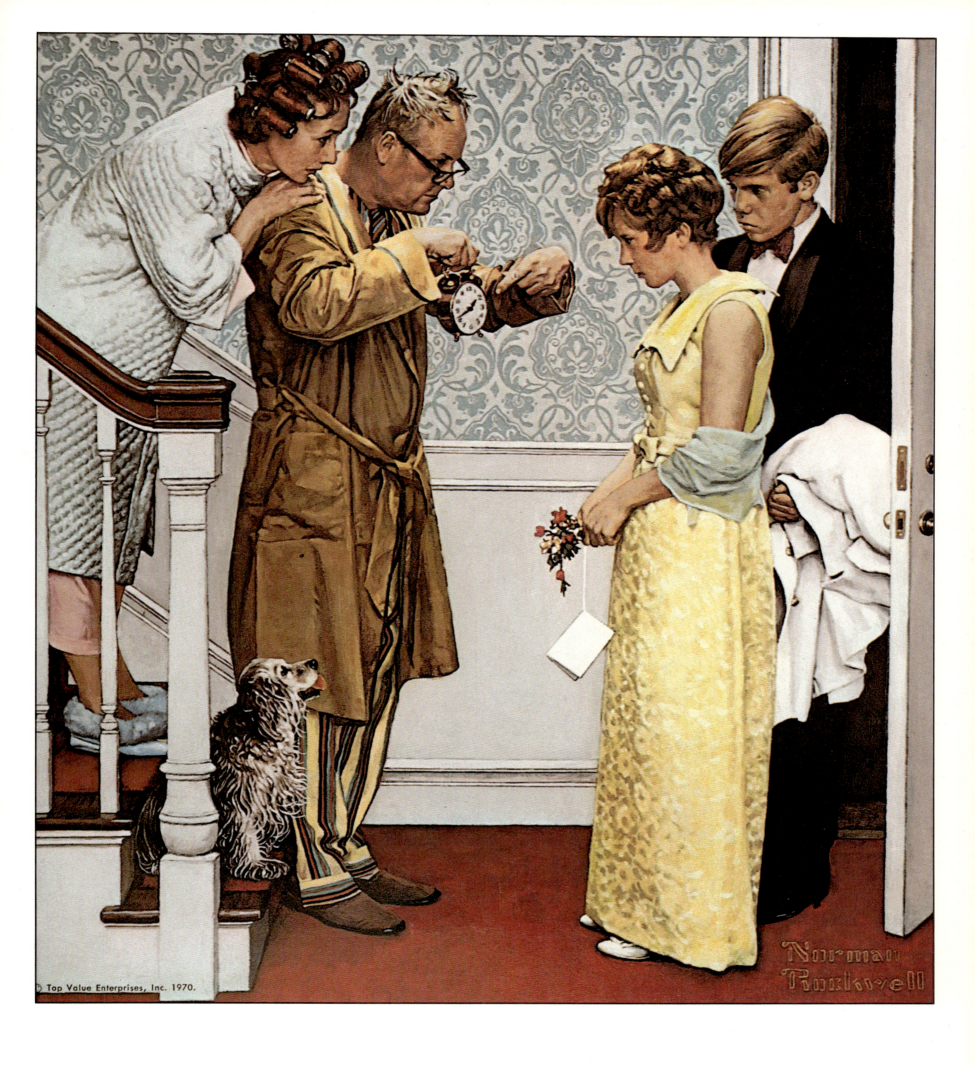

TILLYER LENSES

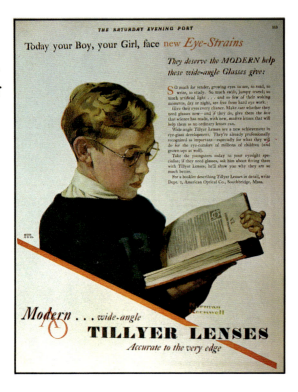

The Tillyer Lens Company is a division of American Optical Company, which has produced lenses for eyeglasses for many years. In 1929 the company commissioned Norman Rockwell to create an advertisement, and his picture of a young boy wearing eyeglasses with Tillyer Lenses appeared in *The Saturday Evening Post* in December of that year. Today the American Optical Company is still a major manufacturer of all types of lenses.

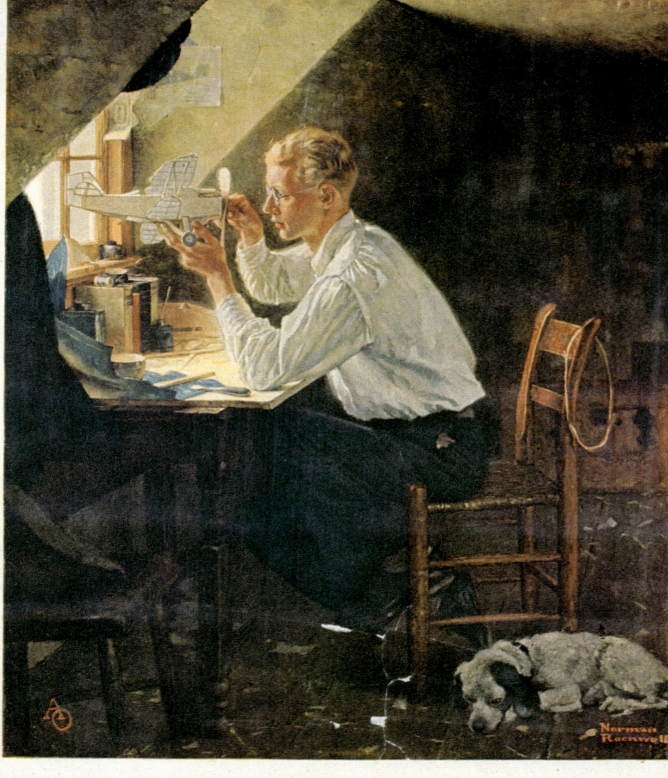

TWENTIETH CENTURY-FOX

In 1900 William Fox, a young Hungarian Jewish immigrant, was working as a coat liner for S. Cohen and Son in New York City for $25 a week. Despite his meager salary he was able to save enough money to form his own business, The Knickerbocker Cloth Examining and Shrinking Company. In 1904 he sold the company for a large profit and went into a daring new venture. He bought a large store, filled it with seats and began showing movies for an admission of 5 cents. This type of show was beginning throughout New York and was called a nickelodeon. In 1909 Mr. Fox began producing his own films with a company called The General Film Company, and by 1916 he moved his production studios to Los Angeles, where at the intersection of Western Avenue and Sunset Boulevard Fox Films began its motion picture operation.

In 1924 Darryl F. Zanuck was a young writer for Warner Brothers Pictures working on scripts for Rin-Tin-Tin, the famous canine star. In 1927 Mr. Zanuck became production chief at Warner Brothers at age 24. A few years later, in 1933, he left Warner Brothers and formed the 20th Century Company with Joseph M. Schenk, who was then the director of United Artists. In 1935 they merged with Fox Films and Zanuck became vice president in charge of production. For more than a quarter of a century Darryl Zanuck ruled Twentieth Century-Fox, and during that time, some of the most famous movies and movie stars made their appearance.

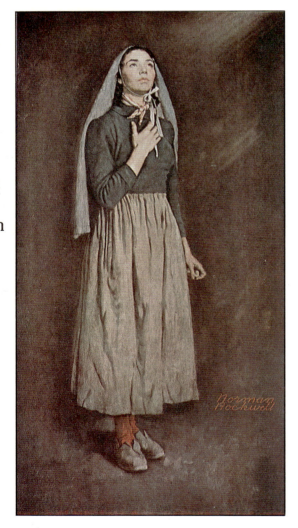

In 1939 Twentieth Century-Fox produced the movie *Stagecoach*, which became a great hit. The movie was so successful that they decided to refilm it in 1965. At that time Norman Rockwell was contacted by Martin Rackin, the producer for Twentieth Century Fox, who asked him to go to Hollywood to paint pictures of the stars in *Stagecoach*. Mr. Rockwell had seen the original movie and enjoyed it so much that the entire project fascinated him. After talking it over with his wife, Mary, he accepted the offer and traveled to California.

His commission was to paint portraits of nine stars: Ann-Margaret, Bing Crosby, Robert Cummings, Van Heflin, Mike Connors, Alex Cord, Slim Pickens, Stefanie Powers and Red Buttons.

In addition to painting the stars, Mr. Rockwell also created a large canvas of a stagecoach being pulled at top speed by six horses with a band of Indians in hot pursuit. The producers of the film were so impressed with Mr. Rockwell, they asked him if he would agree to a bit part in the film. "Why not?" he replied, and shortly thereafter was filmed in his movie debut showing some card tricks to Mike Connors.

The painting appeared on movie billboards across the country, and both the movie and the Rockwell pictures were huge successes.

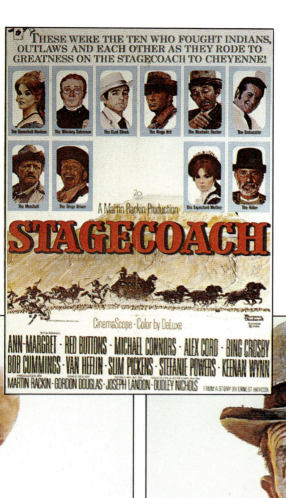

UNDERWOOD TYPEWRITERS

In 1714 an English engineer named Mills got the first patent for a typewriter. But the machine was cumbersome and not easily produced. It was not until 1867 that the first practical typewriter was designed by Christopher Sholes, Carlos Glidden and S.W. Soulé of Milwaukee, Wisconsin. It was patented in 1868. In 1874 this typewriter was placed on the market by E. Remington & Sons, manufacturers of guns in Ilion, New York. This first typewriter was very similar to the modern typewriter used today. However, it was quite large and heavy.

Several years later, the Underwood Typewriter Company began producing relatively inexpensive and lightweight portable typewriters. The price for these early machines was about $50 and they weighed about six and three-quarter pounds. In 1925 the Underwood Typewriter Company commissioned Norman Rockwell to paint a picture to be used as an advertisement. Because of the wide use of the portable typewriter not only in business and industry but also in schools, Mr. Rockwell decided to use a student typing a report about Daniel Boone as his model. The picture was published in *The Saturday Evening Post* on October 13, 1923.

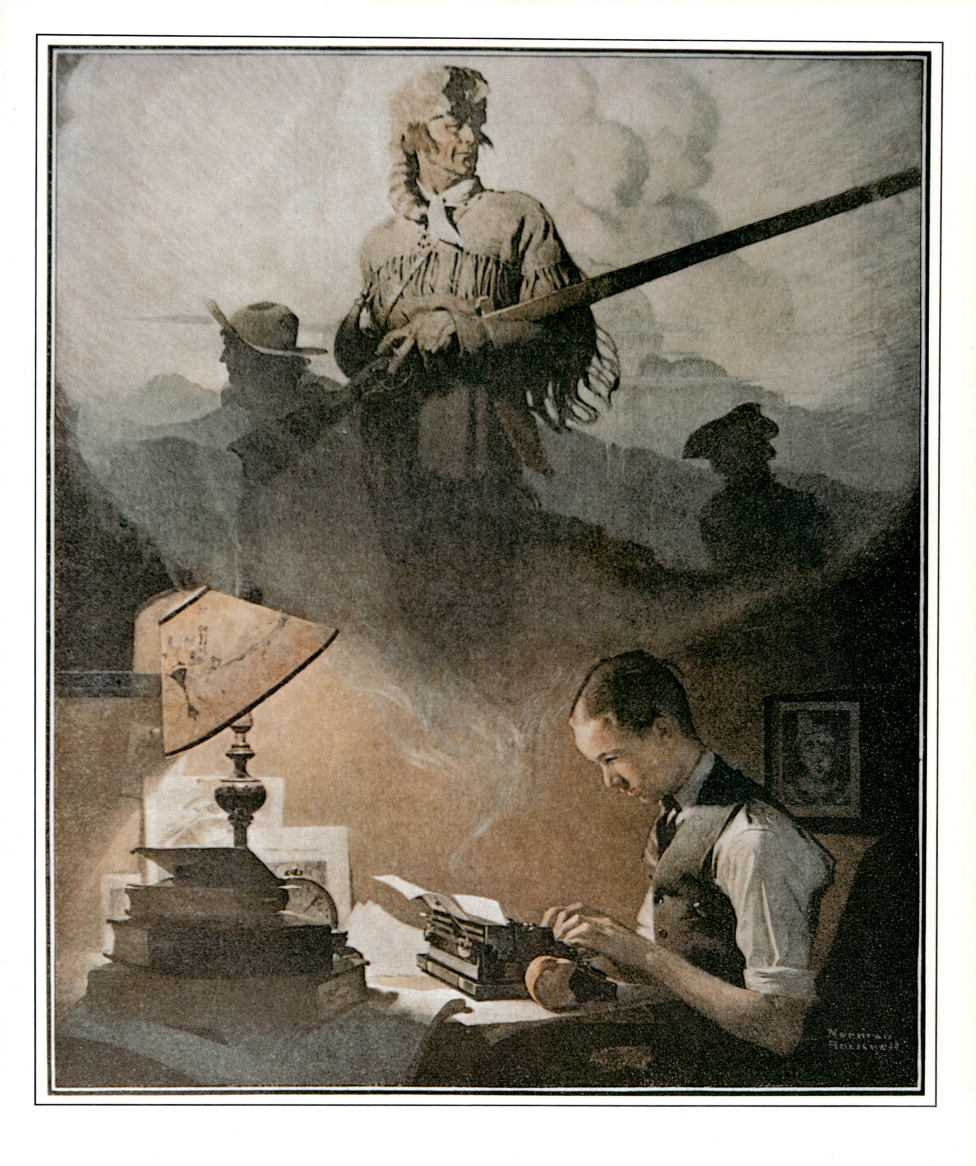

THE UPJOHN COMPANY

By the end of the nineteenth century, the world of medicine and surgery was making great strides and many medical problems that were unsolvable and serious diseases that were incurable were now being successfully treated. However, one problem that still existed was the lack of uniformity in pharmaceuticals. These difficulties ranged from unexpected variations in the strength of liquids or appalling unpalatability of syrups, to pills that were so hard that they passed through the patient without dissolving.

The Upjohn Pill and Granule Company came into being as the result of an invention designed to solve one of these problems; the pills that were too hard. The invention was a new method of making pills by William Erastus Upjohn, a 31-year-old practicing physician in Hastings, Michigan.

Dr. Upjohn was born on June 5, 1853, and was the son of a physician who practiced in a small farming community. Shortly after becoming a doctor, William became interested in a new process for making pills. His idea was that the tablets needed no gums or adhesives to hold them together and their ingredients could be precisely controlled. He applied for a patent for his "Friable" pills in 1884 and it was granted on January 10, 1885. For the next year, Dr. Upjohn continued his medical practice in the afternoons and evenings, and each morning he spent producing his pills, which grew more and more popular. He soon outgrew his attic laboratory and began to look for a factory.

In 1886 the Upjohn Pill and Granule Company opened its door in Kalamazoo, Michigan, with all of the Upjohn brothers as partners. Over the next several years, the company prospered and many new products were created under the Upjohn name. By 1900 more than 700 items were listed in the Upjohn catalog and the name was formally changed to The Upjohn Company in 1902.

In the 1940s the company commissioned Norman Rockwell to paint six advertisements for medical journals and lay publications to promote the Upjohn name. He also painted one for the pharmaceutical journals at the same time. These beautiful paintings appeared in *Life*, November 1, 1943; *Printer's Ink Monthly*, May 1941; and *The Saturday Evening Post*, 1943 and 1947. While the company no longer produces prints of these famous paintings, they can still be seen on the walls of doctors' offices around the country.

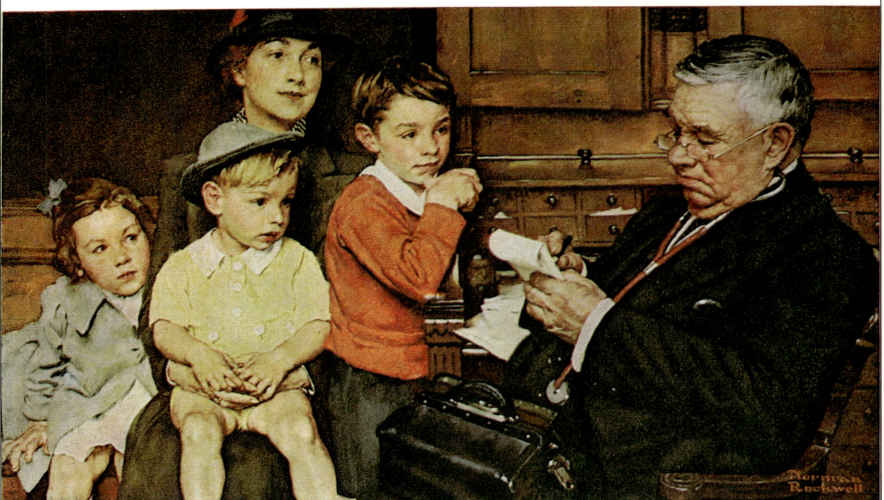

COPYRIGHT 1943, THE UPJOHN COMPANY

Your doctor diagnoses and treats illness in his little patients quite differently than in adults. For children present medical problems all their own—a subject which constituted an important part of his medical studies and training.

Since small children are unable to describe their illness, your physician diagnoses it by studying his patient's behavior, as well as by the physical signs of the disease. Recognizing such behavior and interpreting its meaning are as much a part of his professional knowledge as knowing how to guard against complications—complications which can make the consequences of disease a more serious matter in children than in grownups by interfering with normal growth and development. Similarly, he knows how children differ from adults in their reactions to the medicines he prescribes, and how those reactions differ at various ages.

It is because only your doctor is qualified to determine the special medical care which children need that you should consult him whenever you are concerned about your child's health.

THE UPJOHN COMPANY

203

THE WATCHMAKERS OF SWITZERLAND

The first watch, according to history, was invented about 1500 by Peter Henlein, a locksmith who lived in Nuremberg, Germany. The watch was in reality a portable clock that was so heavy it hung from a belt around the waist. Before this invention, time was told by clocks that used heavy weights, but Henlein's invention of a mainspring as a source of power to turn the wheels, created a new industry. The manufacture of watches by hand soon spread to neighboring countries; however, Switzerland became the center of the watchmaking industry.

Today Switzerland still ranks as one of the major watch-producing centers of the world. Even fine watches created in other countries are proud to say they have a Swiss movement.

In September of 1948, The Watchmakers Of Switzerland Center was opened in New York City as a representative of the Swiss watch industry. About that time, Norman Rockwell was commissioned to paint some pictures to be used in advertisements in the major magazines. These popular ads appeared in *Country Gentleman*, *Life*, *National Geographic*, *Reader's Digest* and *The Saturday Evening Post* between 1949 and 1955 and also appeared as display material in jewelry stores around the world.

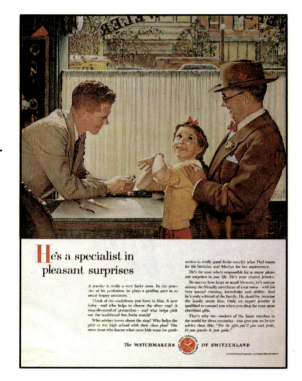

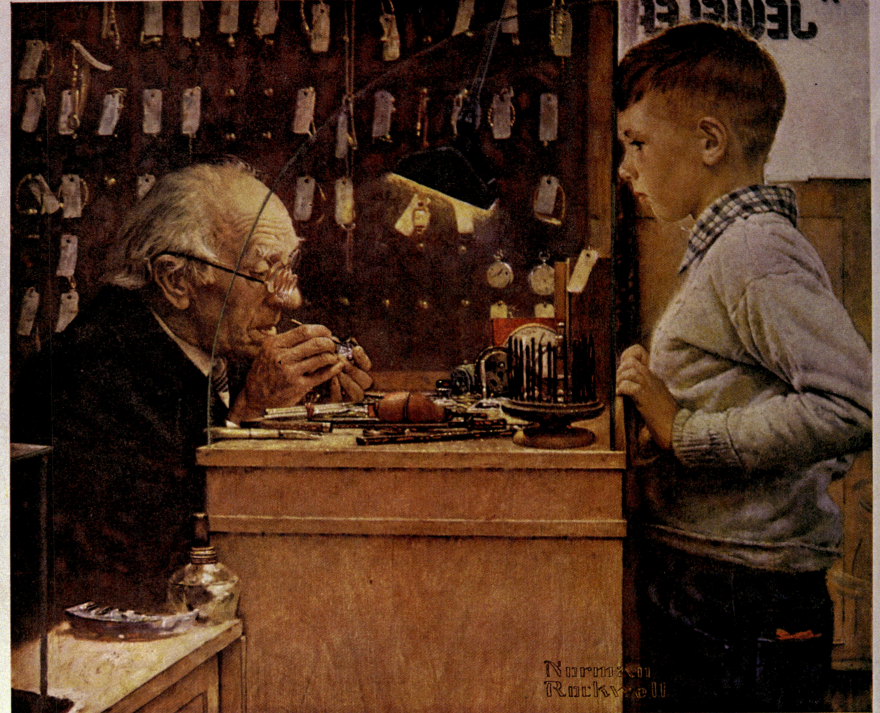

IT'S WATCH INSPECTION TIME, SEPTEMBER 9-18.

WHAT MAKES IT TICK?

WHEN you listen to your watch, it speaks not only of the passing of the seconds but of the skills of all the men whose efforts have gone into its perfection.

To a watchmaker, your watch is like a living thing. His world is as tiny as the watch he is working on—and as large as the history of recorded time.

Your watch ticks 432,000 times a day—as the lever jewels strike the escape wheel. The constancy of this heartbeat determines the accuracy of your watch, the big difference between a fine Swiss jeweled-lever watch and an ordinary watch. For a fine Swiss watch is painstakingly precisioned —from the balance wheel that travels 3600 miles a year to the tiniest screw, no bigger than this period → ·

Whether you're buying a new watch, or having a watch serviced, your jeweler will show you what Swiss craftsmanship means to you in beauty, accuracy, value—and in the ease and economy of servicing. No wonder 7 out of 10 jewelers wear fine Swiss watches themselves! *For the gifts you'll give with pride, let your jeweler be your guide.*

The Watchmakers of Switzerland

Time is the Art of the Swiss

© 1954 Swiss Federation of Watch Manufacturers

205

WESTERN UNION

In 1851 a group of Rochester, New York, men organized the New York and Mississippi Valley Printing Telegraph Company. In 1856 the name was changed to Western Union. In 1861 Western Union built the first transcontinental telegraph line. The last Postal Telegraph, Inc. merged with Western Union in 1943.

Western Union provides the public telegraph system in the United States. It handles the nation's telegrams, money orders and millions of international telegrams. In 1962 it expanded its private wire service to industry and government, enabling customers to send messages, weather reports, and other visual data across a nationwide microwave beam network.

Although telegrams as we know them today have no pictures on them, in the mid-1930s Norman Rockwell was commissioned by Western Union to do three paintings to appear on the top of holiday greetings. A Christmas greeting by Western Union, an Easter Greeting and a Valentine's Day telegram were extremely popular and sent out by the thousands in 1935 and 1936.